W9-CDA-908

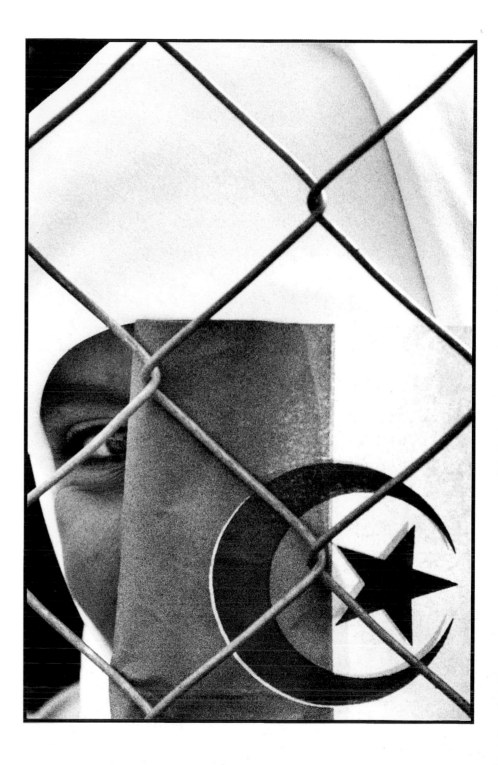

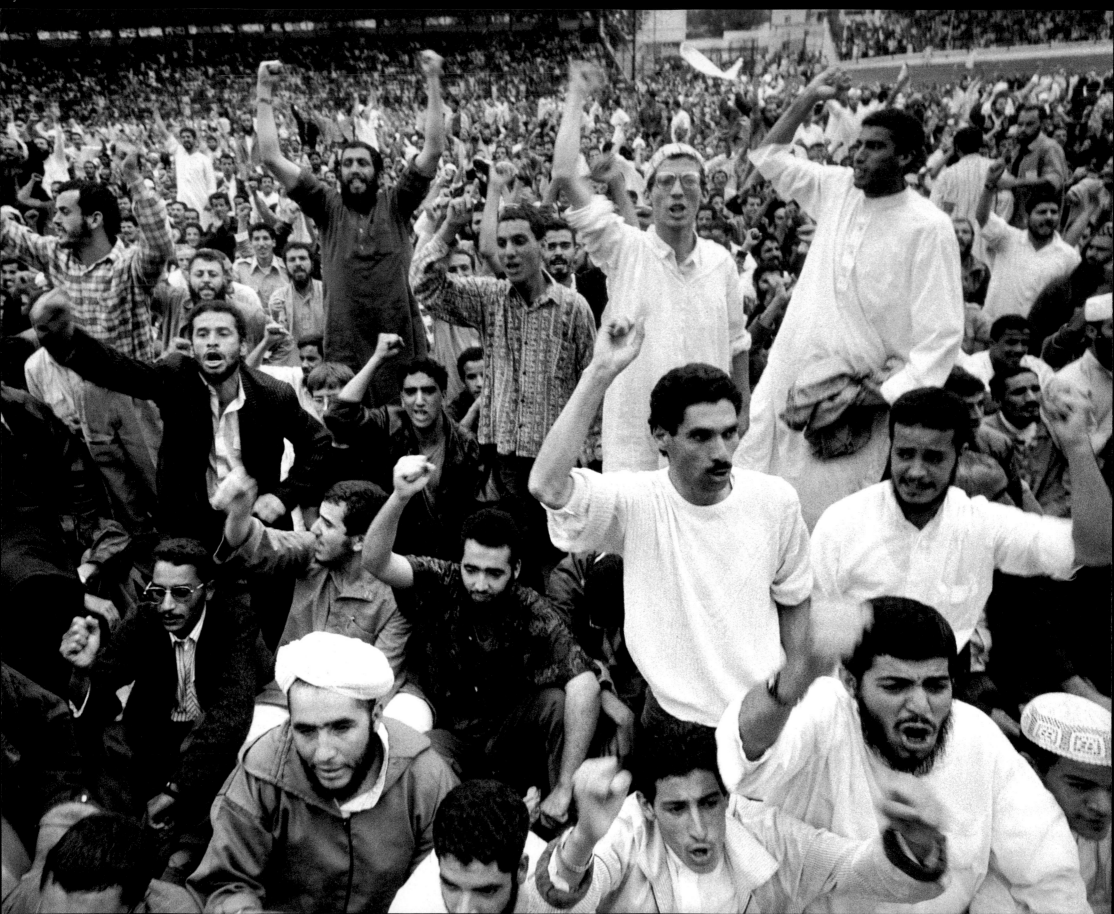

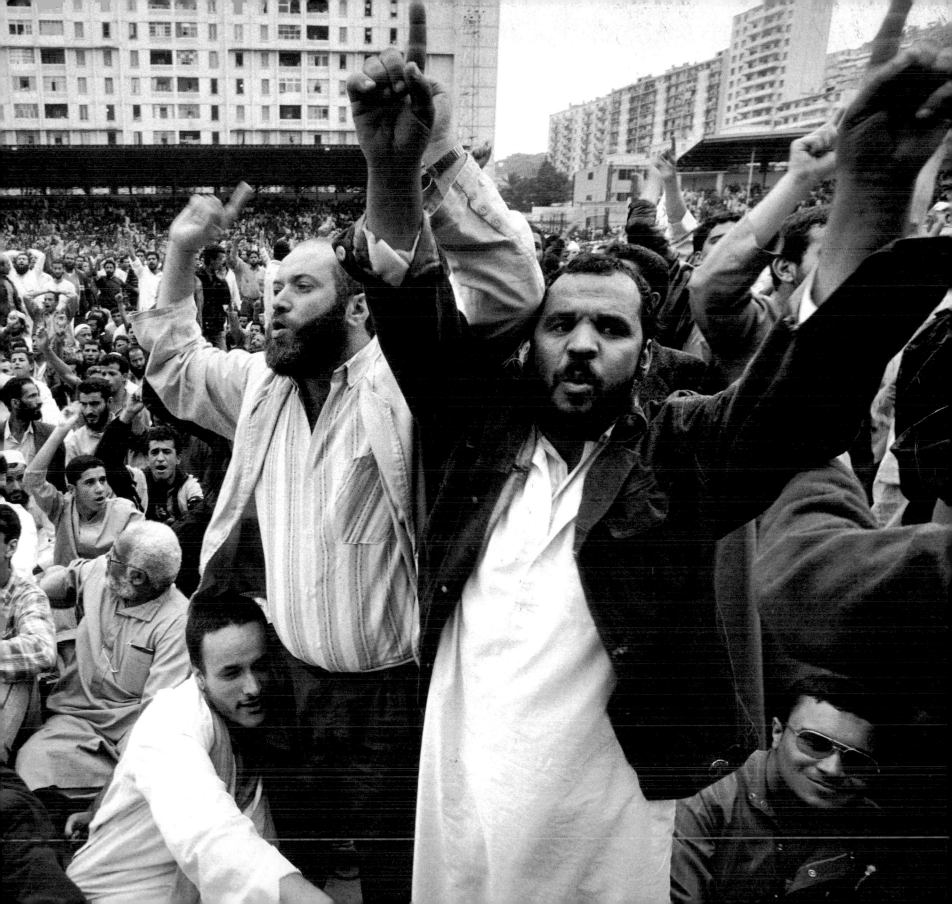

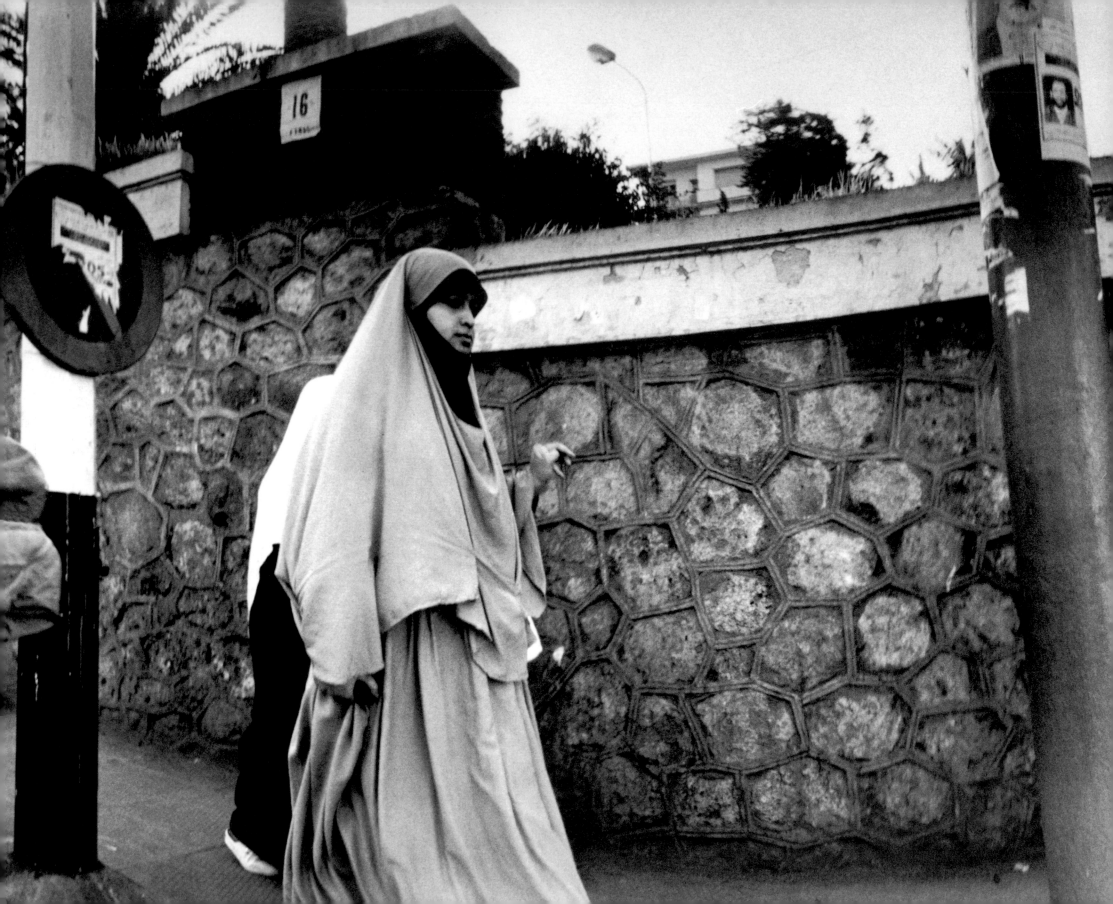

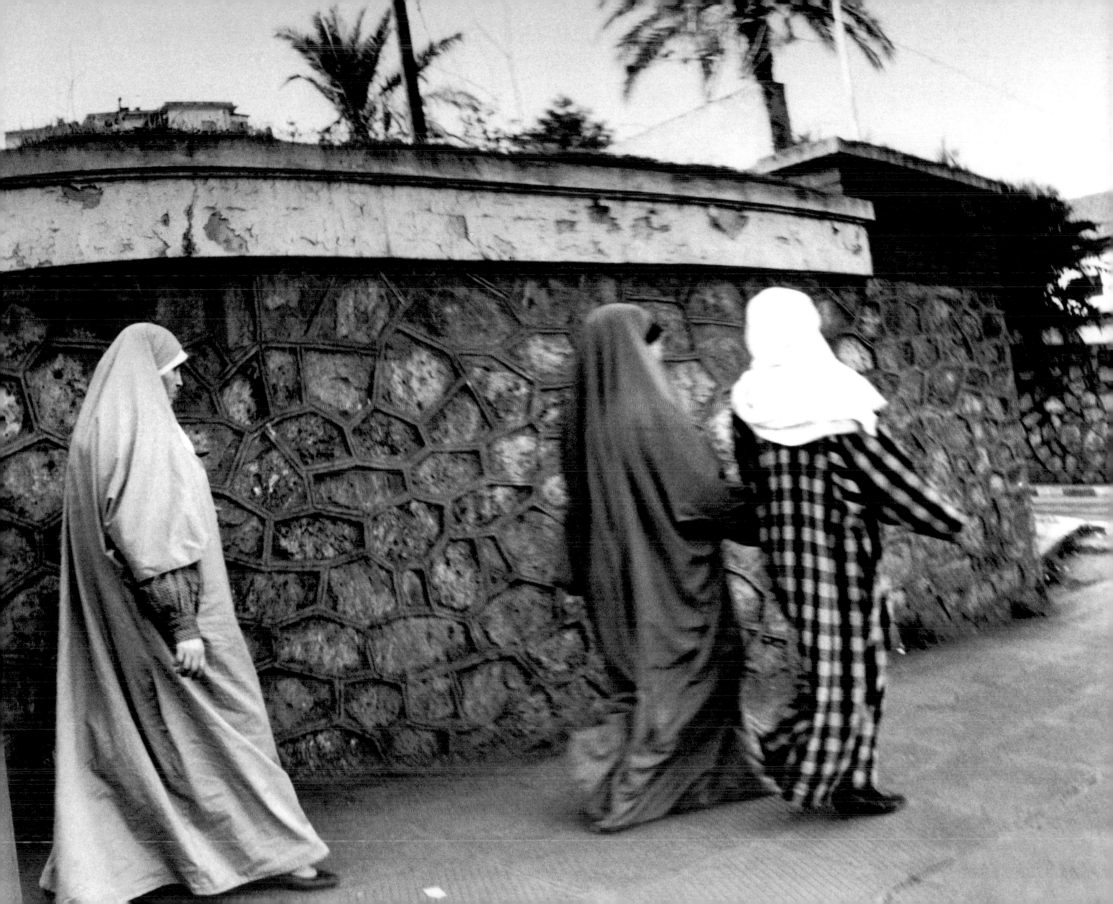

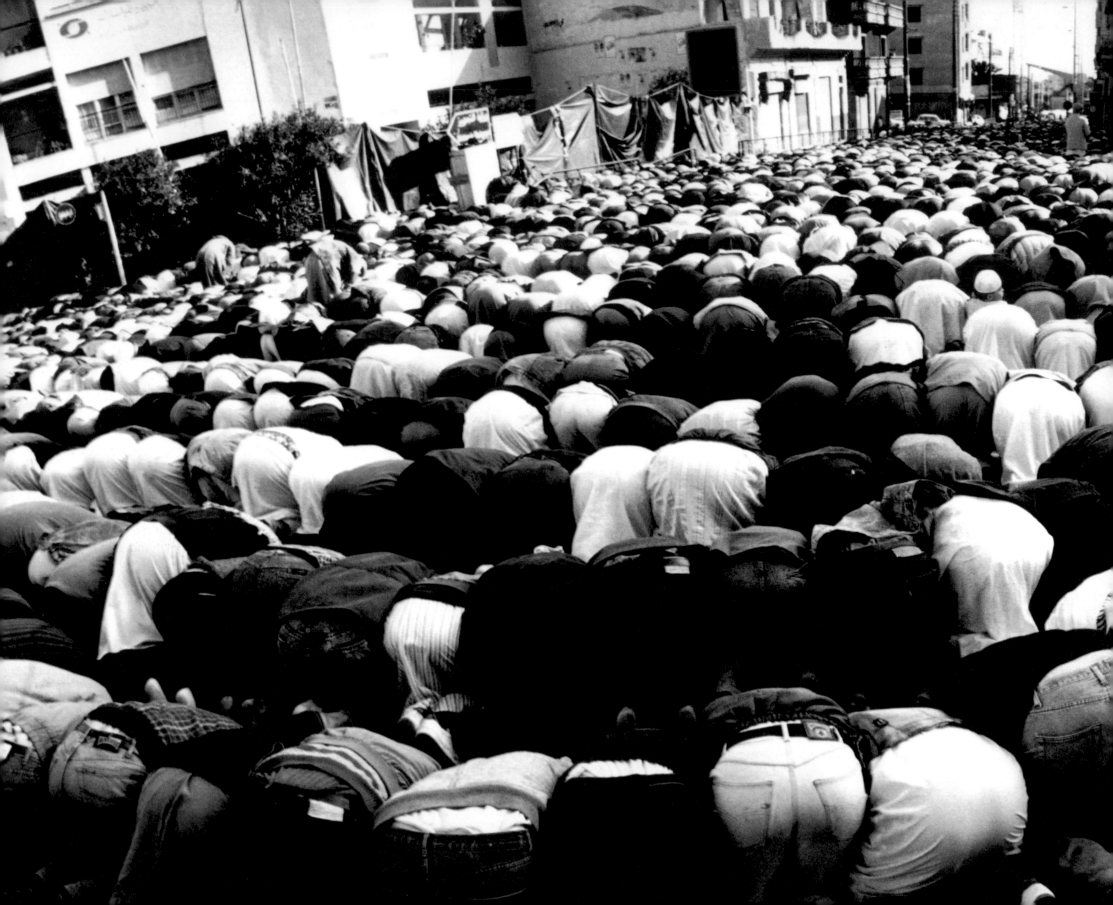

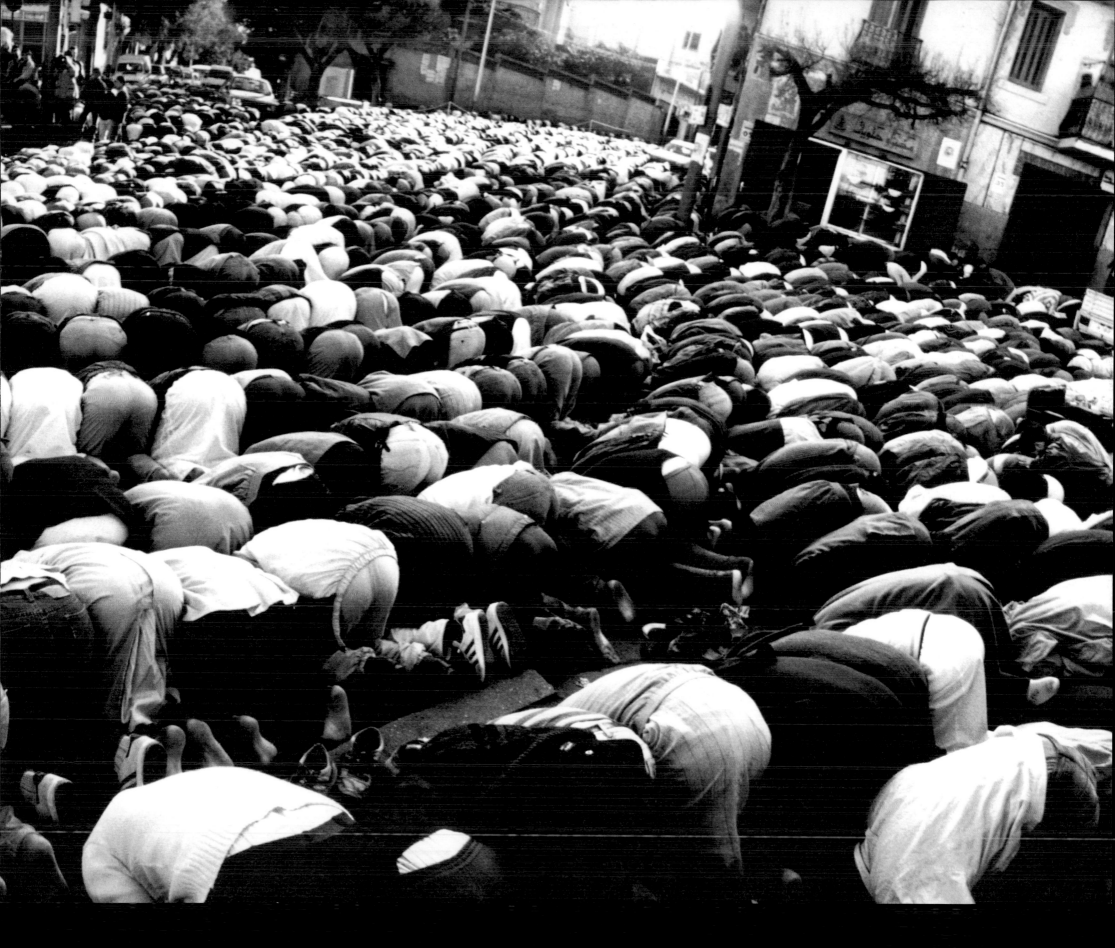

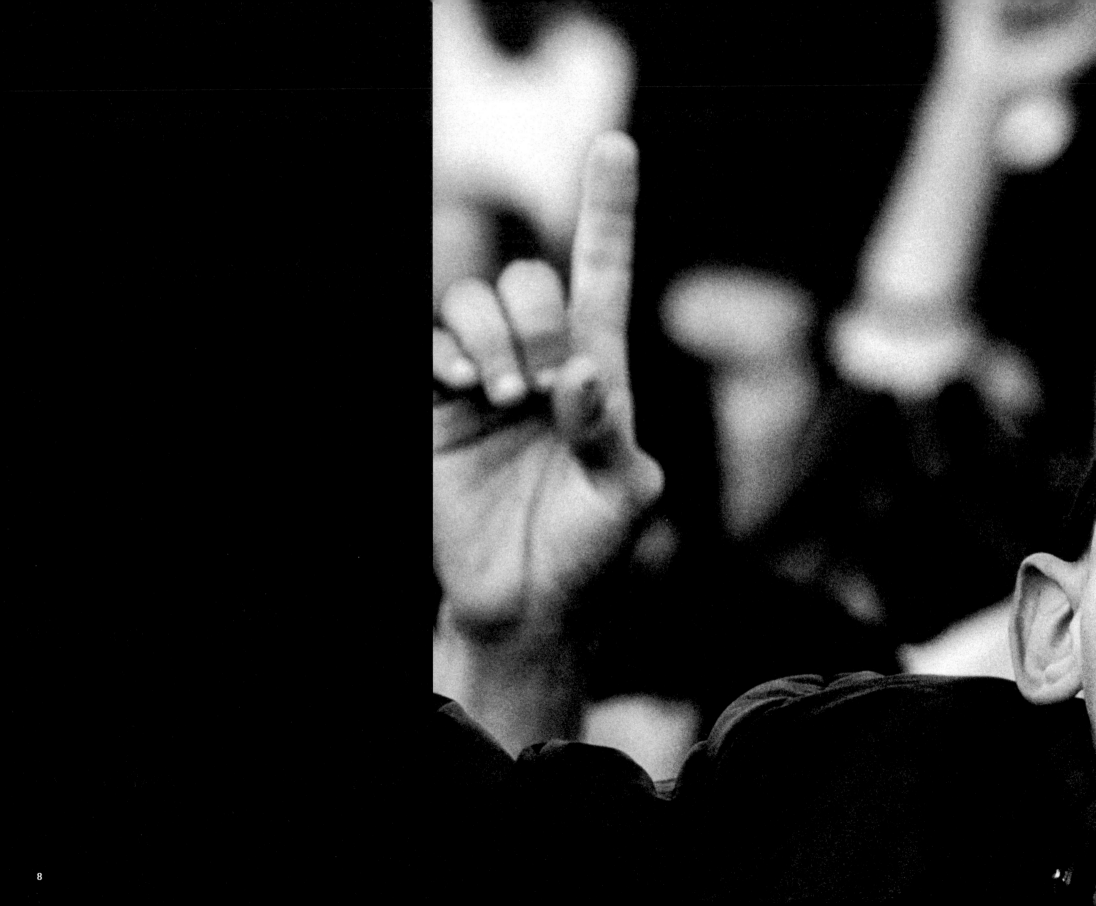

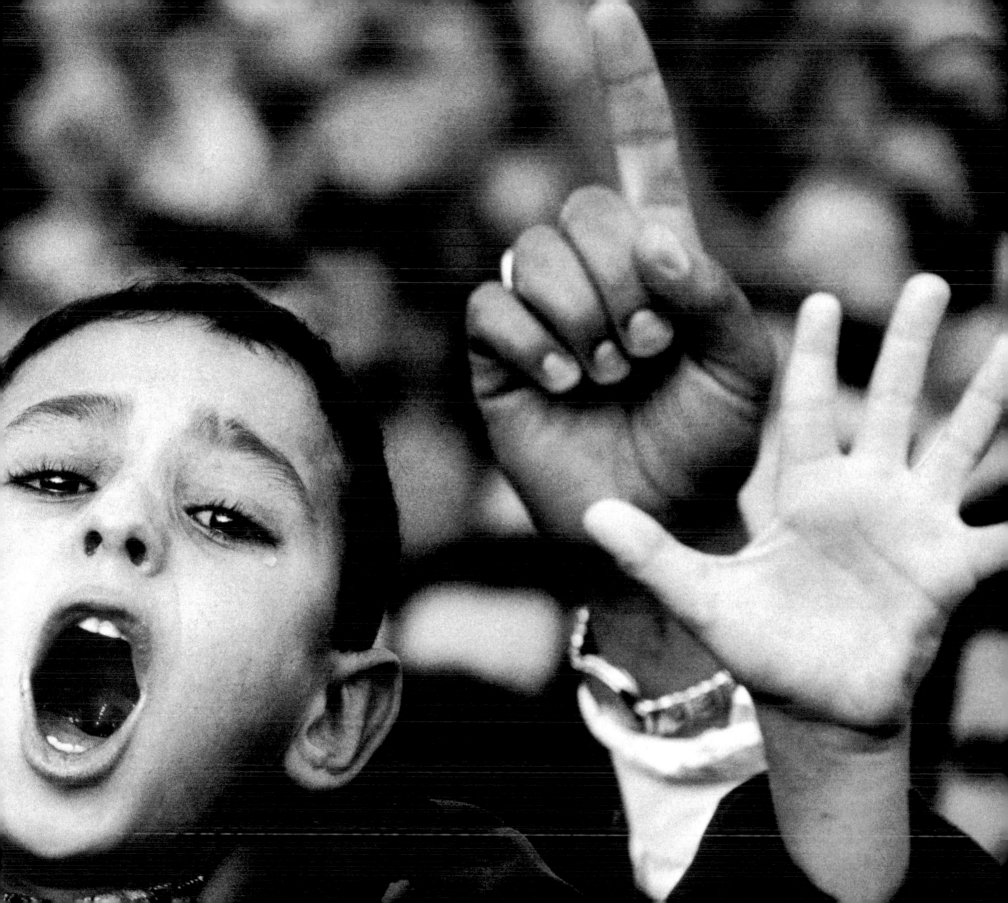

There are many who question the future of documentary photography. They explain to you very seriously that the still image no longer has any meaning if it is only a reflection of reality, that it exists only if manipulated, transfigured, transcended, sublimated by the will of a person who no longer calls himself a photographer and who one must classify, at the risk of incurring his anger, in the privileged category of Artists.

And then someone poses on the edge of your table a series of images made in the past few years on a burning subject in a country in flames.

And these images, snatched by Michael von Graffenried without having been aimed, for to raise a camera to one's eye is to put one's life in danger, testify to a truth that no one is showing, that of daily fear and furor that you won't see on the six o'clock news on television.

So we no longer raise the questions of symbolism, or aesthetics. We watch what was white Algeria turn into the black of disappointed hopes, turning into the red of slit throats.

A photographer can show hate and absurdity: photography exists.

ROBERT DELPIRE
CREATOR AND FOUNDING DIRECTOR OF THE CENTRE NATIONAL DE LA PHOTOGRAPHIE, PARIS, FRANCE 1981–1996

INSIDE ALGERIA
MICHAEL von GRAFFENRIED

APERTURE

LIFE AND DEATH IN ALGERIA

MARY-JANE DEEB

Tension in the streets, Blida, 1995

These striking photographs by Michael von Graffenried were taken between 1991 and 1998, a time during which Algeria was torn apart by a bloody conflict between a secular military government and a radical Islamic opposition. The fighting has taken an estimated seventy-five thousand to one hundred thousand lives to date. Many journalists have claimed that the conflict began in 1992, the year in which Algeria's first free and fair legislative election was annulled; in fact, the conflict began more than a decade earlier.

Algeria won independence in 1962 after an eight-year war against French colonial rule. Its military leaders, who had fought in the war, adopted a socialist, one-party political system which did not tolerate any form of organized political opposition. In the late 1970s, however, an Islamist group called Ahl al-Da`wa (People of the Call), with links to other Islamic organizations in Algeria, started voicing its dissatisfaction with the state's control of religious institutions, such as mosques and Islamic schools, its monopoly on trade, and its opposition to political organizations of any kind.

In the early 1980s, the movement began seizing mosques and agitating against the government. When state security forces attempted to stop those takeovers, bloody clashes erupted between them and supporters of the Islamist movement. Undaunted, Ahl al-Da`wa moved from mosques to university campuses, where it mobilized students. Pitched battles ensued between Islamist students and leftist, secular students, which resulted in a number of casualties.

In response, the state began a systematic campaign to undermine the Islamist movement, which by then aimed to overthrow the government and create an Islamic state governed by shari`a (Islamic law). Islamist leaders were arrested and jailed, police raids were conducted on homes of suspected members of the organization, and Islamist publications were banned.

In the mid-eighties, the Algerian economy suffered from the steep fall in the price of oil and gas on the world market. Since Algeria's major source of revenue comes from the export of oil and natural gas to Europe, the United States, and other parts of the world, its national income fell almost by half. Algeria had to borrow heavily from international institutions such as the World Bank and the International Monetary Fund. In order to do so, the Algerian government had to introduce major economic reforms. It imposed strict austerity measures such as the reduction of food subsidies, currency devaluation, and a tighter limit on social services provided by the state.

The reaction to those measures was immediate: in October 1988, riots broke out in the Bab al-Oued district of Algiers. They spread quickly to the rest of the capital and then moved on to Oran, Constantine, Annaba, Blida, Tiarret, Sinya, and beyond, to the Berber areas of Tizi-Ouzou. Demonstrators protested the elimination of subsidies on basic commodities, high unemployment, shortages of consumer goods, and the unavailability of affordable housing.

Although the riots had nothing to do with Islam, Islamic militants exploited the disturbances to mobilize popular support for their agenda. The armed forces were brought in to quell the riots, but they were unable to restore law and order for ten days. By that time, more than 150 Algerians were reported dead, over a thousand were injured, and an estimated three thousand had been arrested.

The nation was in shock. For the first time since independence the army had been used against the people. In response, the government condemned the violence, met with Islamist leaders, and promised major social, economic, and political reforms. In February 1989, the state drafted a new constitution which eliminated the clause that defined Algeria as a socialist, one-party state, and allowed for the formation of political associations. Later that year, the government legalized a number of political parties, including the Islamic Salvation Front (FIS), an umbrella organization which brought together a number of disparate Islamic groups, linked primarily by their desire to bring about an Islamic state.

In June 1990, the first free and fair local elections were held, and the FIS won the lion's share of the municipal votes. This undermined the ruling party, the National Liberation Front (FLN), the secular organization run by elite technocrats, to which all members of the Algerian government belonged. In December 1991, national parliamentary elections were held, and more than fifty newly formed parties participated. Despite the fact that the leaders of the FIS were in jail, as a result of the campaign to undermine Islamists, the party appeared to be the clear winner in the first round.

Two hundred of the 430 seats still had to be decided in a second round of elections, which was set for January 16,

1992. It became apparent that the FIS would again win the majority of those seats, which would give it a two-thirds majority in parliament and allow it to change the constitution and the political system, if it so desired. The military, acting on its own initiative and fearful of such a transfer of power to the Islamists, suspended the second round of elections, annulled the first round, and demanded the resignation of the president, Chadhli Ben Djedid, who had been in power since 1978.

The cancellation of the 1991–92 elections marked a new phase in the confrontation between Islamists and the government. Islamists held mass demonstrations and attacked government buildings, army barracks, police stations, and security forces. They planted car bombs in marketplaces, killing dozens of civilians, and assassinated journalists, intellectuals, artists, entertainers, and others who criticized their movement. The government responded with ruthless military force, imposed a state of emergency, suspended the National Assembly, banned the FIS, and imprisoned thousands of Islamist supporters. Algeria fell into a state of civil war.

Attempts to resolve the crisis took two forms: one was to bring about negotiations between the government and the Islamists, the other focused on rebuilding the institutions of the state.

The international community was involved in the attempt to foster a dialogue, as in the case of the Sant' Egidio meetings in Italy which took place over several months in 1995. Various opposition parties, including the FLN, the FIS, and a number of moderate Islamist and Berber parties participated, but the effort came to naught when the government refused to attend any of the sessions. Behind the scenes, however, the government had begun talking to moderate Islamist leaders who did not support the FIS.

The attempt to rebuild state institutions began with presidential elections, in November 1995. Four candidates participated, representing the government, the moderate Islamists, and the Berbers. Seventy-five percent of the electorate voted, including both men and women over the age of eighteen, and the government's candidate won with 61 percent of the vote. In January 1996, voters approved a referendum on an amended constitution, but turnout was low, and results were inflated. In June, October, and December 1997, respectively, legislative elections were held for the lower house (monitored by the United Nations, the League of Arab States, and the Organization of African Unity), the municipalities, and the upper house of parliament. None of those elections was entirely fair, and each was contested by various opposition parties.

Although most of the violence in Algeria had subsided by early 1998, the battle still rages in the northwest, in the Metidja region, one of the most fertile agricultural areas in the country. Some of the worst massacres of men, women, and children, most of whom were poor farmers, have occurred there. The reasons for the killings vary as widely as the perpetrators of these odious crimes. Small radical bands of Islamic extremists (such as the Armed Islamic Group or GIA) continue to kill those who are perceived to be disloyal to Islam. Civilians, called Patriots, have been armed by the government to protect their homes and their communities, but they are killing, in retaliation, the murderers of their own family members. In the wake of the demise of the authoritarian socialist state, Mafia-like groups have emerged and are randomly robbing and killing innocent victims. Farmers are assassinating their neighbors in a major land-grab, the result of the state's privatization of agricultural property.

Elsewhere in Algeria the situation is different. Major cities are relatively quiet and safe, and the army and government appear to be in control of most of the country. The FIS and all major Islamist groups have called for an indefinite cease-fire. Moderate Islamists make up one-third of the legislature, and free-flowing parliamentary debates are televised live daily. The press is among the freest in the Arab world. The economy is growing steadily (at an average of 3 percent in 1995 and 1996). However, human rights violations by government forces continue, and international human rights organizations have called for greater transparency regarding the state's presentation of the situation to the global community.

As Michael von Graffenried's pictures in this volume demonstrate, Algerians are a strong and proud people who do not deserve the horror that has ravaged their beautiful country. The vast majority of thirty million Algerians today wish to live in peace and security. A few thousand are perpetuating the cycle of violence that has held the country hostage. I believe Algeria has now turned a very dark page of its history. Graffenried's photographs should remind future generations of the price of civil war.

INSIDE ALGERIA

MICHAEL von GRAFFENRIED

Electoral rally for FIS, December 1991

Wahiba is a sixteen-year-old girl from Raïs, a small village in the Metidja region of northwest Algeria. I first heard her story from a doctor in the psychiatric ward of the Mustafa Hospital in Algiers. Wahiba was treated there for three weeks after the massacre of Raïs by Islamist terrorists on August 29, 1997, which left 349 villagers dead.

When Raïs was attacked, Wahiba's father ran to get help from an army barracks eight hundred yards away. The soldiers on duty there told him to wait on a bench. He waited all night, but not one soldier left the barracks to defend the people. By the following morning, terrorists had slit the throats of all his family members except for Wahiba. She survived thanks to her grandfather, who had fallen on her when his own throat was slashed, pinning her down to the ground. Wahiba passed out, her grandfather's blood poured over her, and the killers left both of them for dead. According to the doctor in Algiers, when Wahiba was admitted for emergency treatment, she refused to drink water, convinced that the fluid was blood.

When I arrived in the Metidja plain, I went to Raïs, escorted by the police, in search of Wahiba. The survivors there told me that no such person existed, but finally a young boy volunteered that he knew her, and that she would be returning to Raïs in two days. When I finally met Wahiba, she took me, weeping, to visit her home. On the way, she pointed to a nearby house and whispered to me, "They came from there. They killed all my family." One of her neighbors had been with the killers who had carried out the massacre.

A sixteen-year-old boy from Raïs told me the recent history of the village. In Algeria's very first election, in 1991, the whole community had voted for the FIS, the Islamic Salvation Front. The FIS promised, if it won, to create an Islamic state and forgo future elections. The FIS won the first round of the

voting. In the name of democracy, however, the state banned democracy: the election results were overturned, and the FIS was immediately outlawed. The state sent many of the Islamist villagers to prison camps in the desert, in the south, along with approximately ten thousand other members of the FIS. Even after their return to Raïs, however, they proceeded to run the village according to Islamic rules. One emir declared himself chief and ordered all the women to wear veils. He determined who could or could not attend school. Raïs functioned as a mini Islamic state for two years, until the government began its campaign to eradicate Islamists. They retreated to the mountains and the forests, and support for them rapidly diminished in Raïs. In response, a core of armed Islamists returned to massacre the villagers, whom they viewed as defectors. Thus was Wahiba's family murdered.

Since 1997, whole villages have been virtually wiped out this way, with hundreds of people killed overnight by extremists. Entire families are marked down for slaughter. Girls are abducted, raped, and murdered. The victims almost always have their throats slit, and the attacks are always carried out at night, often within a few hundred yards of an army post. Some Algerians explain that the soldiers are young, untrained recruits, too frightened to leave the barracks at night. Others say that the soldiers refuse to risk their lives to help Algerians who voted for Islamists. Yet others believe that, because the Metidja plain is one of the most fertile regions in Algeria, the state is deliberately trying to clear the area so it can resettle and exploit the land.

Dangerous Profession

The violence in Metidja is just one component of the civil conflict that has riven Algeria since 1992, far from television cameras or the attention of the international community. The first wave of killings targeted

journalists and photographers—more than sixty of my colleagues have been killed by Islamist terrorists to date—so foreign coverage of the crisis has been scant. For most photographers the risks are far too dangerous even to contemplate working in Algeria. With my dark curly hair, tanned face, and anonymous clothes, however, I pass easily for an Algerian. By 1994, the situation had become gravely dangerous even for Algerians, but I realized that after only three years, at least I was no longer working as an outsider. For example, when I was invited to the 1994 'Id al-Kabir festival, an important Islamic holiday, I stayed with a local family (see pages 24–25); by the second day of the festival, they took me with them to visit their family relations; and by the third day, when people customarily kissed each other in the street, many men I did not know kissed me too.

It is still crucial for my safety that I work in absolute silence, because my Swiss-accented French would immediately give me away as a foreigner. But because Algerians themselves no longer speak to people they don't know in the street or on buses, my silence goes unnoticed. There is a total lack of trust. You never know whose side anyone is on. It is only with the help of Algerian friends and my use of a hidden camera that I have been able to visit safely ten times since October 1991.

I am still not afraid of working in Algeria, though I must be very careful. If I am threatened, or if I suspect that somebody would like to kill me, I can leave the country immediately. I have great respect for all those Algerian journalists and photographers who cannot escape so easily, yet who live and work in their own nation, day after day, despite the acute dangers and the high number of deaths among their ranks.

Algerian Hospitality

I secured my first visa easily, almost by accident, when I set up a workshop with ten

Algerian photographers, at the invitation of the Swiss ambassador, and we photographed Algiers together. A group exhibition ensued, and suddenly I had ten new friends. It was still easy then to get to know people, and if you made one friend in Algeria, you became the guest of that person's entire extended family. In Western countries, if an Arab comes to the door, the door will likely be shut. In Algeria at that time, however, an extra place was always set at the table in case a stranger arrived. I traveled around Algeria for two months without once staying in a hotel. The friendships I made gave me confidence and changed the direction of my work. They compelled me to return to Algeria again and again, despite the danger to people in my profession.

I was just beginning to comprehend traditional Arab hospitality, when that legacy too was diminished by war. These days, if you invite a stranger into your house and give him a bed and a meal, the police may arrive at your house the next morning and accuse you of sheltering a terrorist. For my Algerian friends, one of the greatest hardships of this conflict is the fact that they can barely offer the generosity that their religion demands. The family is without a doubt the only structure that still survives in this dislocated country.

During one of my trips in 1997, I was no longer able to stay with my friends, so the state gave me police protection. On this visit, though, I had to attend a wedding hosted by a family to which I am very close. I warned the security forces that I could not attend a wedding celebration surrounded by plainclothes policemen. They refused to let me out of their sight, but finally agreed to be discreet and stay a few hundred yards away. After an hour of celebrations, the brother of the bride asked me, "Are those guys here for you?" I was very embarrassed, apologized, and explained how hard it had become to work as a journalist in Algeria. Half an hour later, the wedding hosts were offering cakes to the policemen parked outside in their unmarked car. This is typical Algerian hospitality.

Stealing Pictures

A profound anti-photography culture exists in Algeria which predates even the recent extremist attacks on journalists. Their disdain for the camera is one born of Islam, a religion that prohibits pictorial images, but it has been fed by the recent political history of Algeria. During the war of independence, forty years ago, the French army and the police used photography as an instrument of control and identification. Many women were suspected of concealing bombs under their clothes, so the French forced them to remove their veils when photo-identification cards were made. This was an anomaly, because women never needed identity cards in Muslim society; they were always accompanied by men. Having to face the camera unveiled like this was a gross violation, almost a form of rape. The mass terror and fear brought on by seven years of civil war have further exacerbated Algerians' distrust of the graven photographic image. I have traveled a great deal in other Islamic countries where the camera is shunned, such as the Sudan, Syria, Israel, and Palestine, but I do not know any other place where photography is regarded with such suspicion. (See: von Graffenried, Michael. Sudan: A Forgotten War. Bern, Switzerland: Benteli Editions, 1995.)

Algerians will accept the presence of a camera in only a few situations, such as circumcisions or weddings. Banal, everyday events, however, cannot be photographed. People do not understand why someone would want to record daily life. Northern Algeria especially has never received many tourists, so the people are not accustomed to cameras, and film is very hard to find in the shops.

In Europe I promote the idea of photographing with the permission of the subject.

I hate zoom lenses. In Algeria, at the beginning, I tried to do the same. A camera is usually a great help, because it gives you an excuse to make contact with strangers, but not in Algeria. People refused to be photographed. After heavy soul-searching, I resigned myself to taking photographs surreptitiously. I found an ancient Widelux panoramic camera with no conspicuous lens or shutter noise, which I chose for practical, rather than aesthetic reasons. As I stalk by my subject quickly, almost invisibly, the camera makes just a faint whirring noise as the lens sweeps from left to right across a 150-degree view. Under my old beige windbreaker, I clasp my hands across the top of what looks like a primitive pair of binoculars hanging on an old leather strap. Because I do not put the camera up to my eye, people do not imagine that I am taking photographs. The camera has a fixed focus and no light meter, and at first it was very difficult for me to determine how to take photographs with it. Especially with portraits, I had to acquire a sense of what exactly would fit into the frame.

People in the street are always on their guard and alert to anything unusual. Yet when they see a camera just half a yard away from them they say nothing, for they don't know who the mysterious photographer might be, why he is photographing them, and for what purposes his photographs might be used. One day I went into a cafe and placed my panoramic camera on the counter, beside my cup of coffee. The other customers could see that the lens was slowly moving in the dim light of the cafe, but still they did not imagine that I was photographing them (see pages 32–33). No one even asked me what was happening, because Algerians no longer speak to strangers. They fear for their safety.

The Initial Picture

This Algerian project was inspired by one photograph, the importance of which I discerned long after taking the picture. My very first photograph of Algeria featured a police barricade of the Kouba mosque in Algiers. It was 1991, and the civil conflict had not yet begun full force. It was a Friday morning, the Islamic day of worship, and a cordon of riot police was surrounding the mosque area. I asked one of the officers for permission to take some photographs. He refused and said that I needed permission from the Ministry of the Interior. For four hours, I watched and waited, without taking out my camera. During this time it became clear that the military was stopping the faithful from entering the mosque. Undaunted, scores of Islamists began prostrating themselves in the street, worshipping Allah at the feet of the policemen. I wondered what kind of country this was where the faithful were not allowed to worship as they pleased. Intrigued, I stole one photograph in the few minutes during which the crowd of men prayed (see photograph

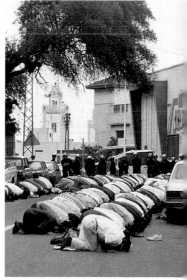
Ibn Badis mosque, Kouba, October 1991

this page). Later I discovered that the FIS had been using mosques at that time for demonstrations—as a place not only to pray but also to fight against the state with fiery sermons, propaganda, and indoctrination. A FIS leader was speaking at the Kouba mosque that Friday, and droves of FIS members were attempting to attend. The police tried to quash the gathering by diverting as many worshipers as possible to other mosques.

Police Portraiture

Now, journalists or photographers who arrive in Algeria must accept full protection from

the state. Unfortunately this puts a limit on what they are able to see. The state, for example, sometimes packs hundreds of journalists into buses and takes them to the villages where massacres like the one in Raïs have been carried out. Because press members are protected "for their own safety" by the state in this way, many journalists think it is no longer worth working in Algeria. My visits are generally unofficial. I work surreptitiously even on my official trips, so my time in Algeria is well worth the trouble. The state cannot control everything, and something remarkable always presents itself.

On one of the government's official tours, I was able to take my first photographs of the Ninjas, the special anti-terrorist units that hunt down and eradicate armed Islamists (see pages 68–69). Some of the Ninja recruits are traffic policemen who underwent emergency paramilitary training. With their balaclavas and Kalashnikovs, they are a menacing sight; their masks both protect them by concealing their identity and proclaim their ruthlessness.

Fatiha, Mustafa Hospital, Algiers

In March 1995, I was able to spend some time in the Ninja barracks, one of the most secret places in the country (see pages 62–67). No Algerian photographers had been able to visit them. I was invited to work inside because the government wanted to show that it was in control and that terrorism had become residual. Two days after photographing the Ninjas, I was sleeping in my hotel room when a car bomb went off at 5 A.M., just after the muezzin had called the faithful to prayer. The intended targets were the families of the Ninjas. Nobody died in the blast, but sixty-nine women and children were injured, simply because their fathers and husbands were policemen (see pages 80–85).

The police officer who had invited me into the barracks was transferred to another job, and then he quit the police altogether. First he tried living in exile in Tunisia, but his family grew homesick. So he returned to Algiers and set up a private security business, protecting people and shops. As the former head of police training, he knew how to select the best employees. With the nation opened to a market economy, all high-ranking army officers and civil servants must find a way to earn a living. Security is a job with a promising future in Algeria.

Propaganda War

Propaganda and manipulation of the media are commonplace in Algeria, with each faction of the civil war trying to use the press as an instrument for its own ends. In 1995 the Minister of the Interior at that time gave journalists albums filled with two hundred color photographs of decapitated heads. The government's twisted message was this: "Islamists kill people this way, so we must eradicate them." The minister himself told me, "We have to wipe out terrorism, otherwise it will spread to Europe. You should be grateful for what we are doing for you Europeans."

That same year, I photographed mug shots of wanted Islamists in a police station. The faces of those who had already been eradicated were crossed out. One Ninja returned from an operation, and vengefully wrote "abattu" (finished) on a mugshot of an Islamist he had just executed (see pages 76–77). When my photo was published in Germany, lawyers called me to ask for more, in an effort to secure political asylum for those Algerian Islamists who were clearly being targeted by the state. I refused to cooperate, however, on the grounds that I try not to let myself be used as an instrument by any one side in this war. Furthermore, it seems unjust to me that Islamists sentenced to death by the state qualify for political asylum, while journalists threatened with death by the Islamists go unprotected by the international community.

I stumbled across another surreal exercise at the Algiers Olympic Stadium on November 1, 1997, a national holiday. Outside the field, Islamists were praying; inside, two women's football teams were playing to a crowd of sixty thousand all-male spectators (see pages 124–127). For the Islamists, this was pure provocation—Islamic women are not allowed to play sports, much less show their legs and wear shorts. For the government, this was pure proclamation that Algeria is secular, and women are liberated. The minister for sports awarded the cup to the winning team.

The Islamists, for their part, frequently use children for their own propaganda. In December 1991, I photographed a young boy on the shoulders of his father during an FIS rally. Before the 1991 elections which were overturned, a crowd of FIS members gathered together for a rally on Martyr Square in the center of Algiers. Hysterical, the boy was shouting "Allah u akbar" (God is great) with tears streaming down his cheeks. Shortly after I took his picture, he fainted (see pages 8–9).

Dying by Numbers

On my last visit to Algeria, in June 1998, Algiers at first seemed much quieter than I had seen it in years, and the ex-Ninjas were back on their motorbikes handing out traffic fines. One of them stopped a lorry driver in the port of Algiers, and the two men began to argue. Two shots rang out, and the lorry driver was killed. The next morning the newspapers reported: "Terrorist killed in the port of Algiers." A change in uniform does not mean that all the Ninjas have forgotten their paramilitary training.

The police say they are obliged to kill Islamists on sight, because the Islamists don't give themselves up, they fight to the death. In the cemetery of Algiers the Islamists killed by police are buried close to the police killed by Islamists (see pages 78–79). The two sections are separated so that the families do not have to meet each other on their Friday visits to pray at the graves.

Even the Ninjas stay clear of the Casbah these days. When I first arrived in Algiers, in 1991, before the conflict erupted, a man from the Swiss embassy took me to the Casbah. He told me that he could no longer take the metro in Paris, where, in his previous job, he had been stationed as a diplomat, because he had been mugged at knife point. Yet he felt at ease in the Casbah. There were no thefts or crimes, and it was the quietest place you could imagine. Now, however, this magnificent old town which gave the city its name, Alger la Blanche, has become a hideout for killers who can escape up one of the thousands of stairways into its maze of narrow streets. Violence has become banal. Everyday, bodies are found in the dustbins of the old city.

In 1995, I had permission to visit the Mustafa Hospital in Algiers. There I met a young woman named Fatiha. She was on her way to pick up her wedding dress when a car bomb exploded on the bus she was riding. When she regained consciousness, she found herself in the hospital, her face completely shattered. Her fiancé's mother came to visit her and found her beauty gone. She never saw her future husband again (see photograph this page).

I have not wanted to show the dead in my photographs, but it should be noted that the war has already caused approximately one hundred thousand deaths, and twelve thousand people have disappeared. I met a man in the hospital, in the morgue, who showed me the corpse of a woman which had been in cold storage for three months because nobody had

come to claim her and nobody knew her name. She was a victim of the same bomb that had destroyed Fatiha's face (see pages 90–91). Driving out of the city I passed a man's body lying by the roadside (see pages 140–141). He could just as easily have been killed by terrorists in the night as been struck accidentally by a car. In a healthy country, people would contact the police at once. Here nobody does, for fear of being accused of complicity or worse, and the body continues to lie there.

The Cycle of Violence

Killers are easy to recruit. Many young men have nothing else to do with themselves. Sometimes they play games like dominoes, or they lean up against a wall killing time (see pages 34–35). Trabendo, the black market, used to do big business selling cheap goods and spare parts from France. Now that visas are impossible to obtain, unemployment is almost the rule among young people under thirty, who form 75 percent of the population. A bearded Islamist will pick one out of the crowd, offer the young man a gun, and ask him to kill a journalist in a cafe the next day. The young man is usually happy for the responsibility.

One young man named Ahmed had managed to stay out of the war and was open to all kinds of ideas; he frequented the disco, liked nice clothes and the company of girls, and he drank and smoked marijuana. One of his cousins was a member of the FIS and asked Ahmed to deliver a passport to someone for him. Ahmed could not refuse a request from a blood relative, so he carried out the errand. A year later the man was arrested, because the passport was fraudulent, and he surrendered Ahmed's name to the police. Ahmed returned from the disco one night at 2 A.M.; one hour later the police were at his door. Ahmed has served four years in prison as a terrorist for handling what turned out to be a false passport. After his first year in jail, rubbing shoulders with real terrorists,

Ahmed began to pray five times a day. Now he is out of prison, and he continues to practice Islam. He no longer drinks or flirts. From the government's perspective, prison rehabilitated Ahmed and made him into an exemplary citizen. In fact, the penal system has promulgated radical Islamism in a fringe of society that had never been zealously religious.

Since 1995, the government has been arming self-defense groups in the Berber Kabyle villages, in the eastern mountain regions, because Islamists were stealing guns that the villagers used to hunt wild boar. Now there are more than five thousand armed civilians, known as the Patriots (see photograph this page). Often they are trained by veterans who fought against the French in the war of independence. I met one woman named Ouralia who is one such trainer. She is sixty-three years old and was condemned to death by the French during the war of independence. In 1962, when the independent nation was born, she gave up all her jewelry in order to help fund the new National Bank of Algeria. Now she takes out her hunting gun to show the young men of the village how to use and clean it (see pages 94–95). The village where she lives was the first one attacked by Islamists and also the first to kill armed terrorists in retaliation (see pages 92–93). It is easy to hand out guns, but difficult to control the use of them and even harder to take them back once peace returns. The government had to admit in 1998 that some Patriots carried out personal vendetta massacres with their government-issued rifles.

The Swiss army has given me, as a citizen, an automatic gun and ammunition, which I am obliged to keep at home in Switzerland. This inspires me to ask myself all kinds of questions. What would it take to make me capable of killing someone? When does a person have the right to kill someone else? What are the boundaries of self-defense? Does a political party have the right to take up arms if its election

victory is confiscated? Does a state have the right to eradicate its citizens? I have not come up with compelling answers to these questions. I have learned from my time in Algeria, however, that although killing for the first time is very difficult, the second and third times it becomes much easier. Human beings can get used to most anything. Thousands of Algerians have stepped over this threshold since 1992, and a return to some kind of peace will take many years.

Nevertheless, there are signs of hope for democracy. The press is one of the most independent in Africa, and opposition parties are now tolerated. Several relatively fair elections have been held since 1991. Since the last one, in November 1997, demonstrators have gathered every day to protest electoral fraud on the part of their president, Liamin Zeroual. A president has never before been directly accused by the people of Algeria. But democracy is usually reduced to a few square yards, as protesters are carefully surrounded by the police (see pages 146–147).

In the Name of Faith

I go to Algeria primarily to visit my friends, and photography comes later. At the same time I am a photojournalist who sells his photographs to the press, even if the images I offer are black and white and panoramic, something the press does not always want. It is very complicated. Often I have to force myself to take out my camera. I am a bit ashamed because I photograph people who would not accept what I was doing if they understood. I fight against my inclination to work only with the subject's consent, while I fight against my subject's aversion to the camera. Yet I have faith that I am working for the greater good by taking these pictures.

I do not believe that a single photograph gives information, but a collection of photographs does. By returning to Algeria again and

again I am able to put the jigsaw puzzle together and present a more precise picture of this country at war with itself. The enigmas remain, however, like the bus burning in the middle of the night (see pages 128–129). Although the Islamists have made public institutions and transportation a favorite target of their bombings, when people see a bus burning, they still maintain that it was caused by an overheated engine. This is the most civilized and peaceful explanation. Nobody wants to admit that there is a war on, so that they can imagine there is hope.

I tell my Algerian friends that Switzerland, that peaceful little paradise of a country, holds the record among European countries for its suicide rate. They are Muslim and cannot understand this. Nobody commits suicide in Algeria. It would be the ultimate sin against Allah. They would rather have their throats cut than give up faith and plant a bullet in their brains. So the battle to defend this faith continues.

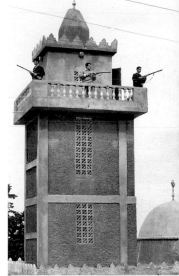

Patriots, Igoujdal, March 1995

Many people think I am obstinate for returning to Algeria again and again. My closest friends and family members persistently question why I continue to go. They insist that it is dangerous and not worth the risk to my safety. My answer to them is that I have found something in Algeria which does not exist in our occidental countries: even amid the violence, there is great morality and coherence among most citizens. You have to live it. I am longing for the time when I will be able to travel freely again in this wonderful country.

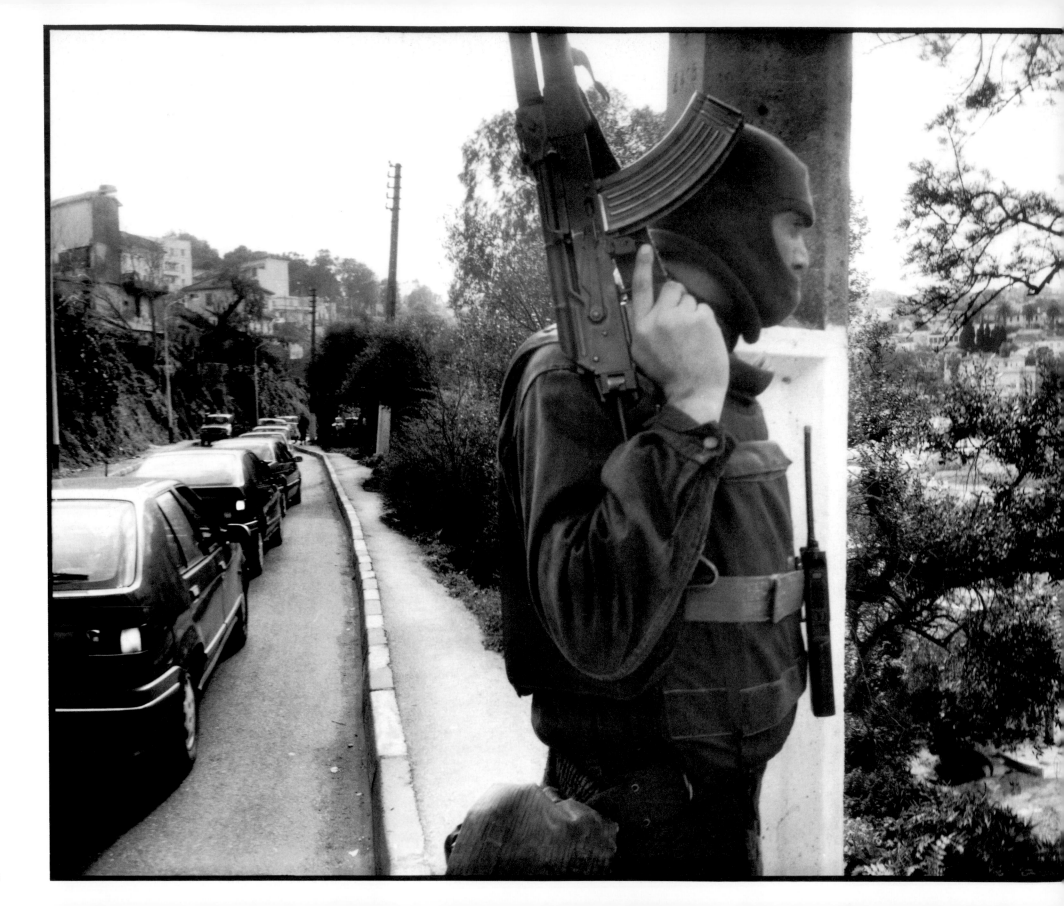

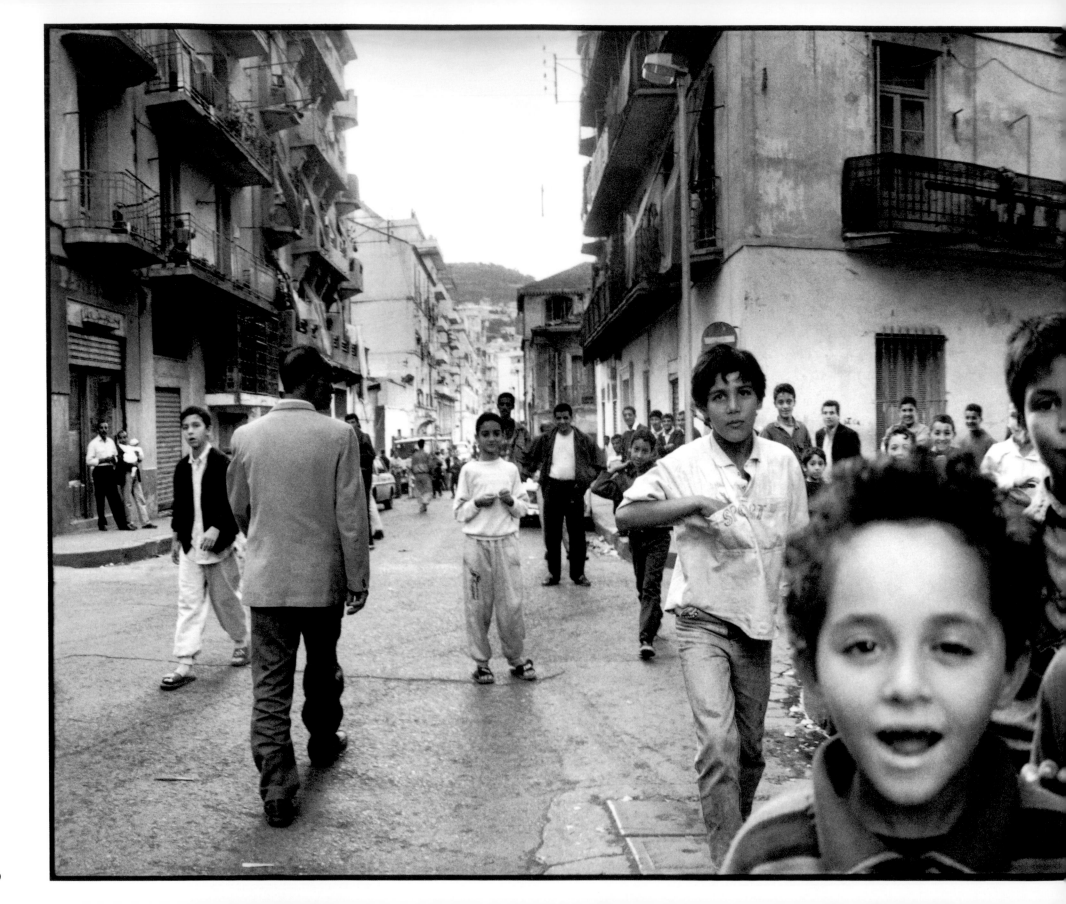

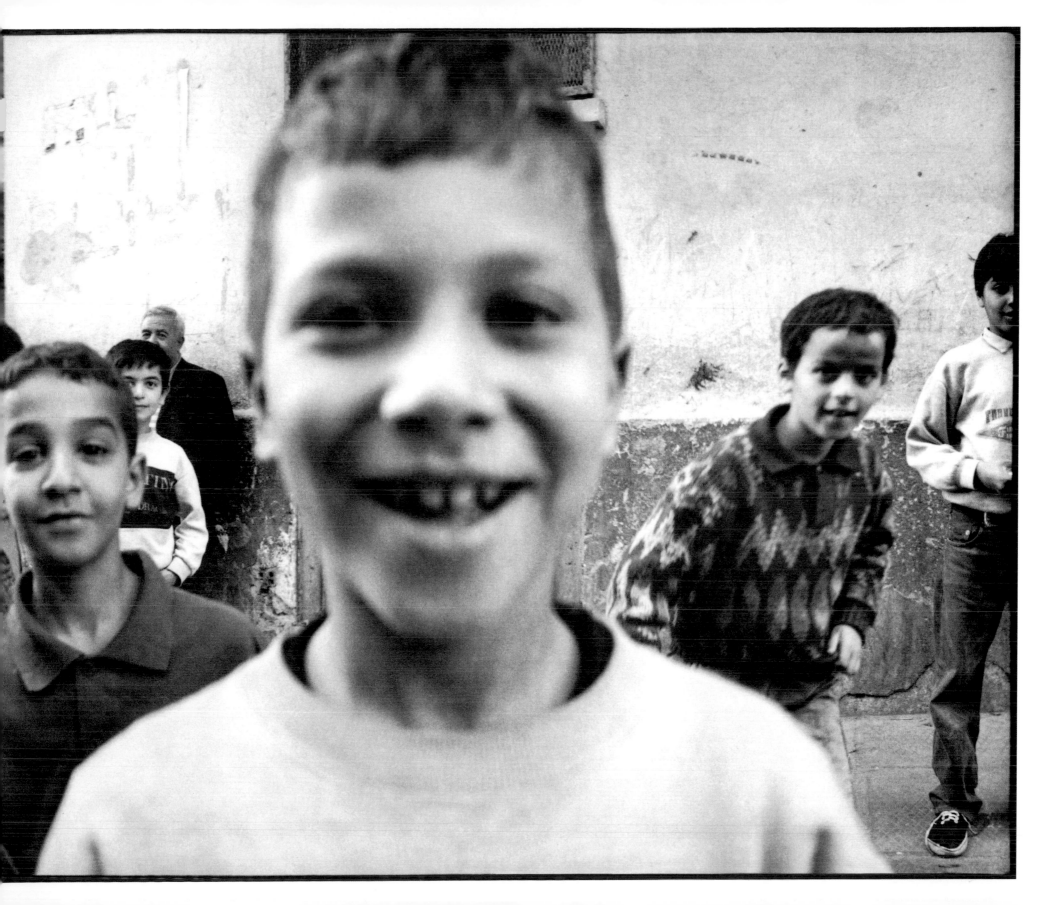

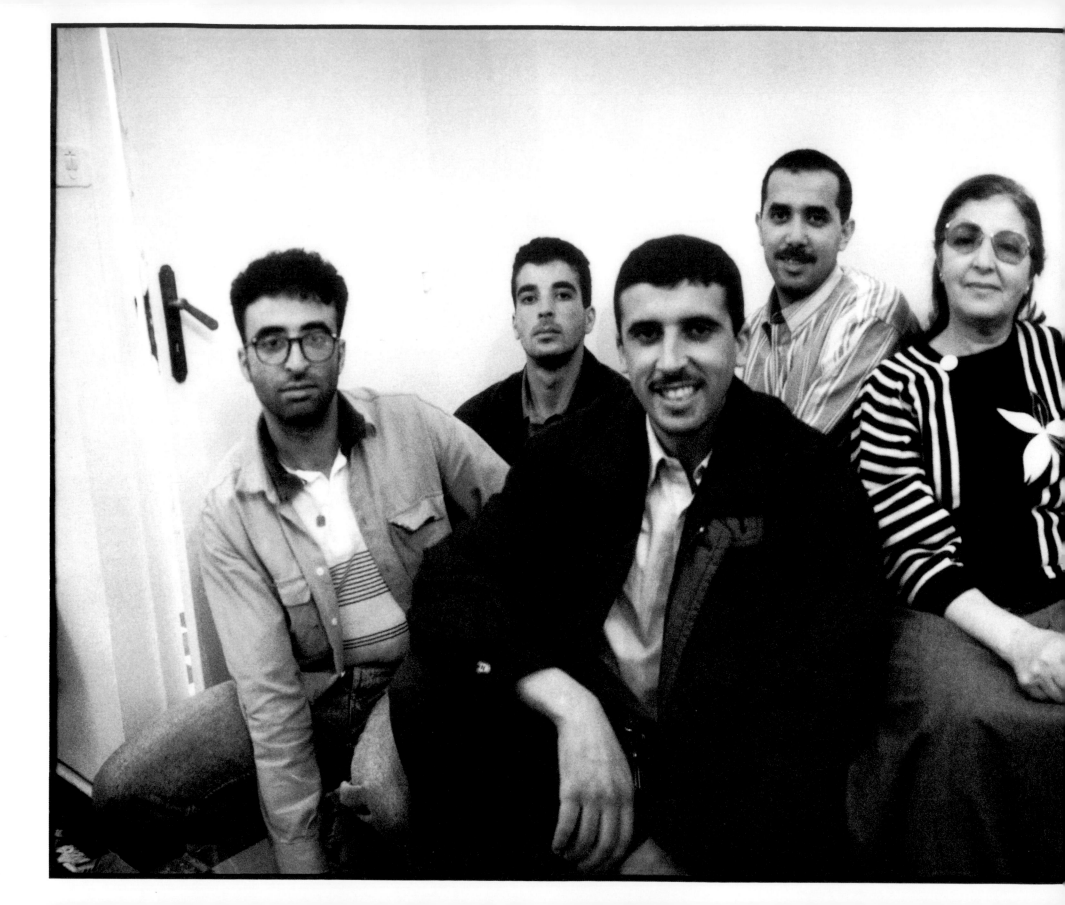

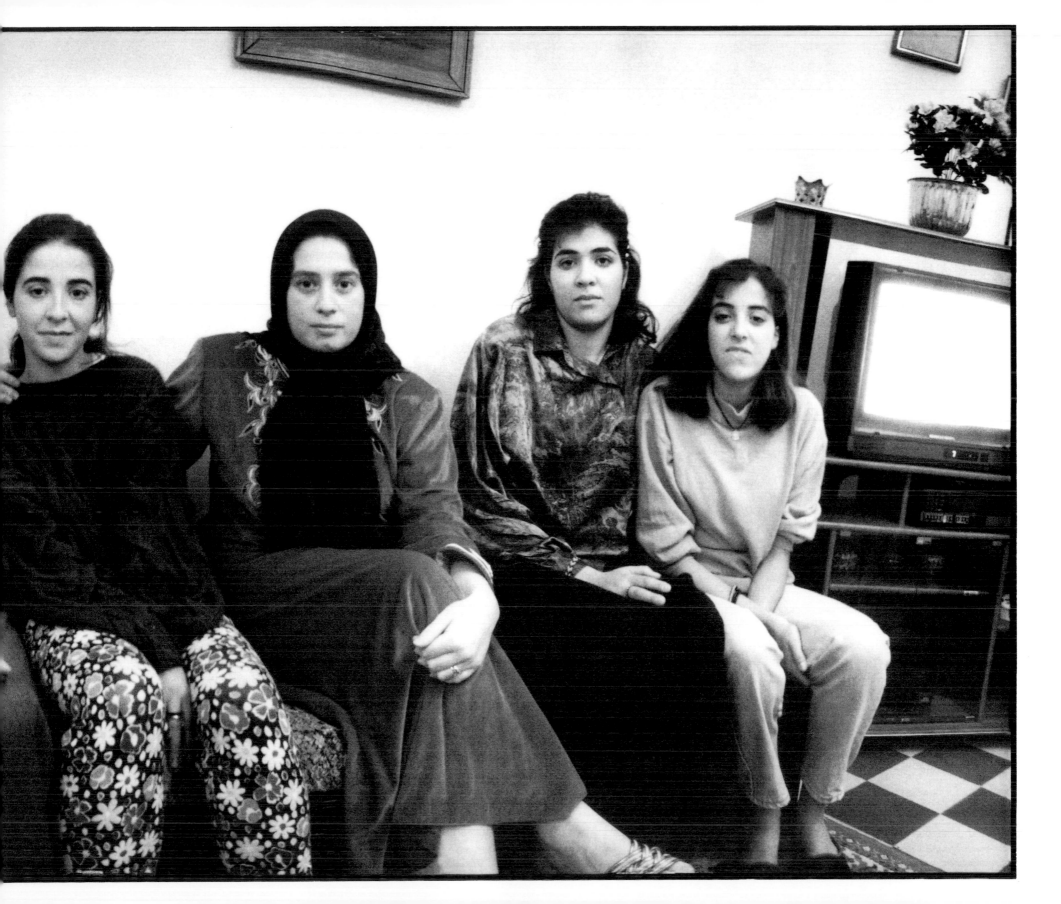

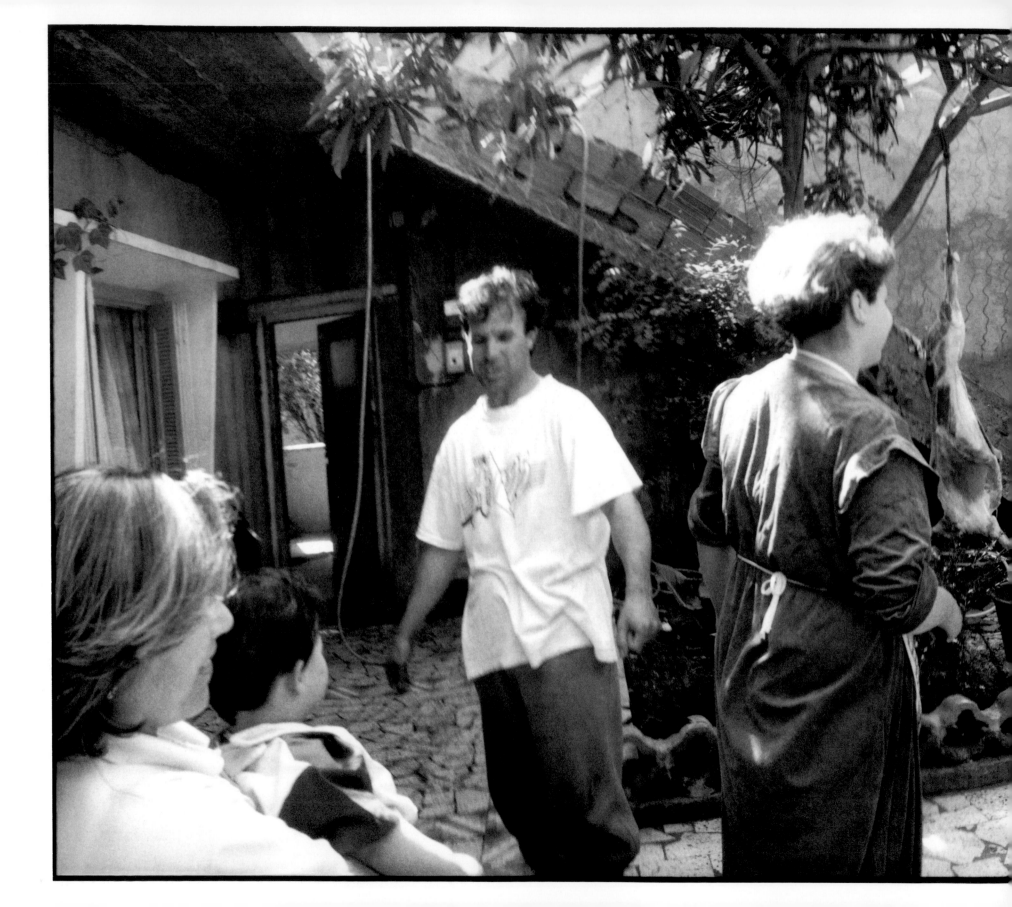

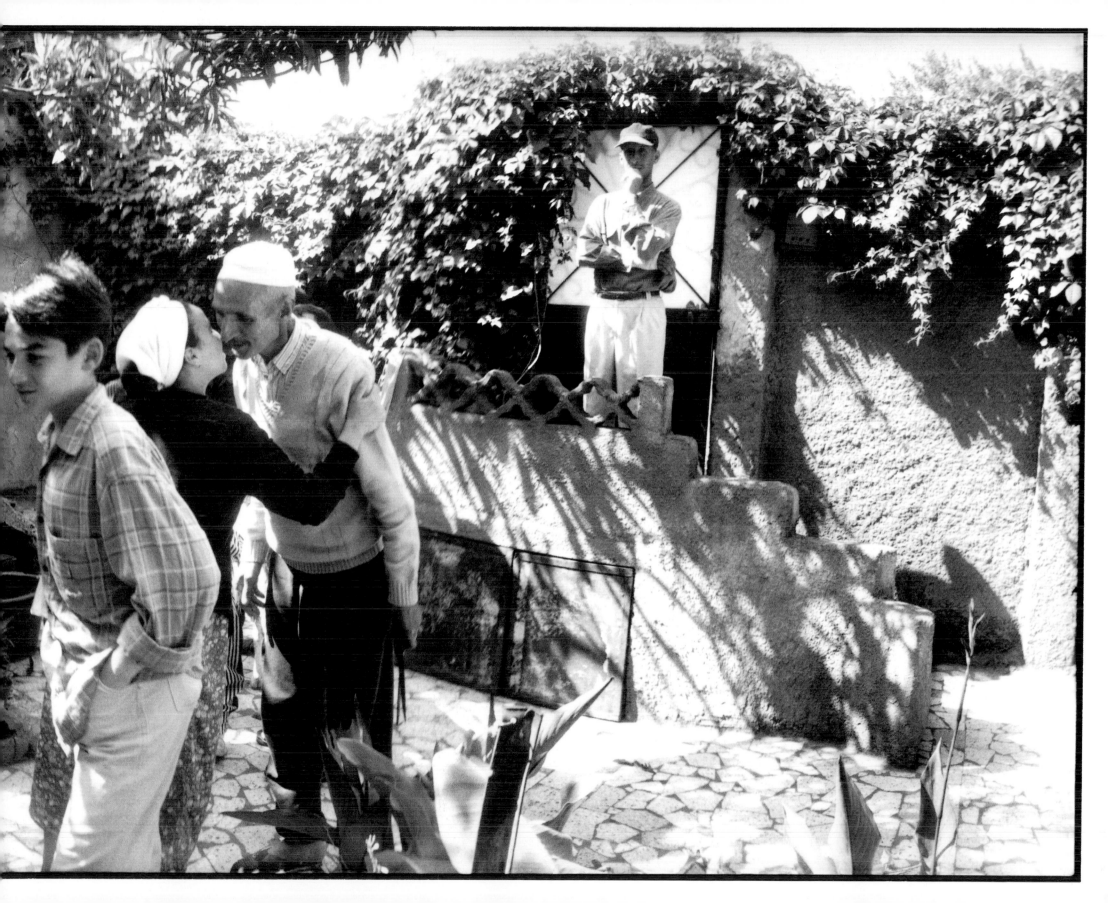

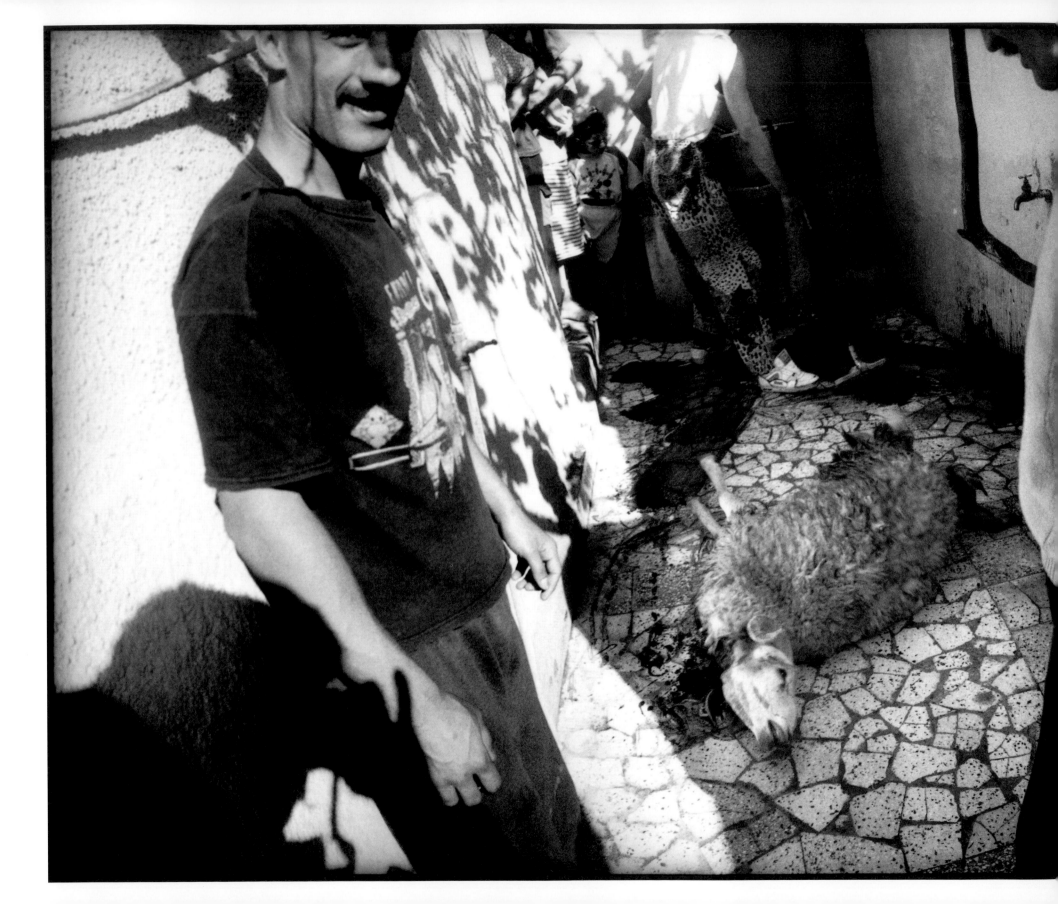

27

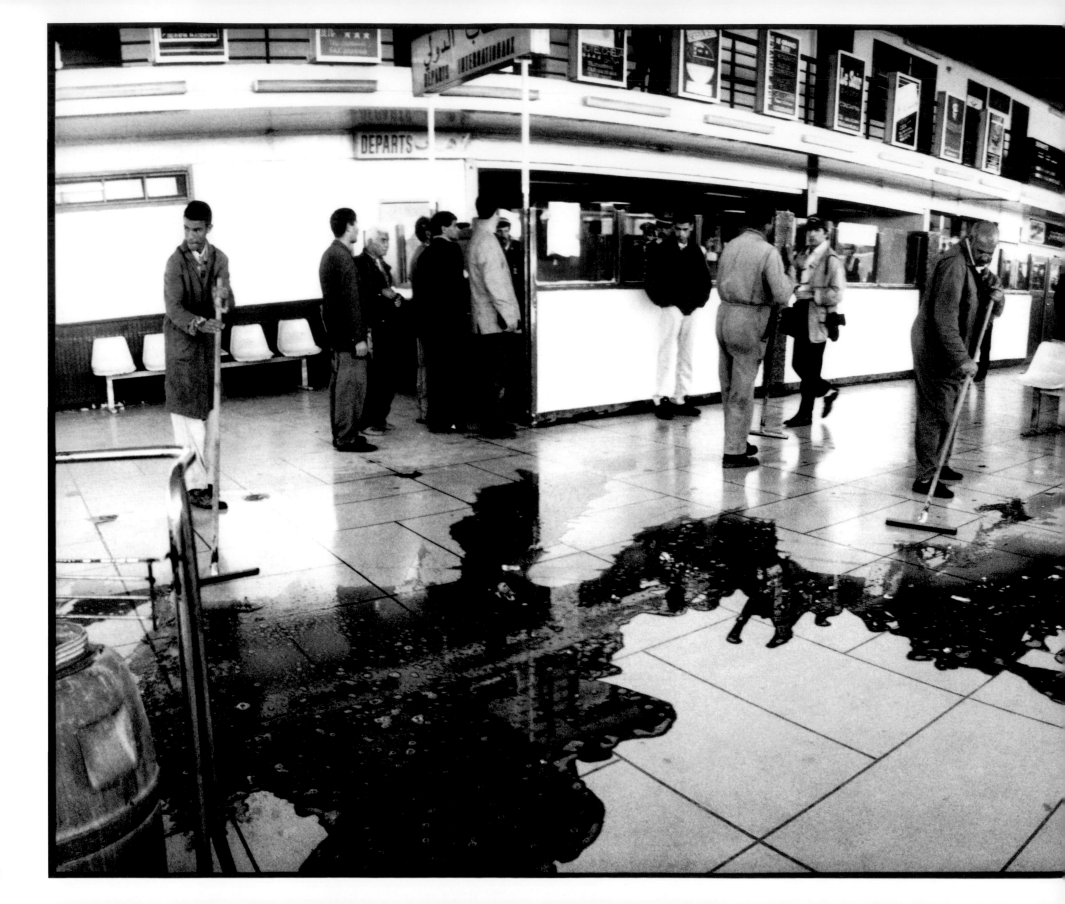

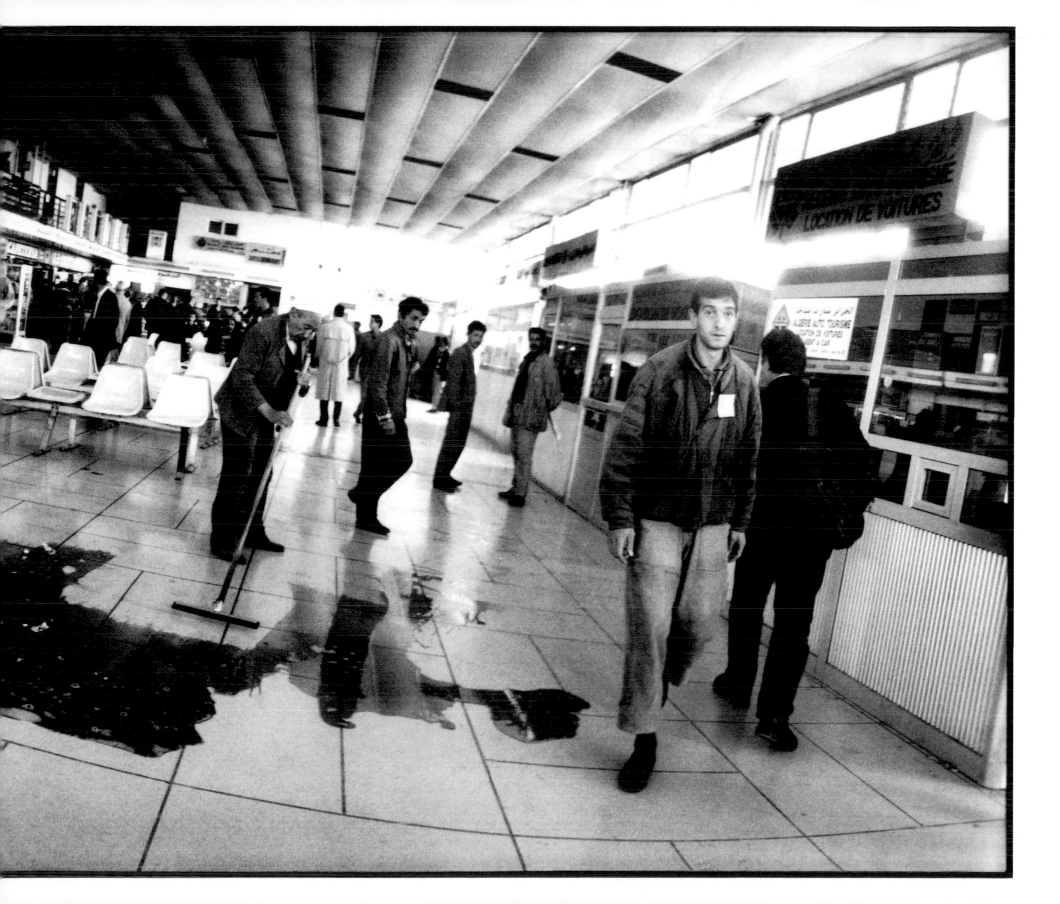

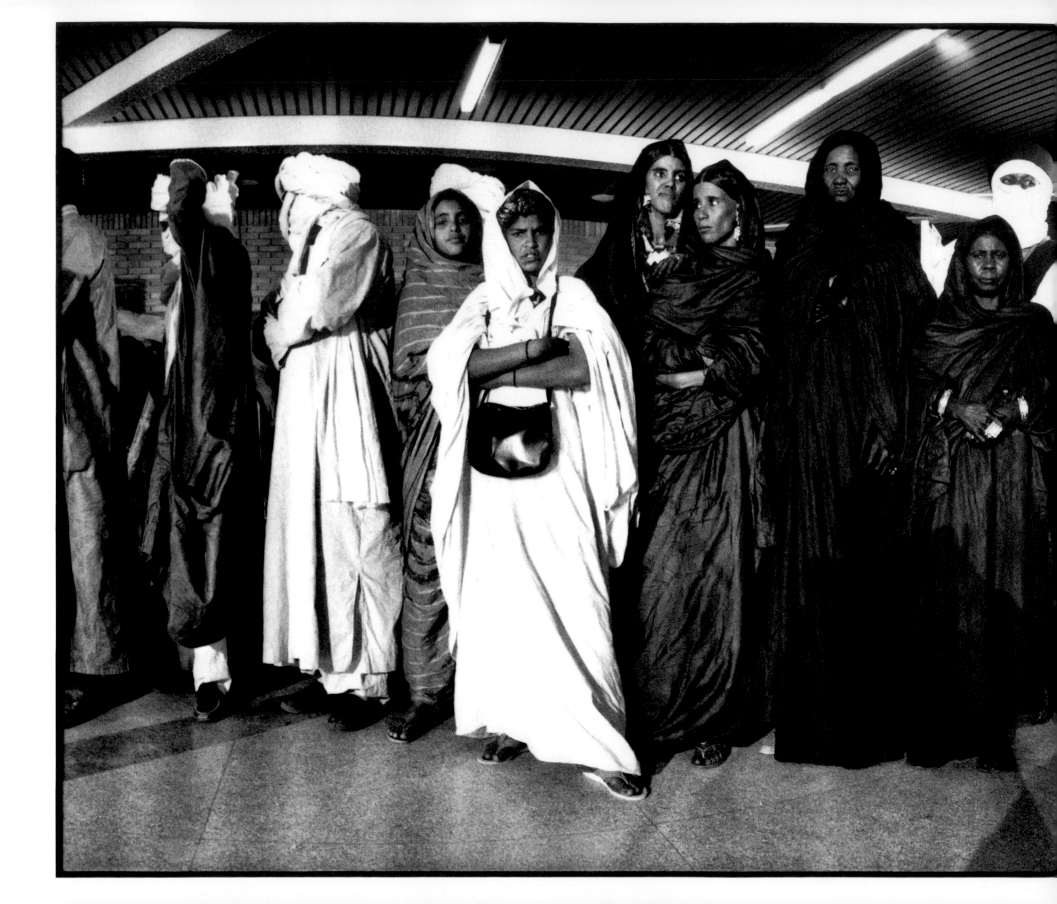

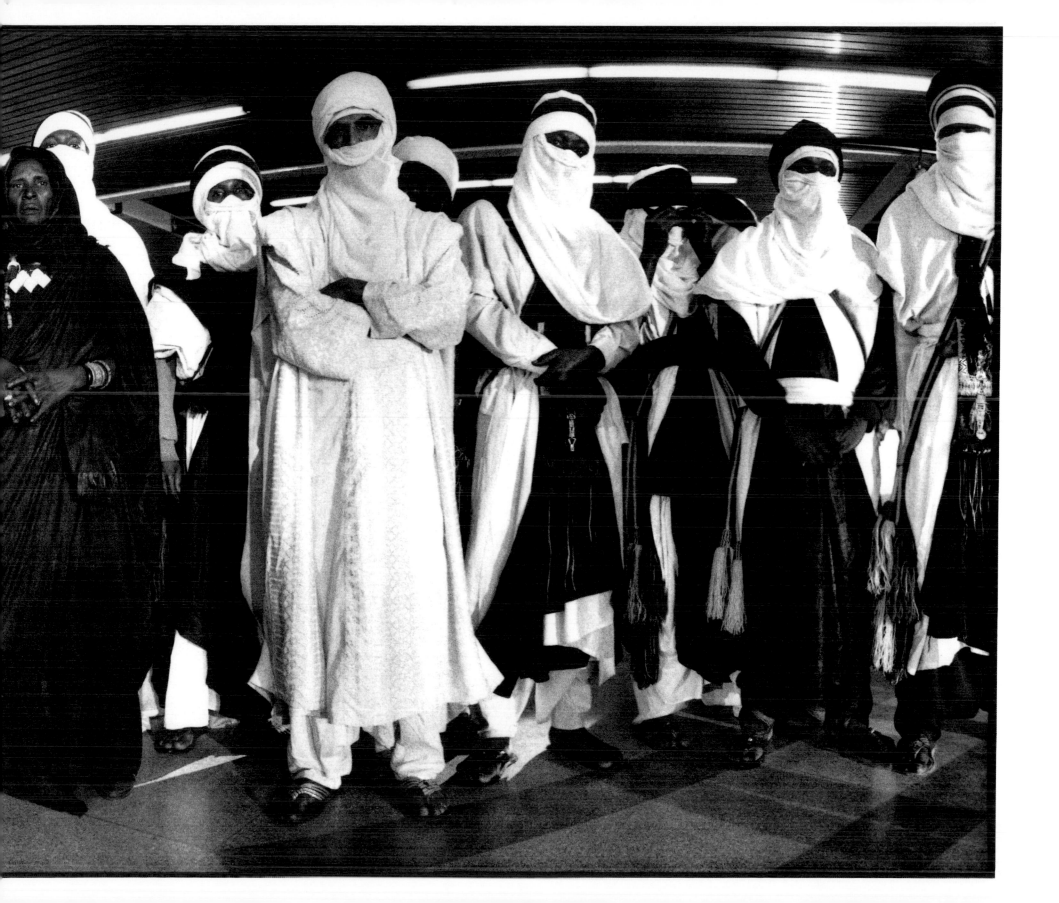

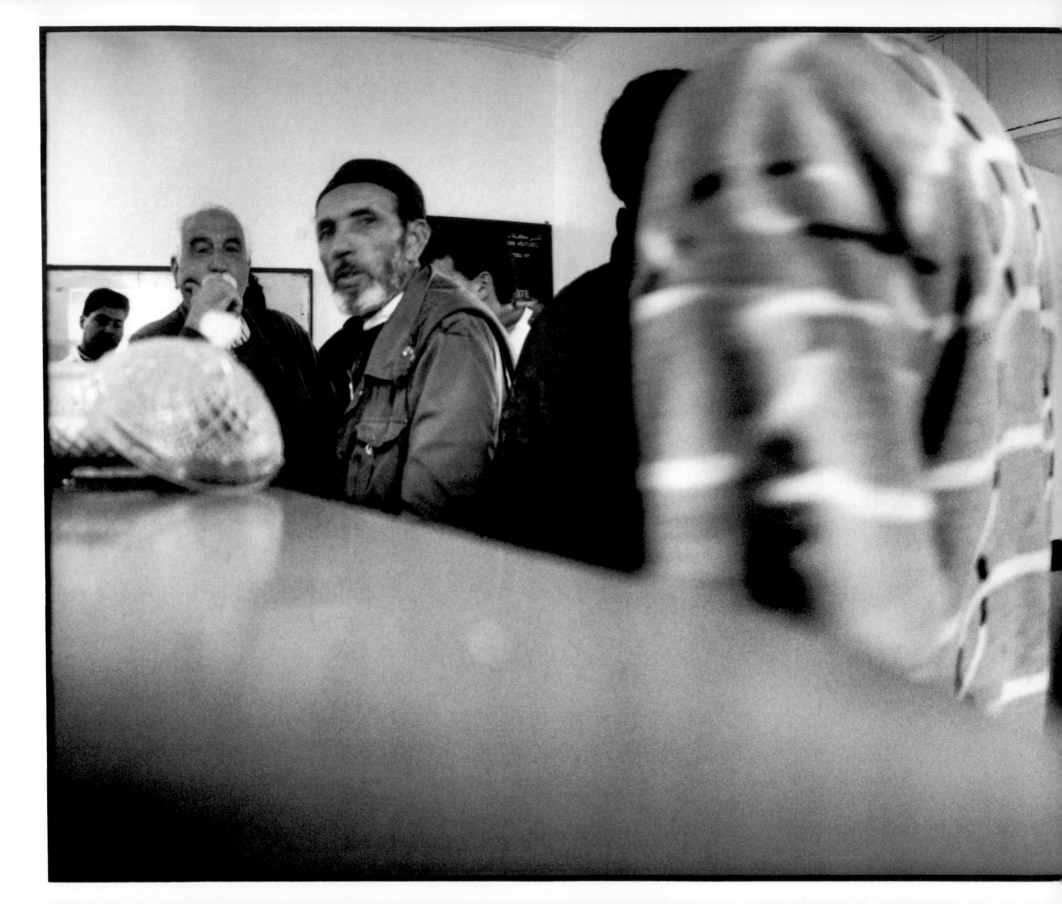

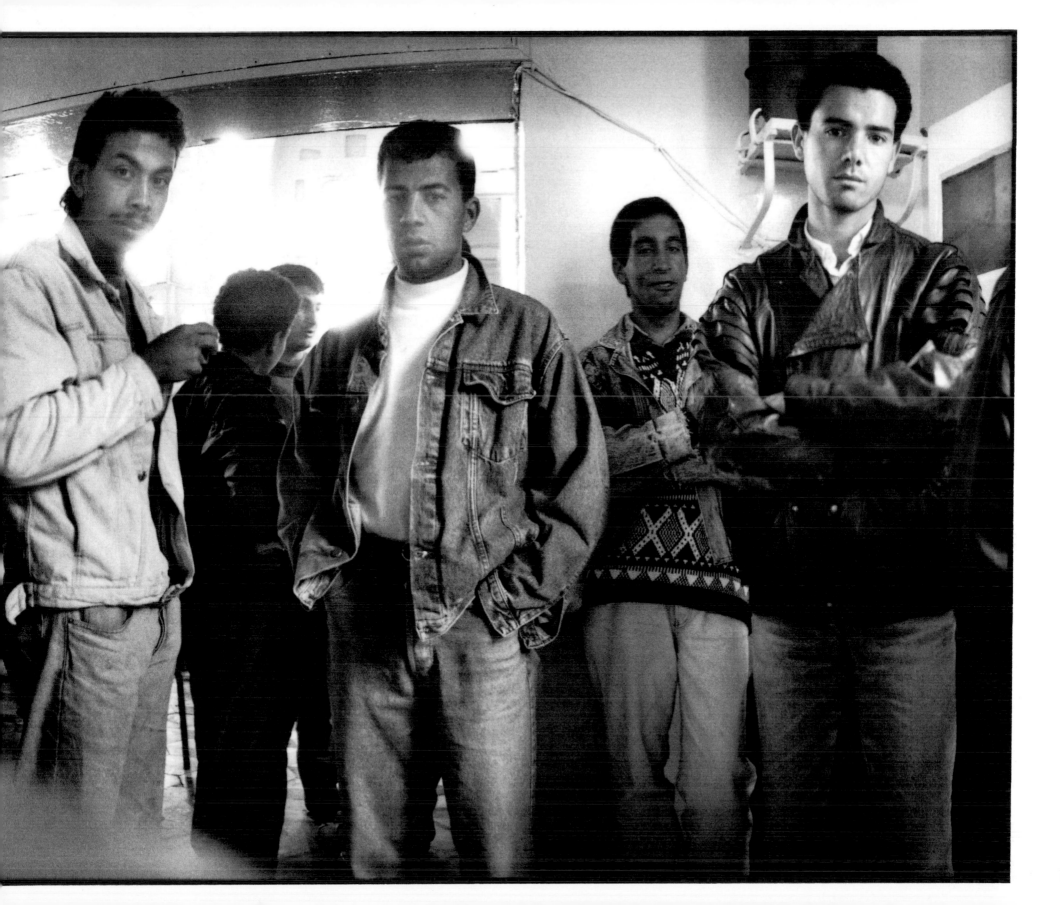

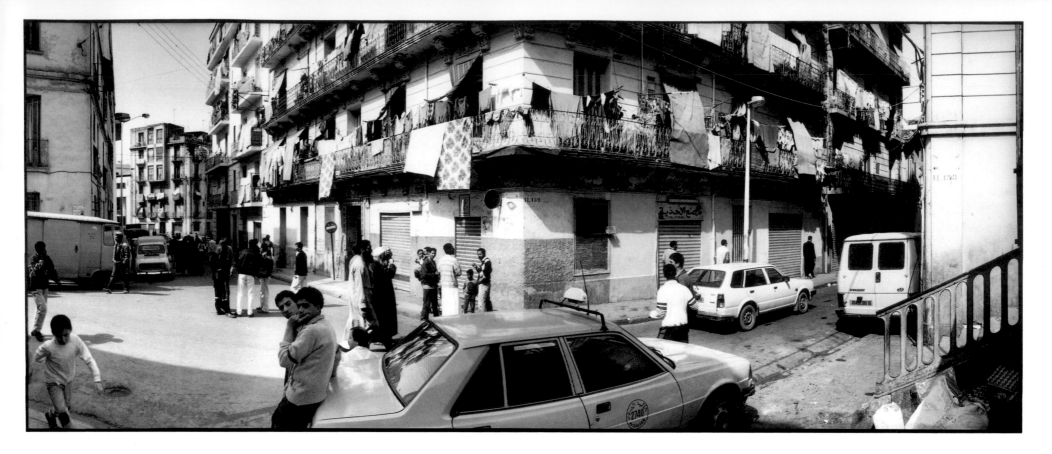

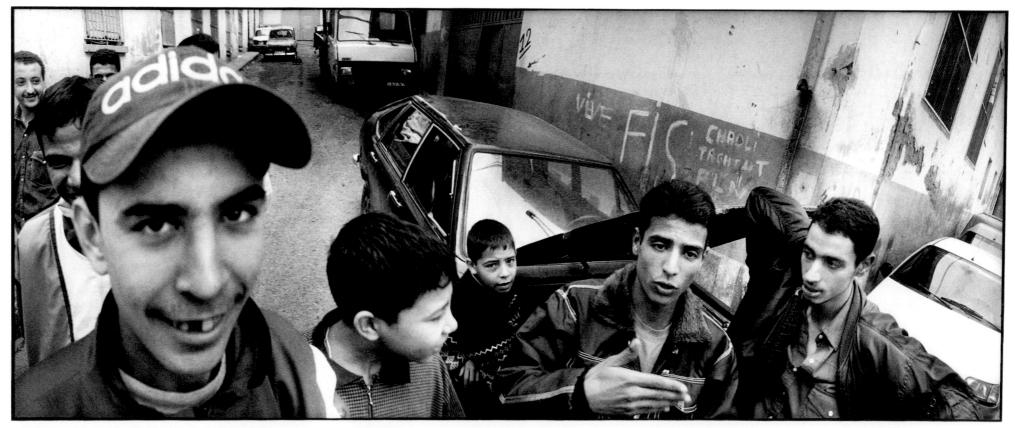

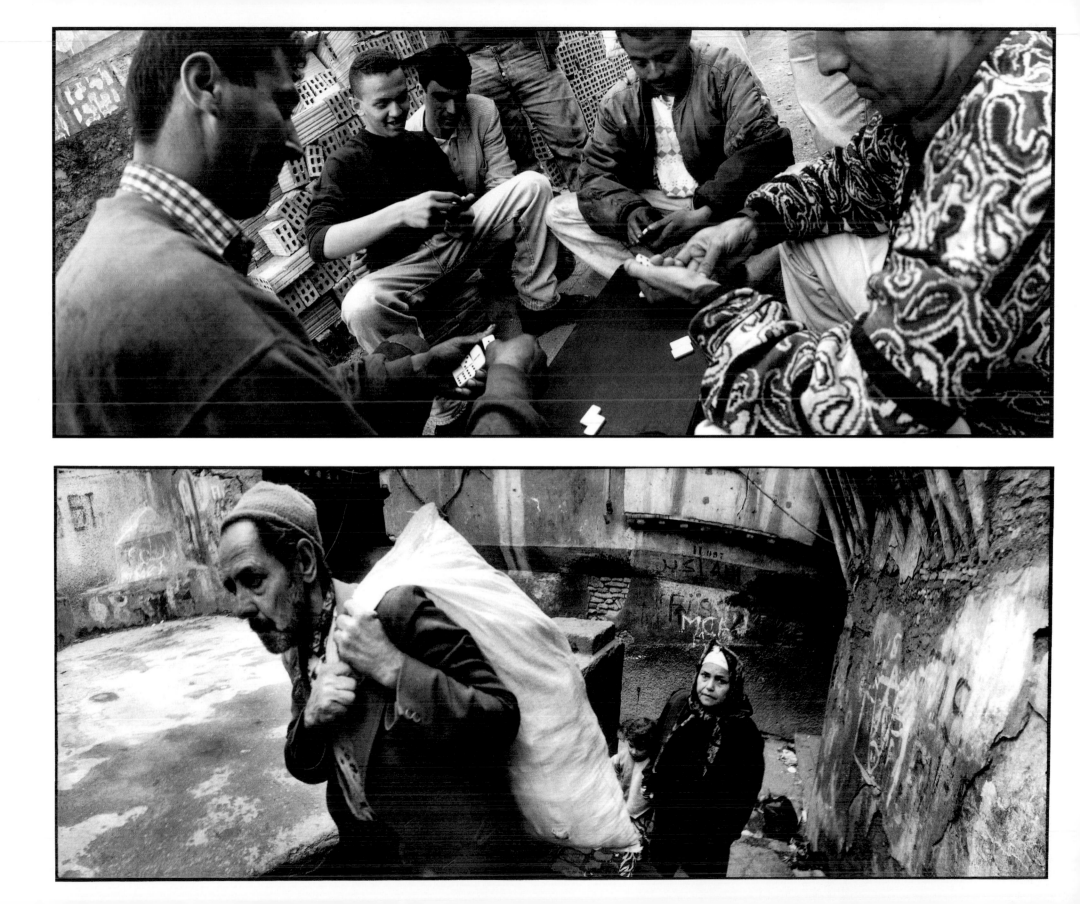

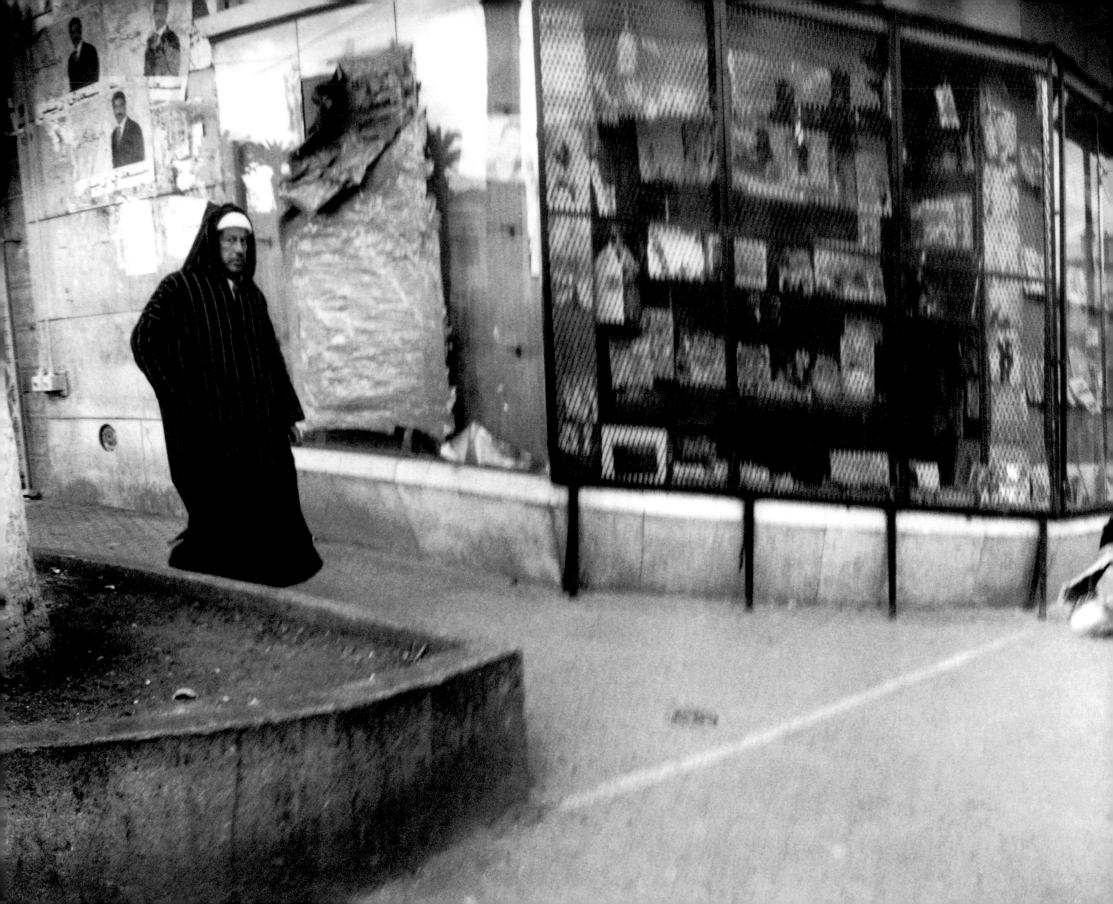

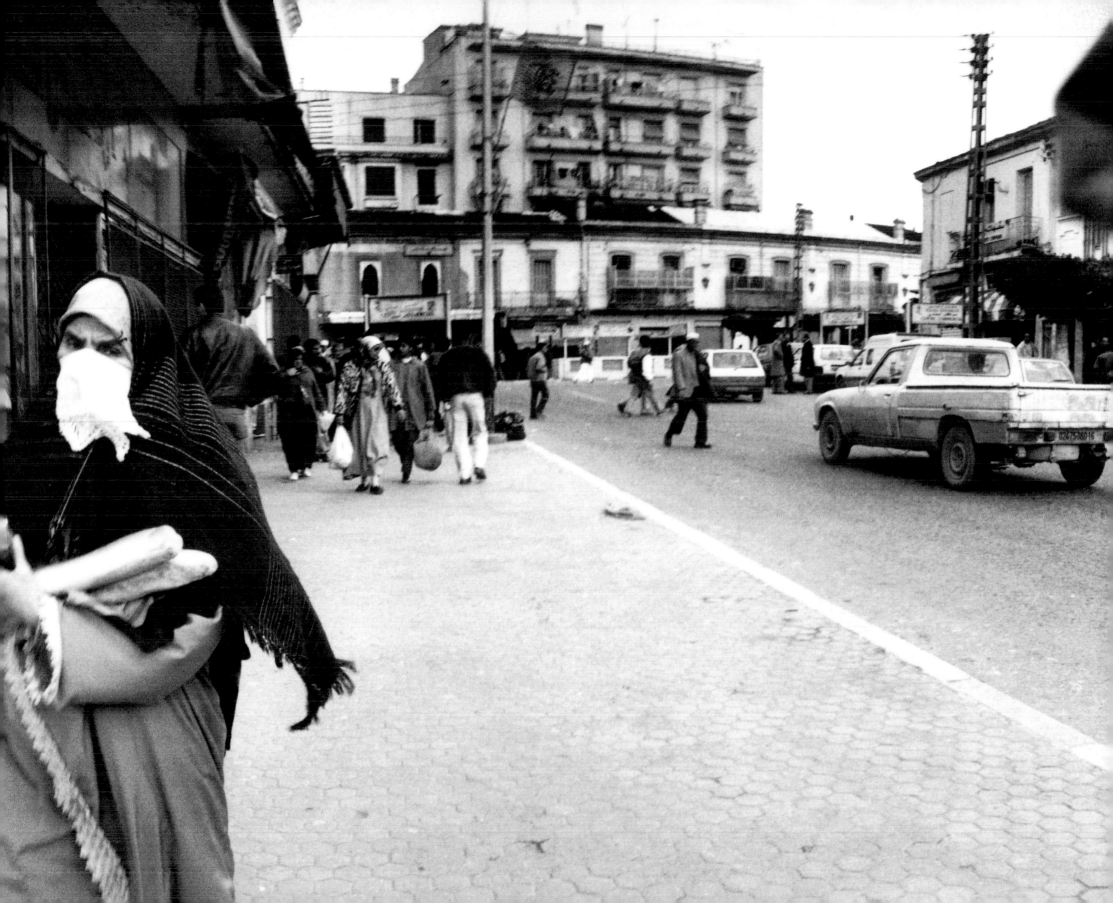

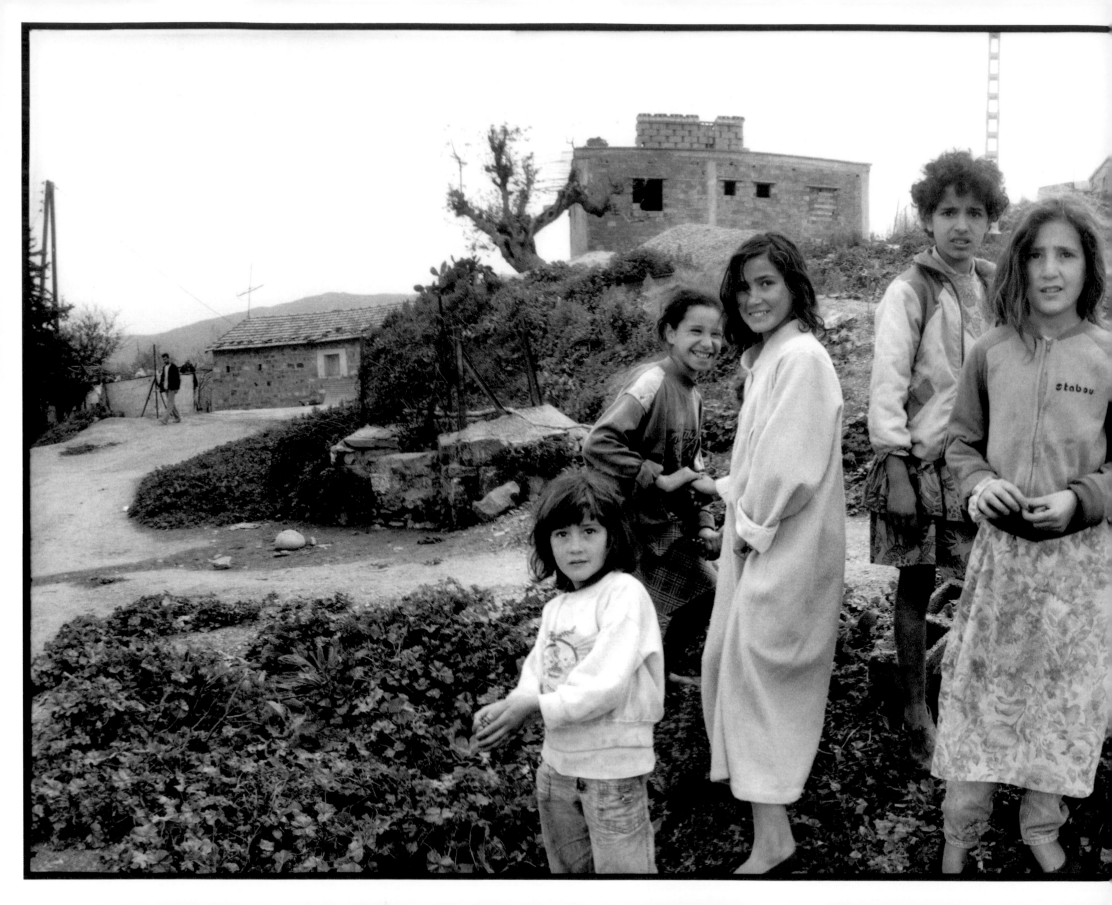

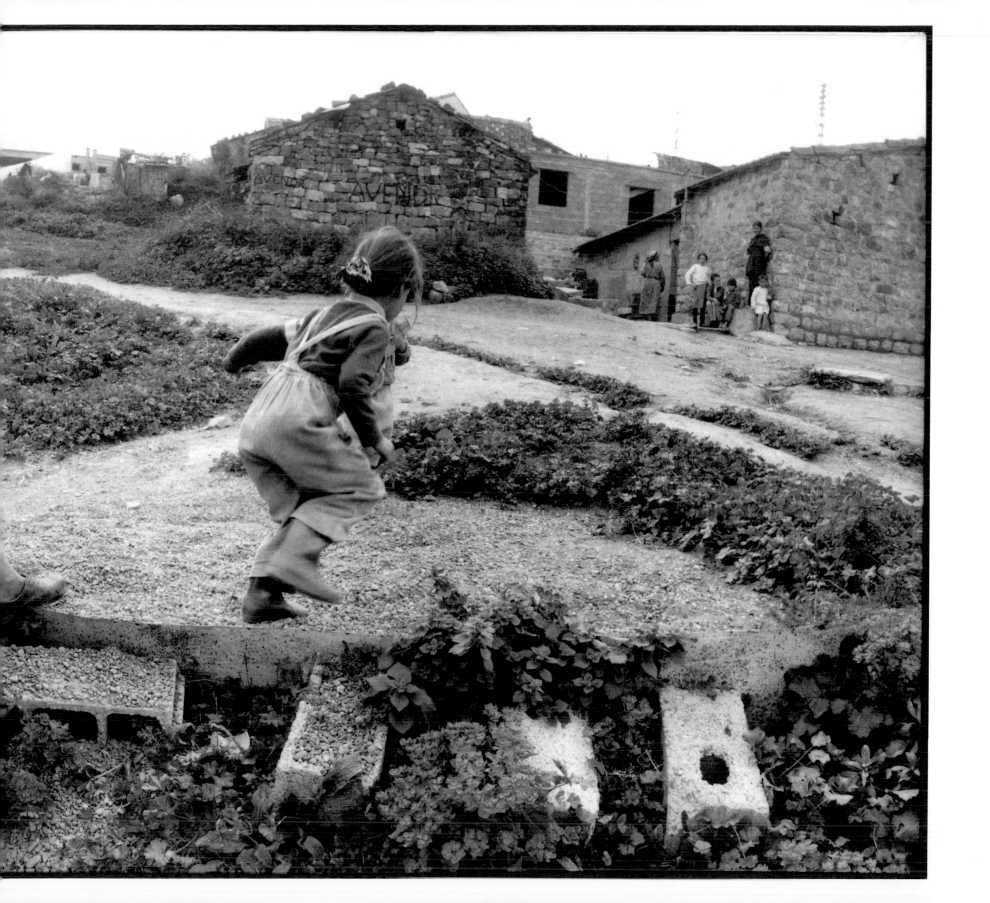

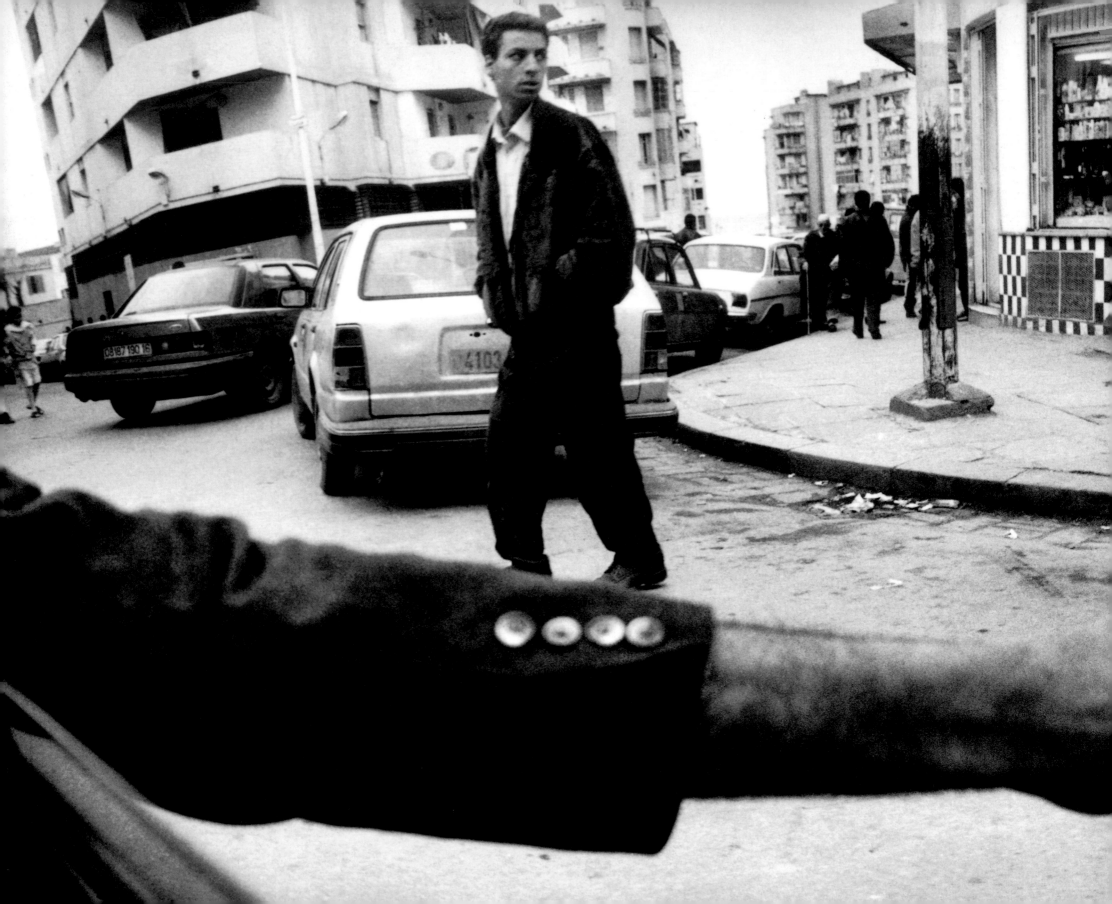

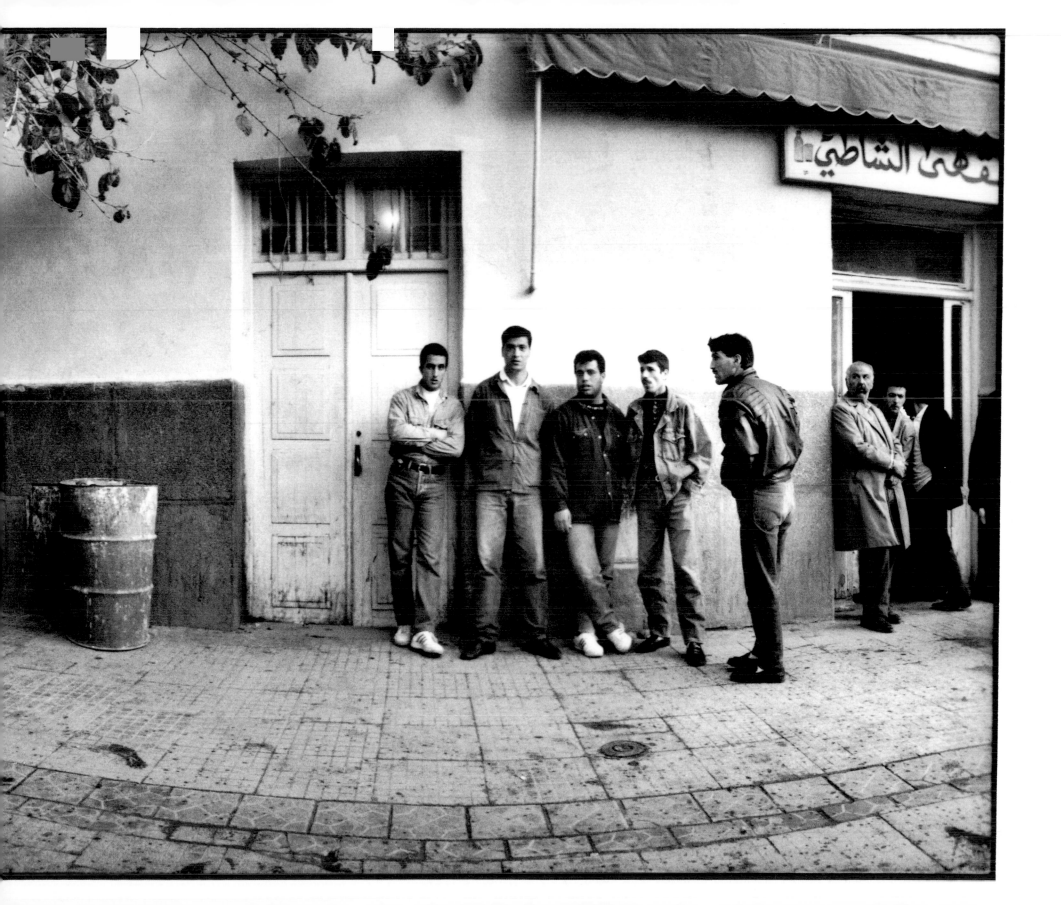

43

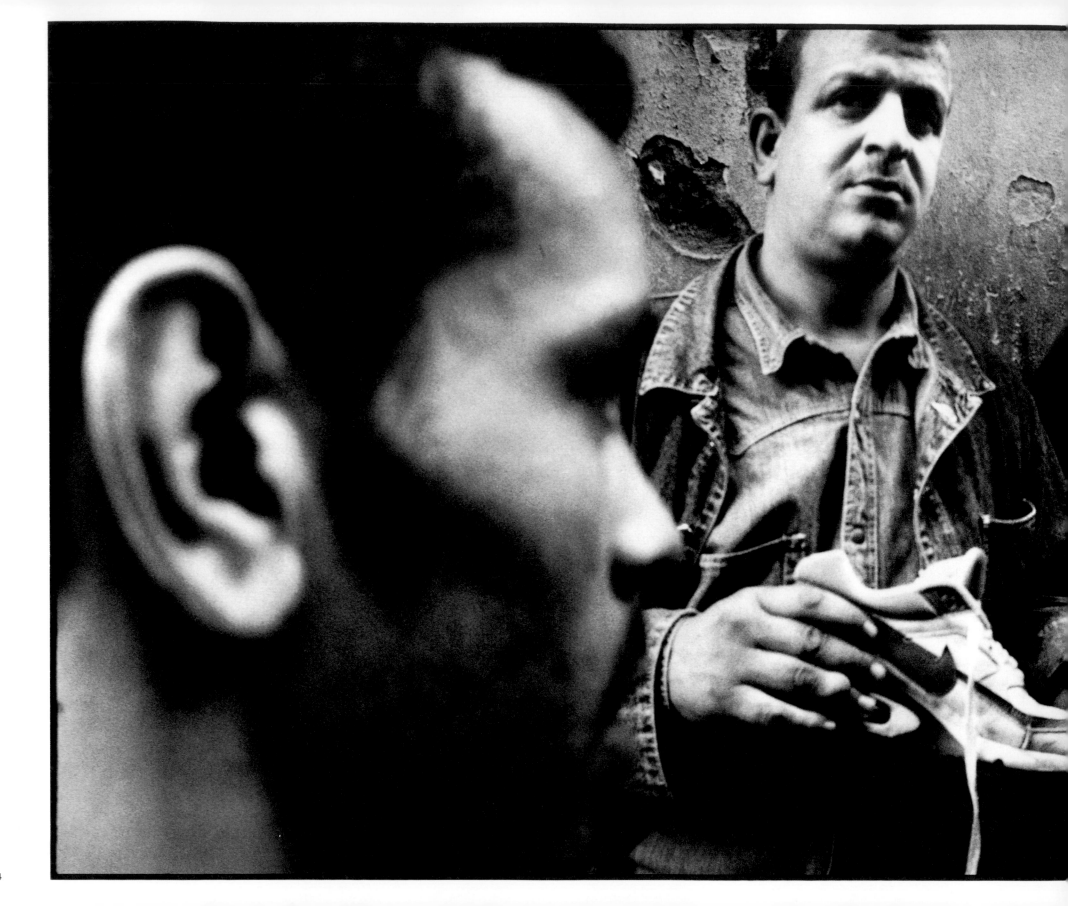

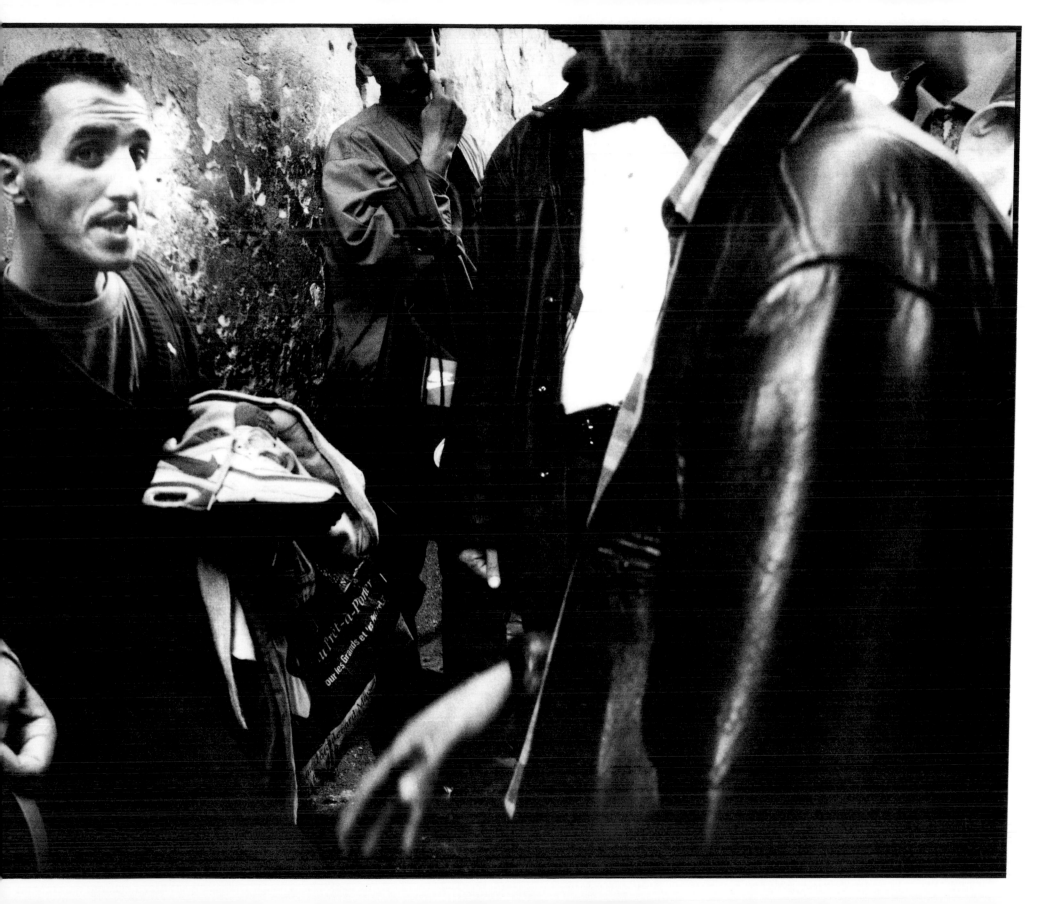

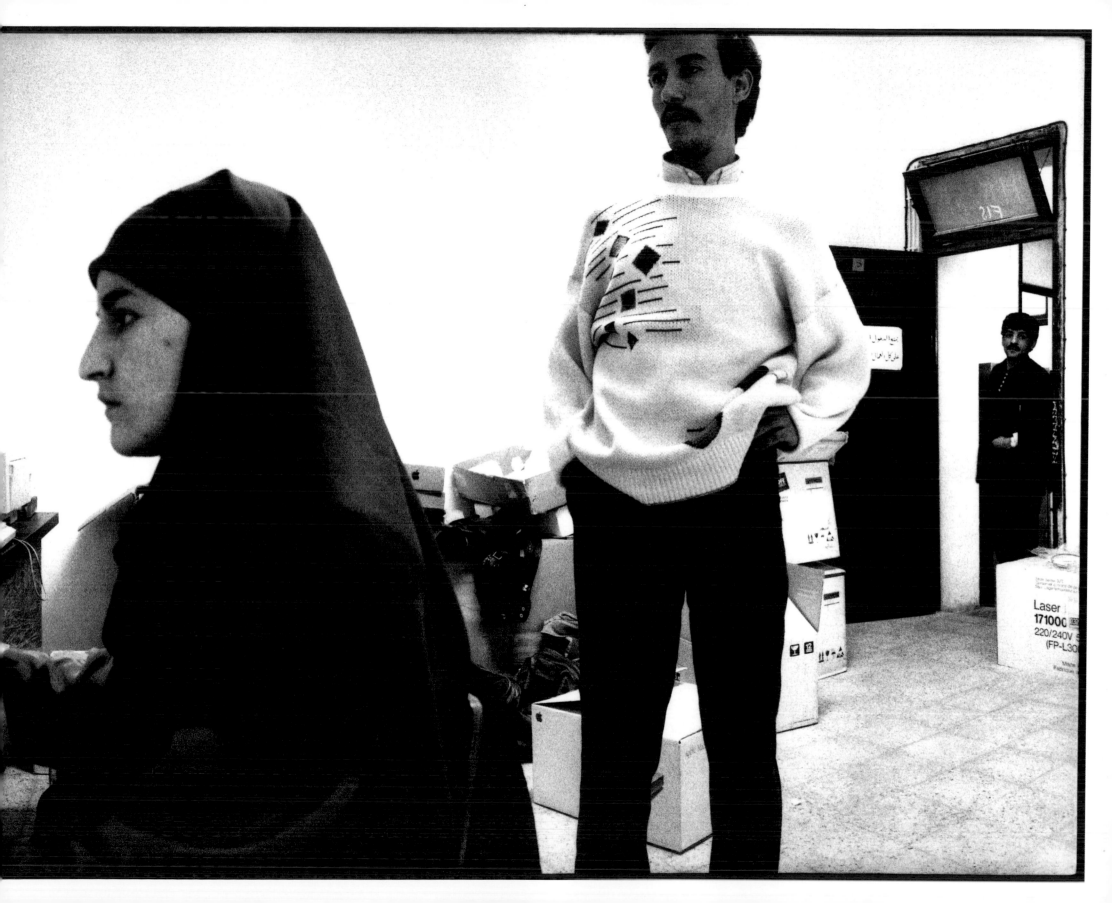

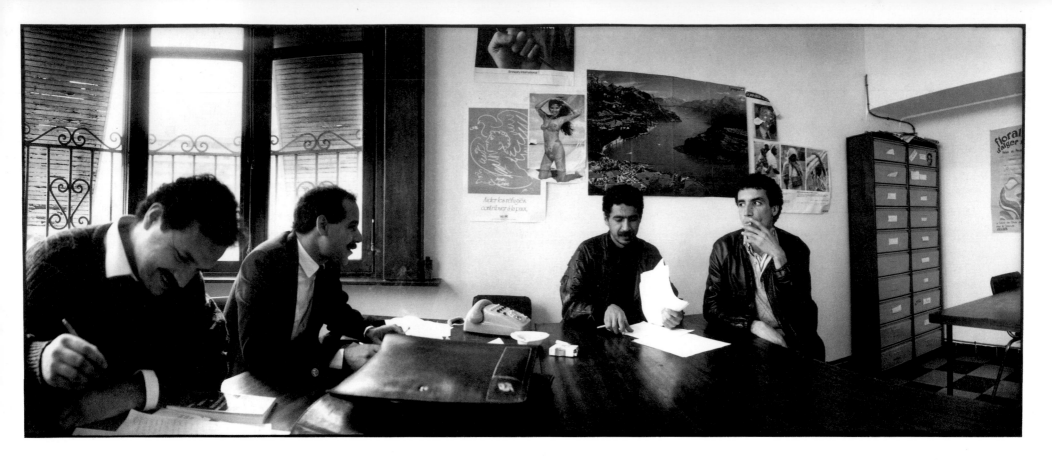
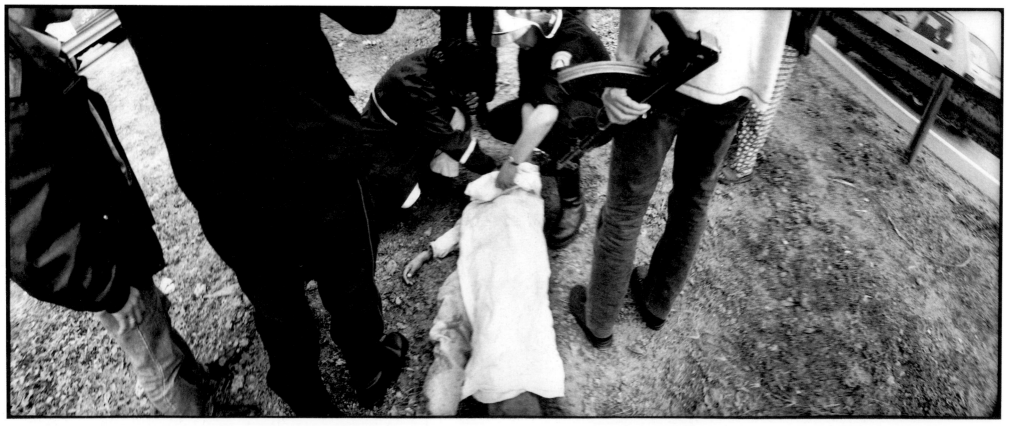

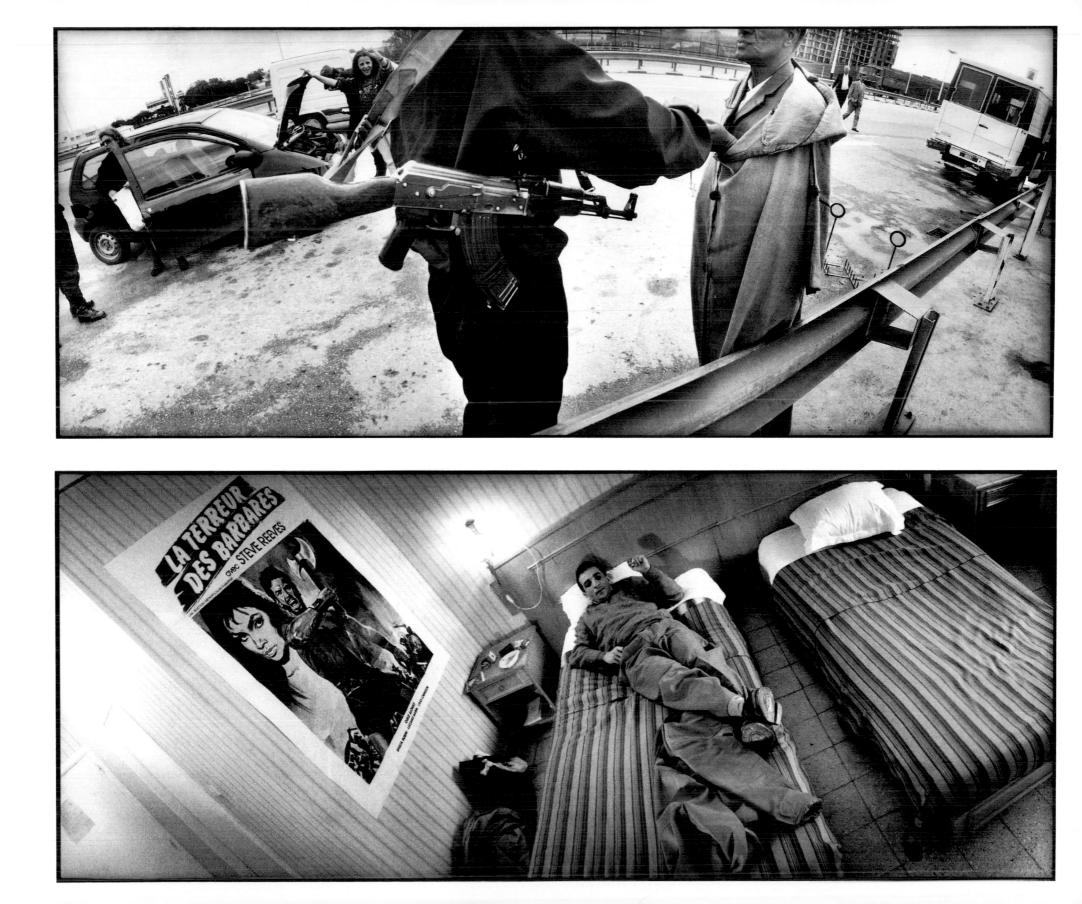

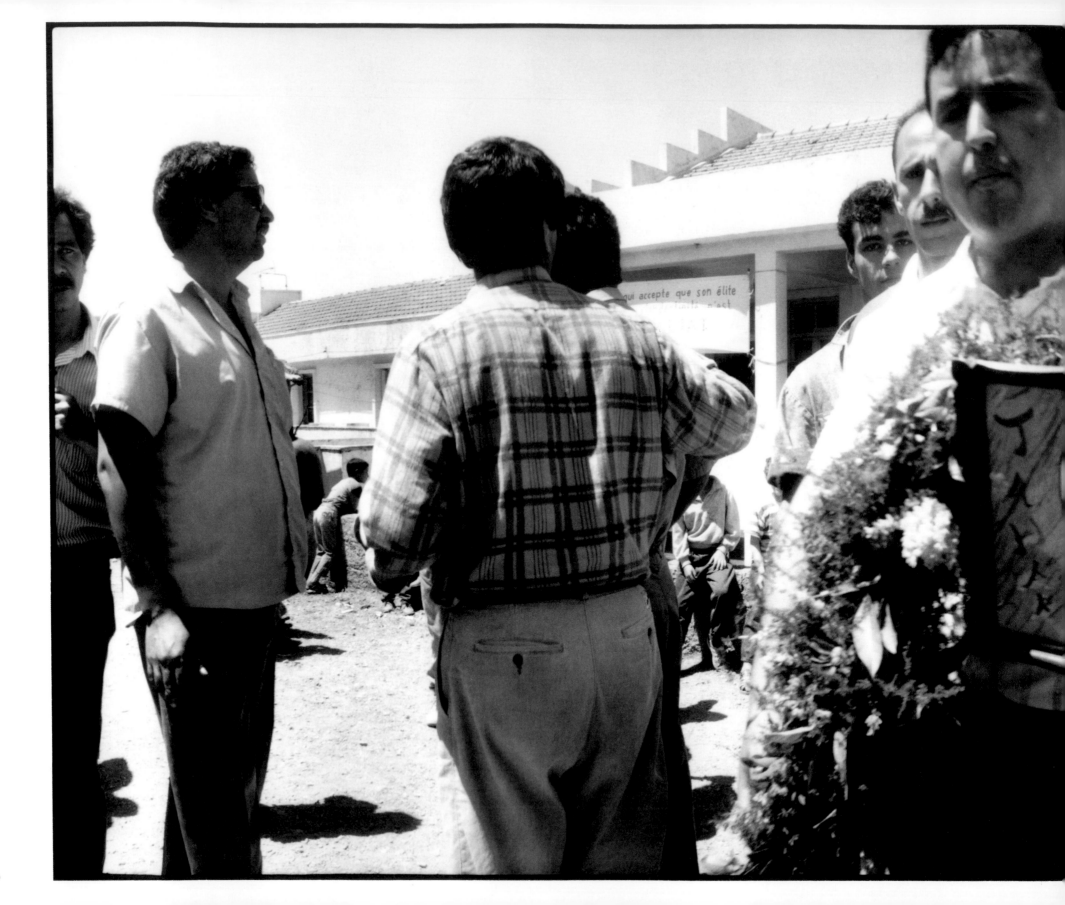

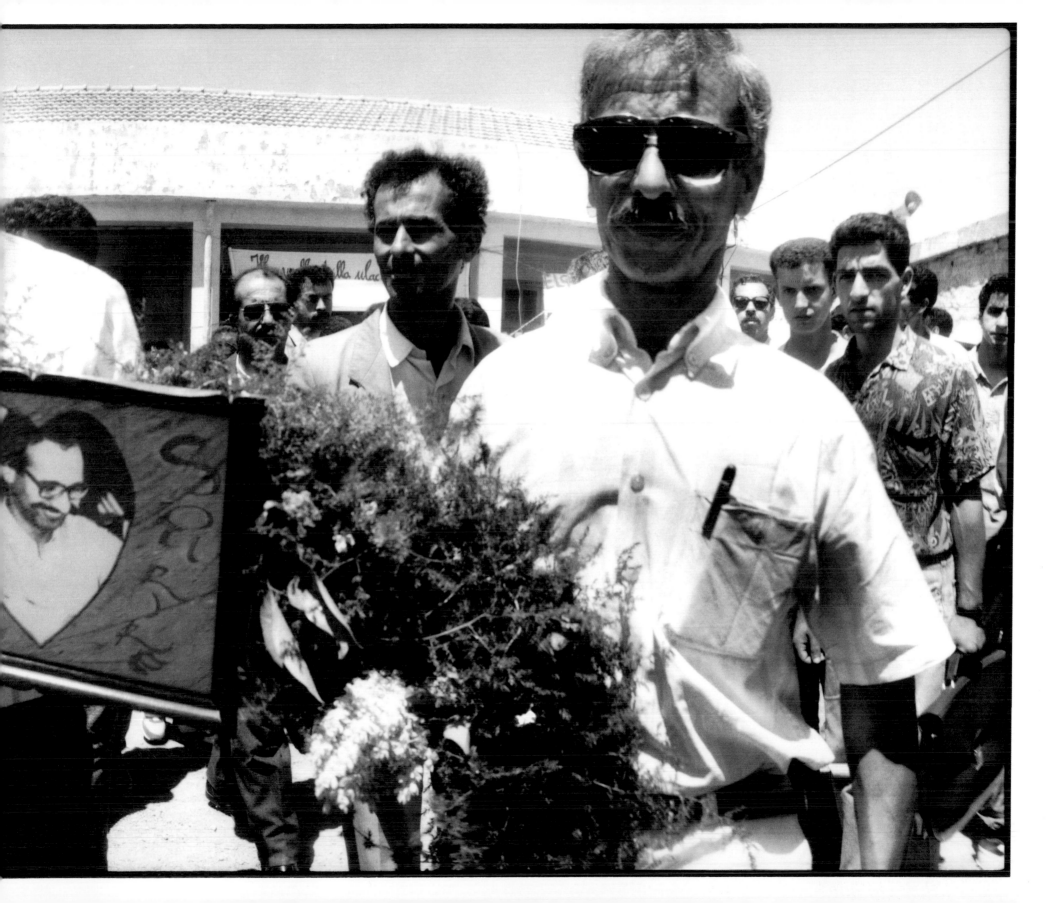

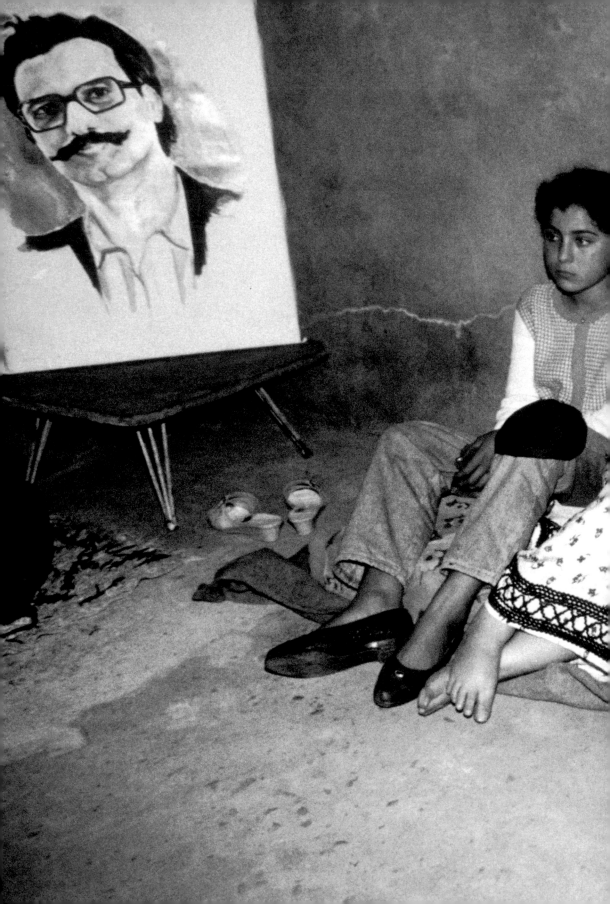

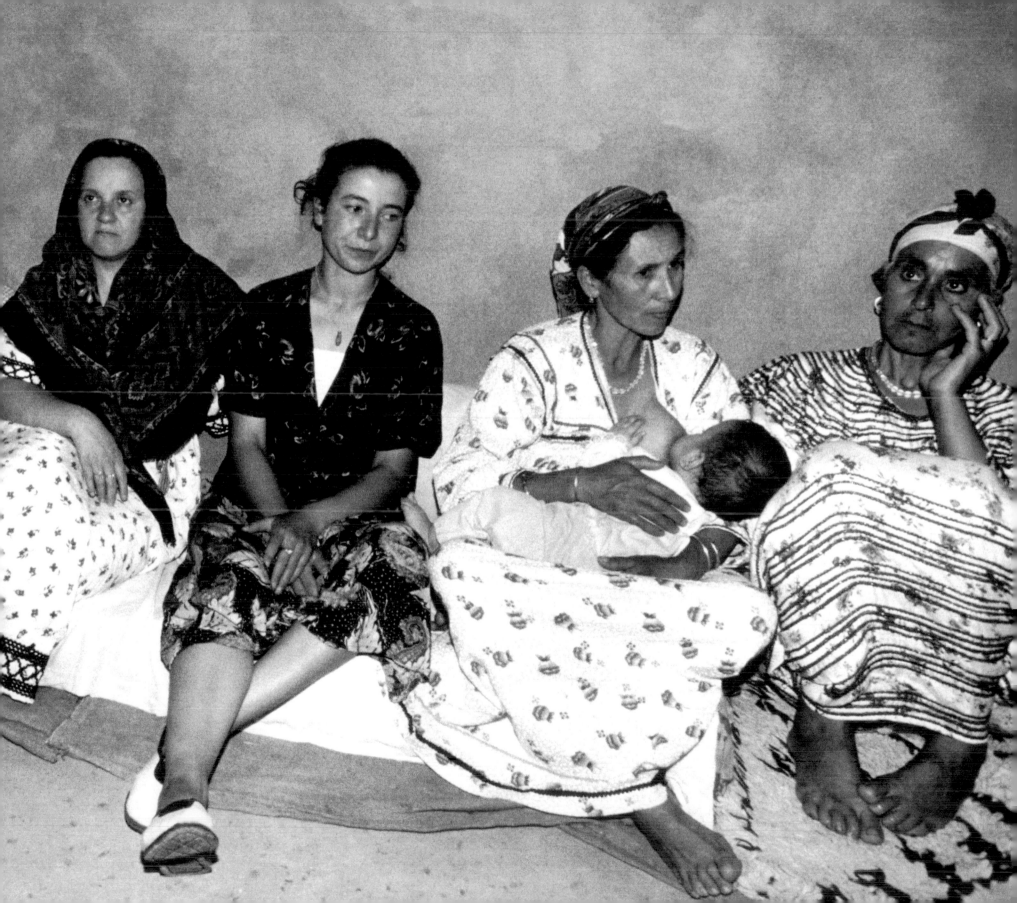

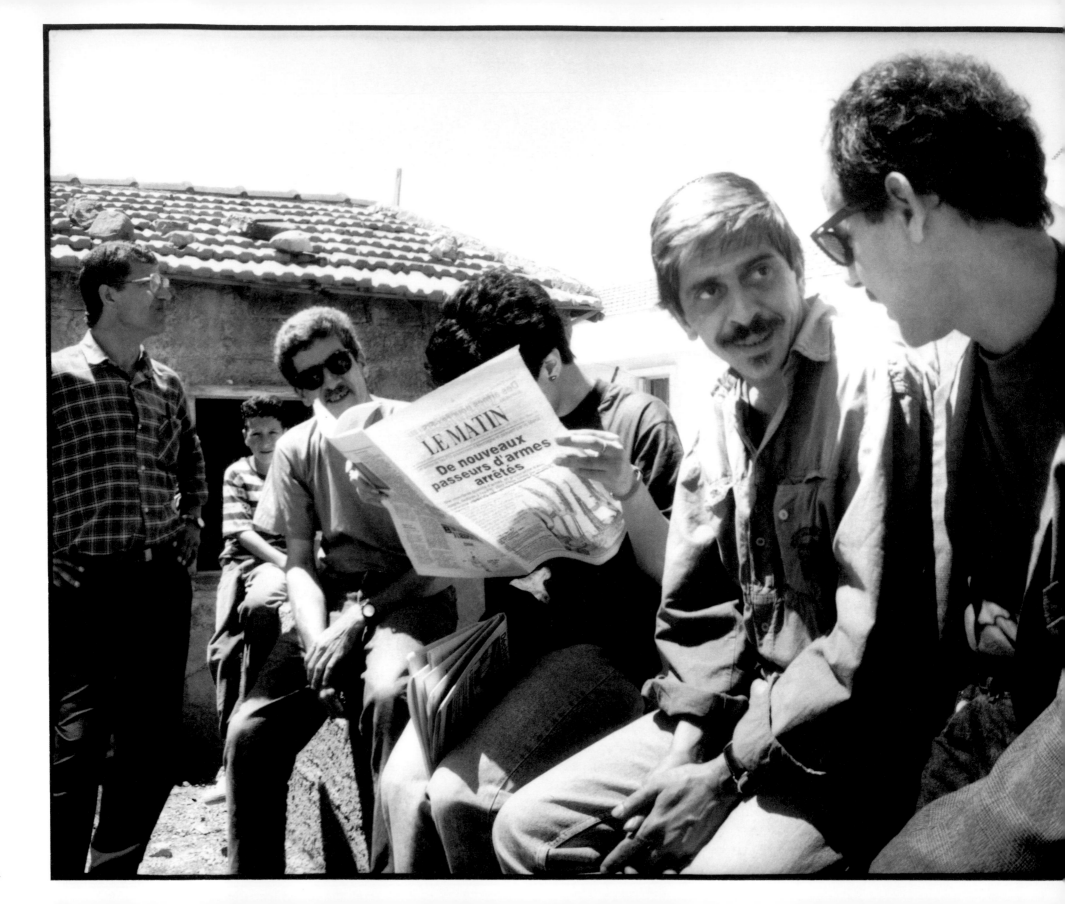

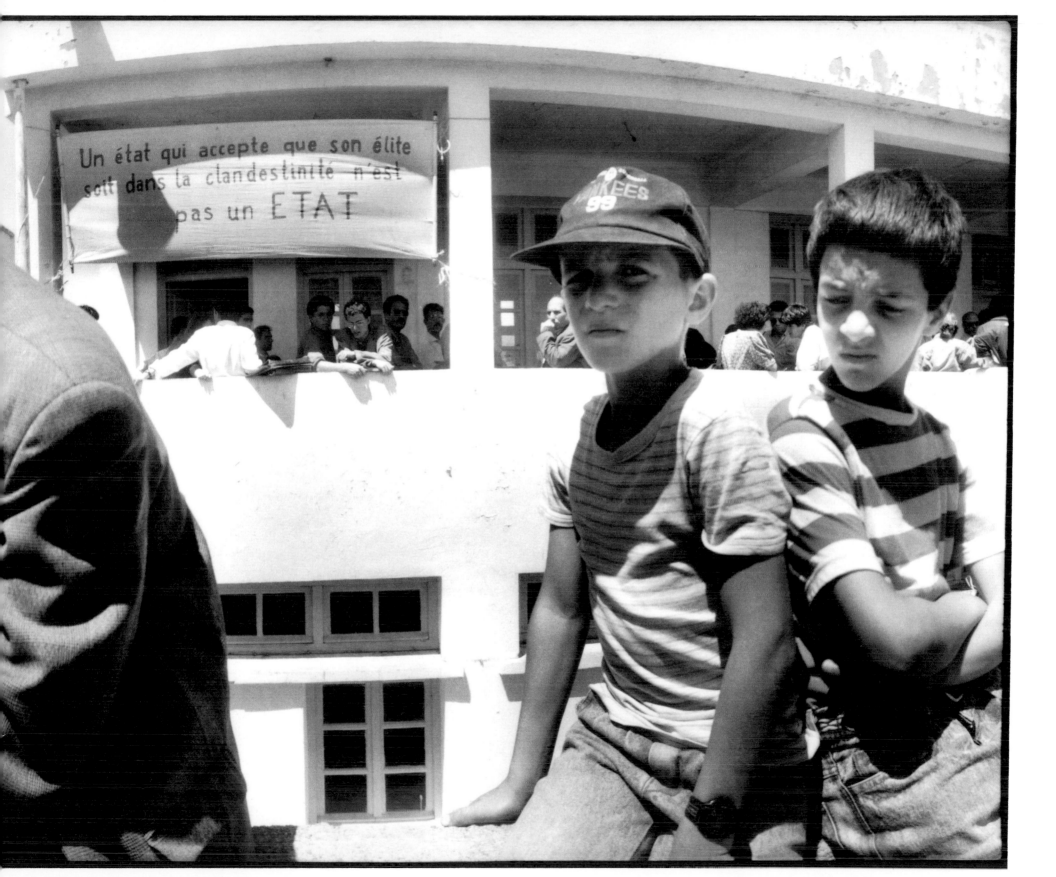

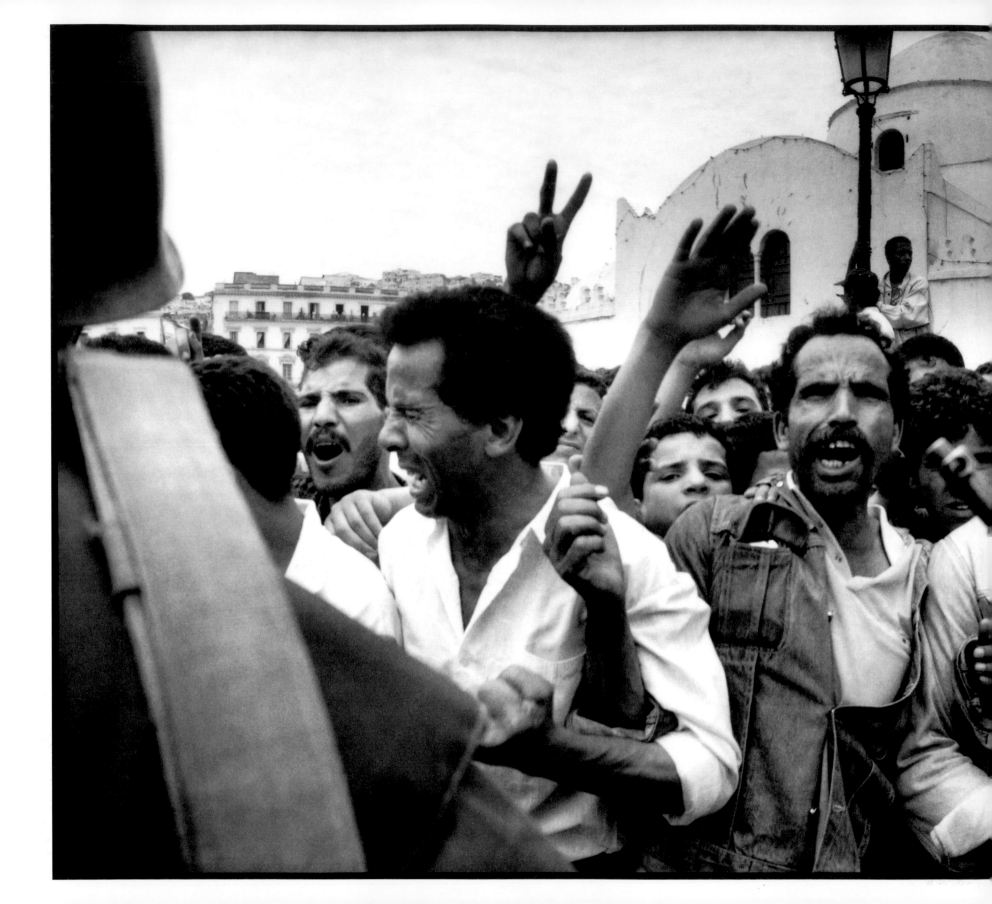

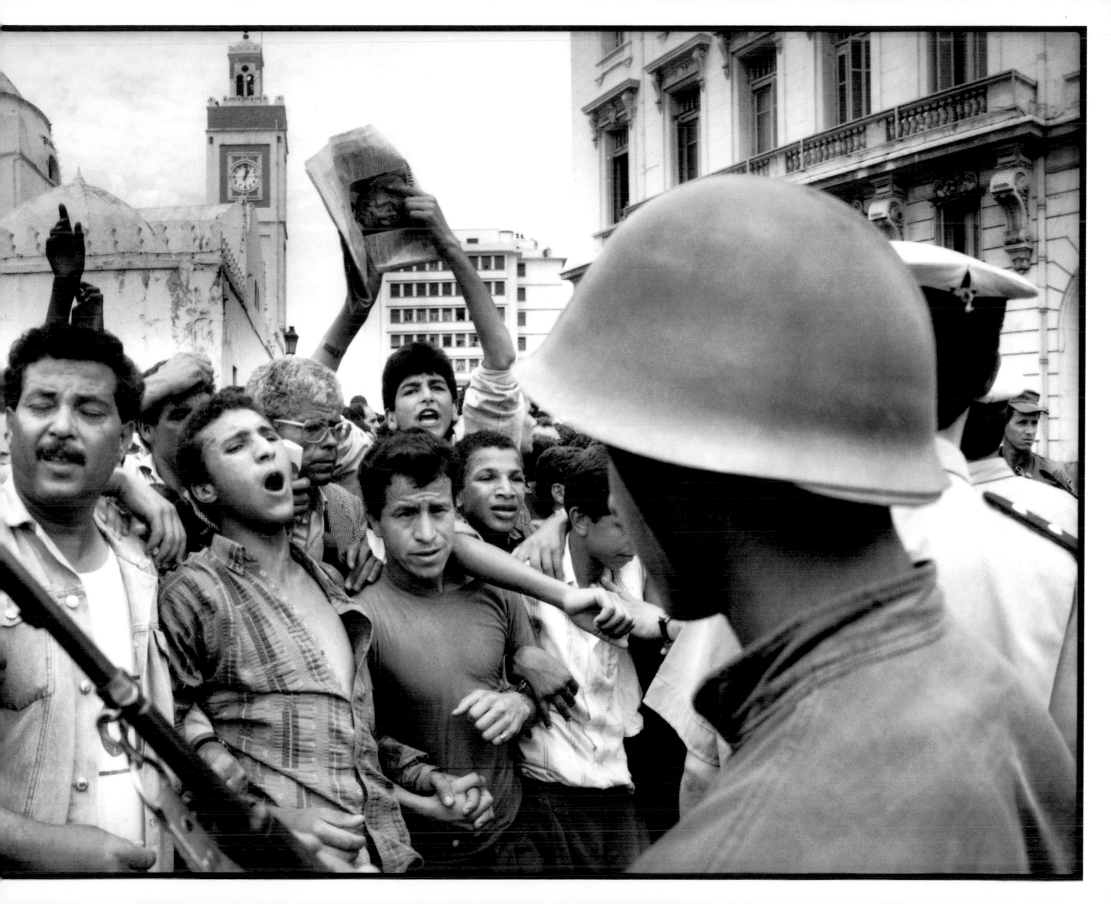

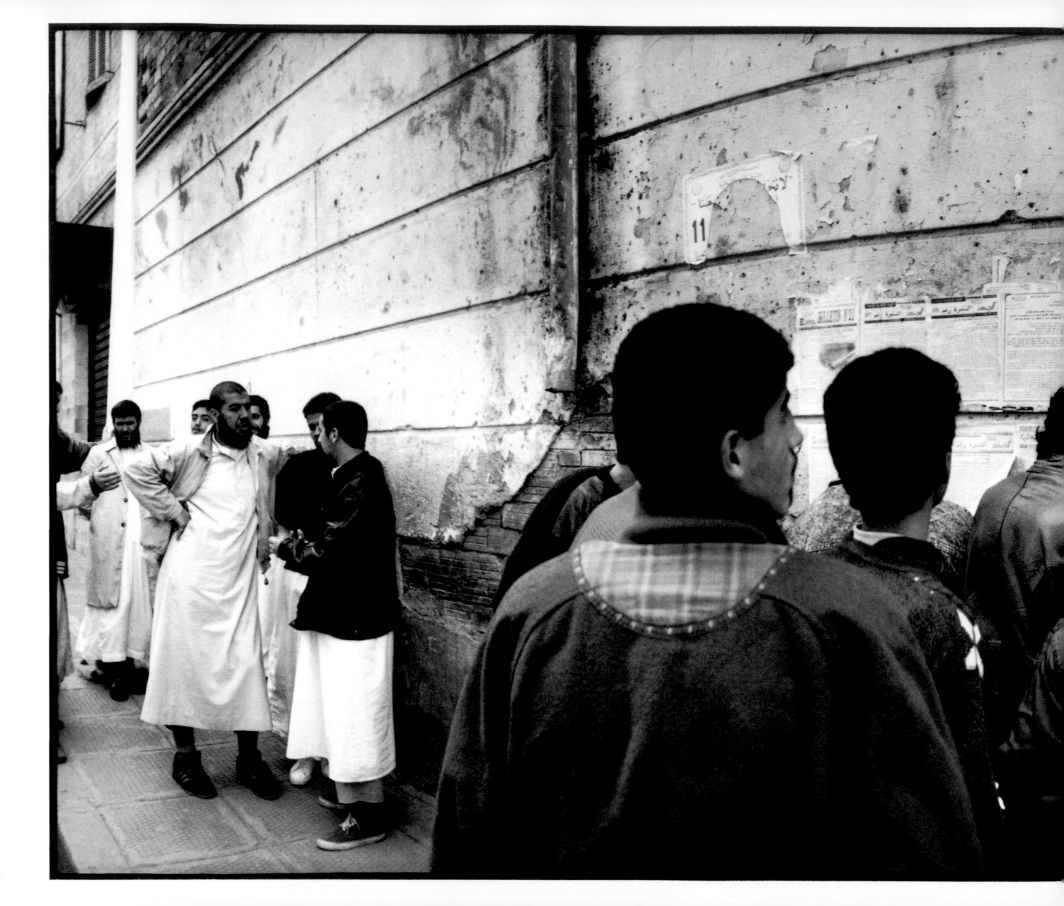

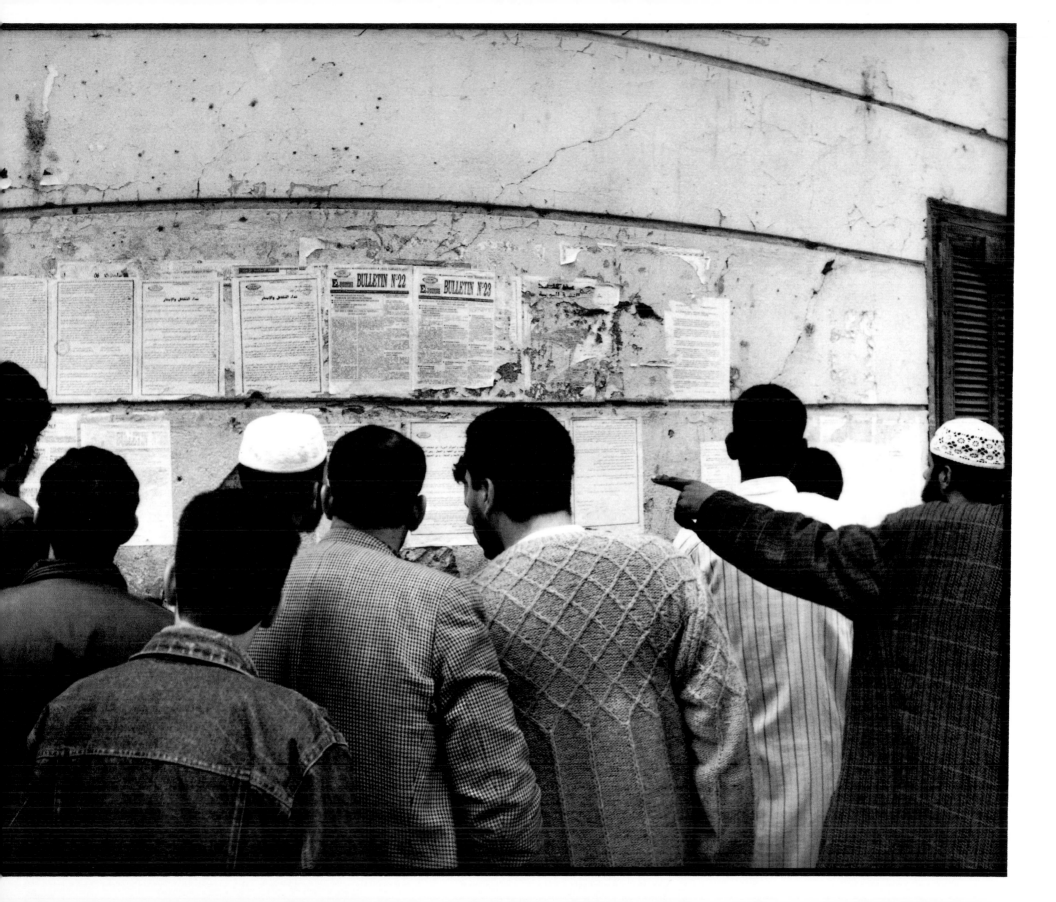

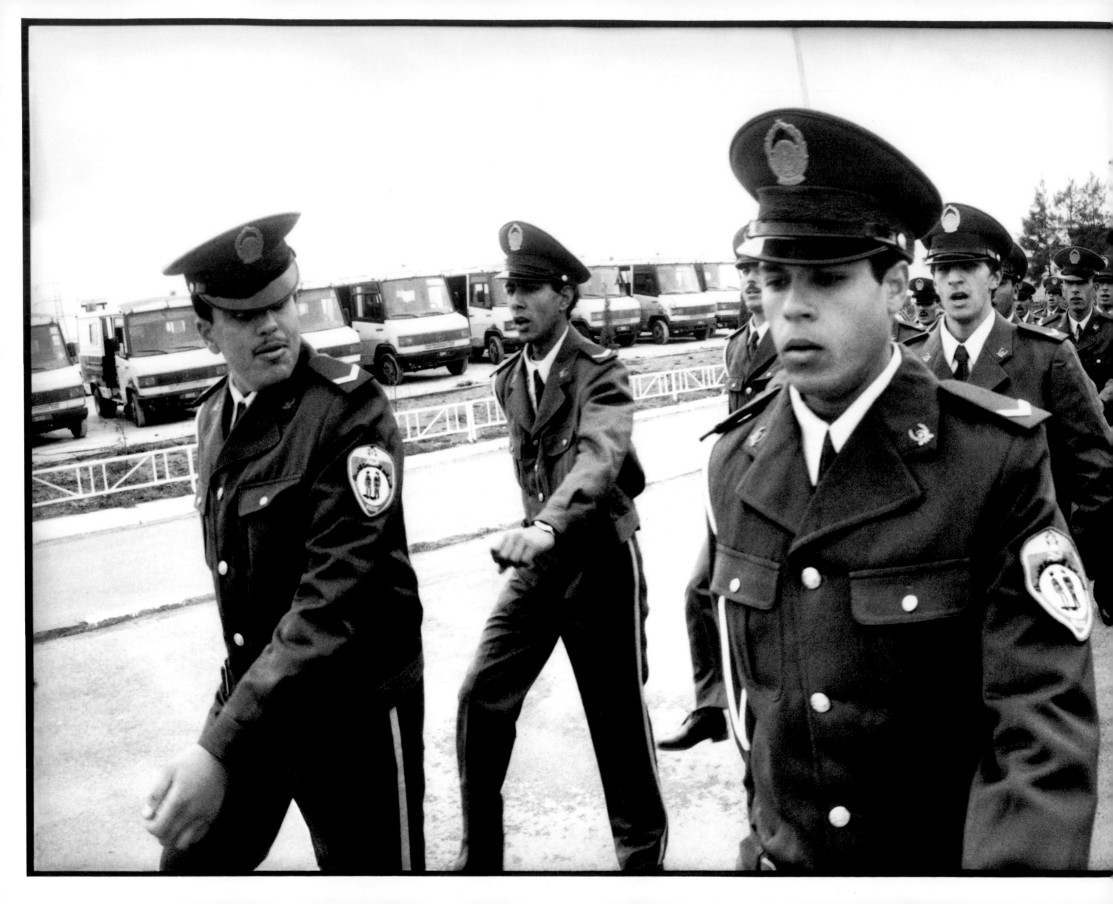

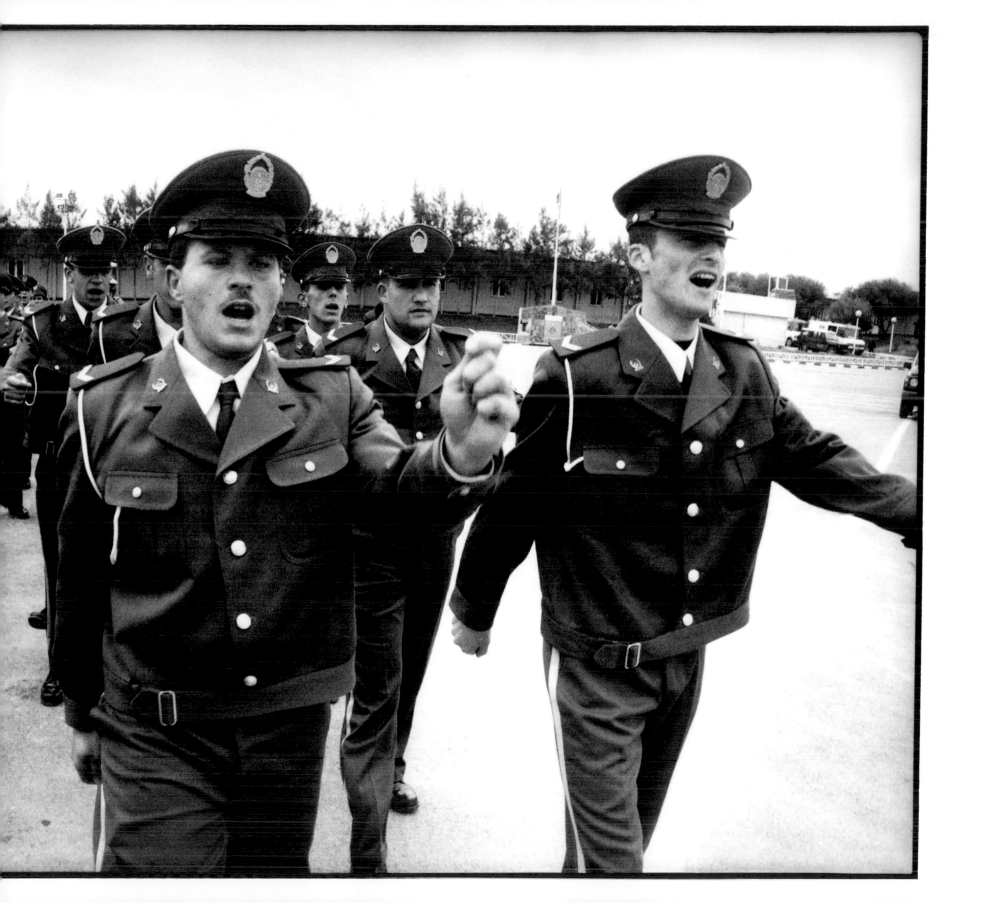

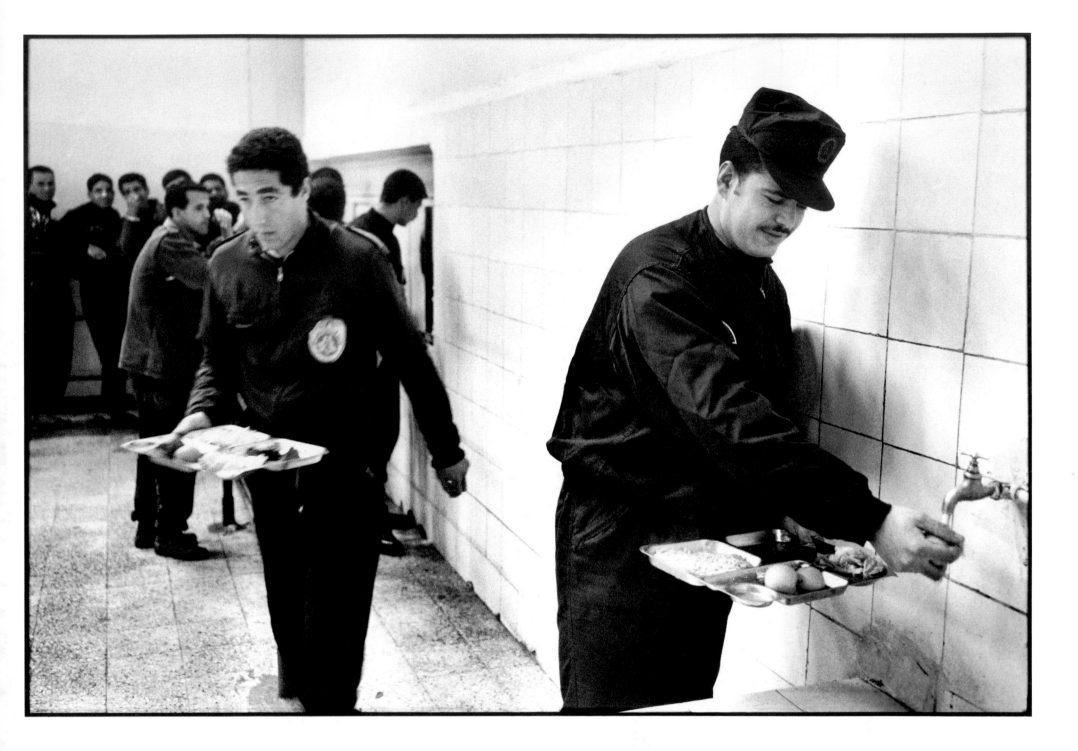

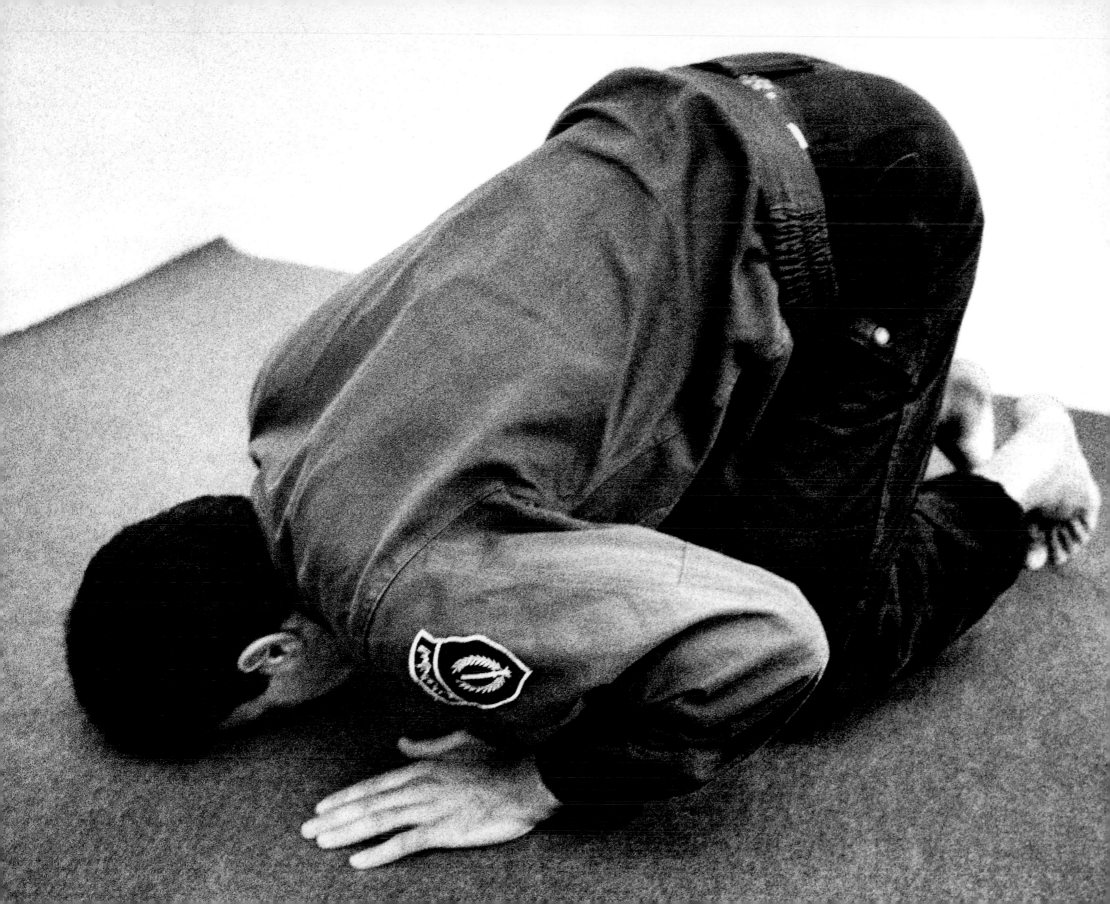

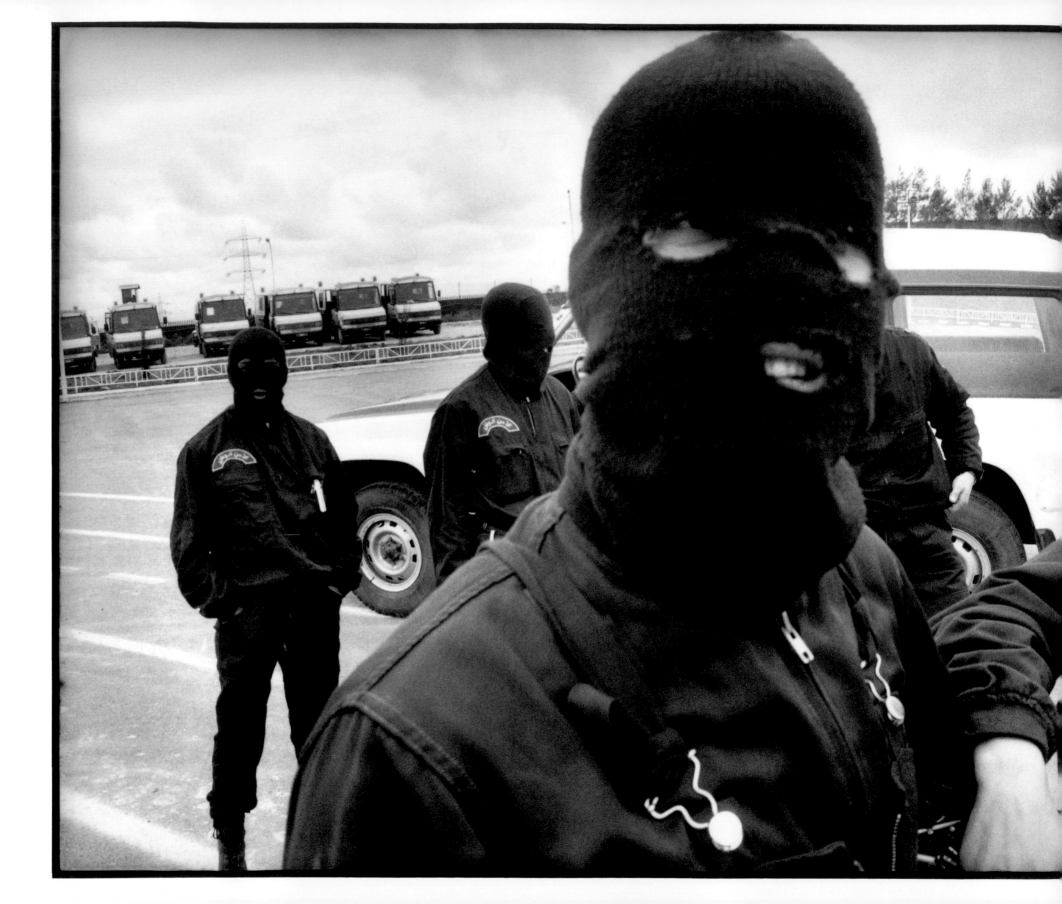

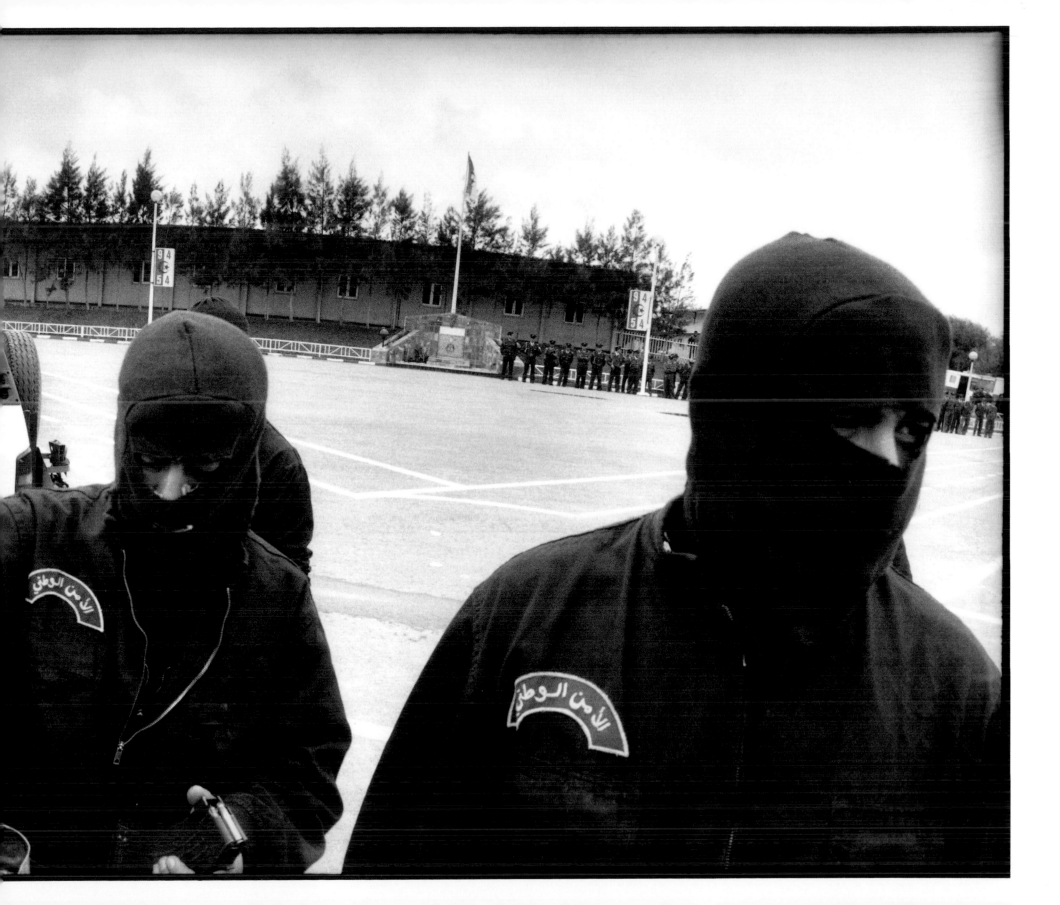

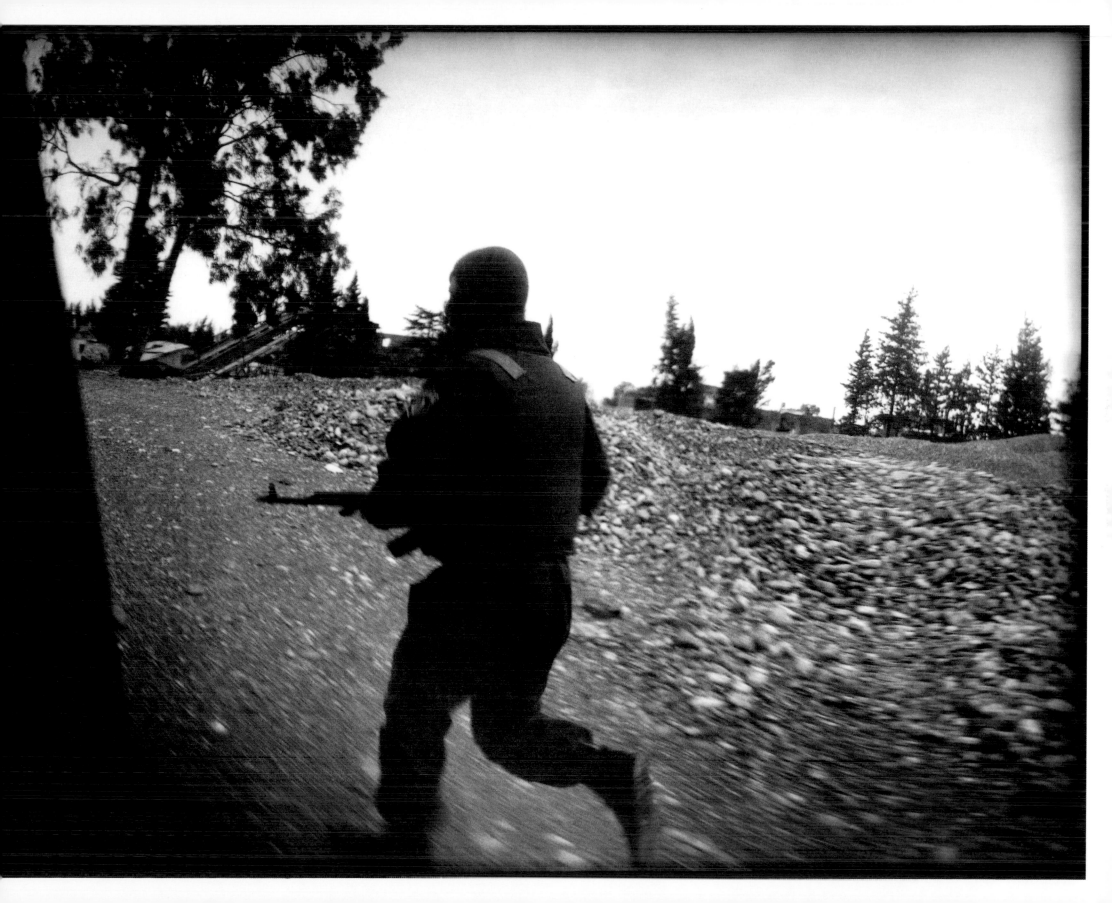

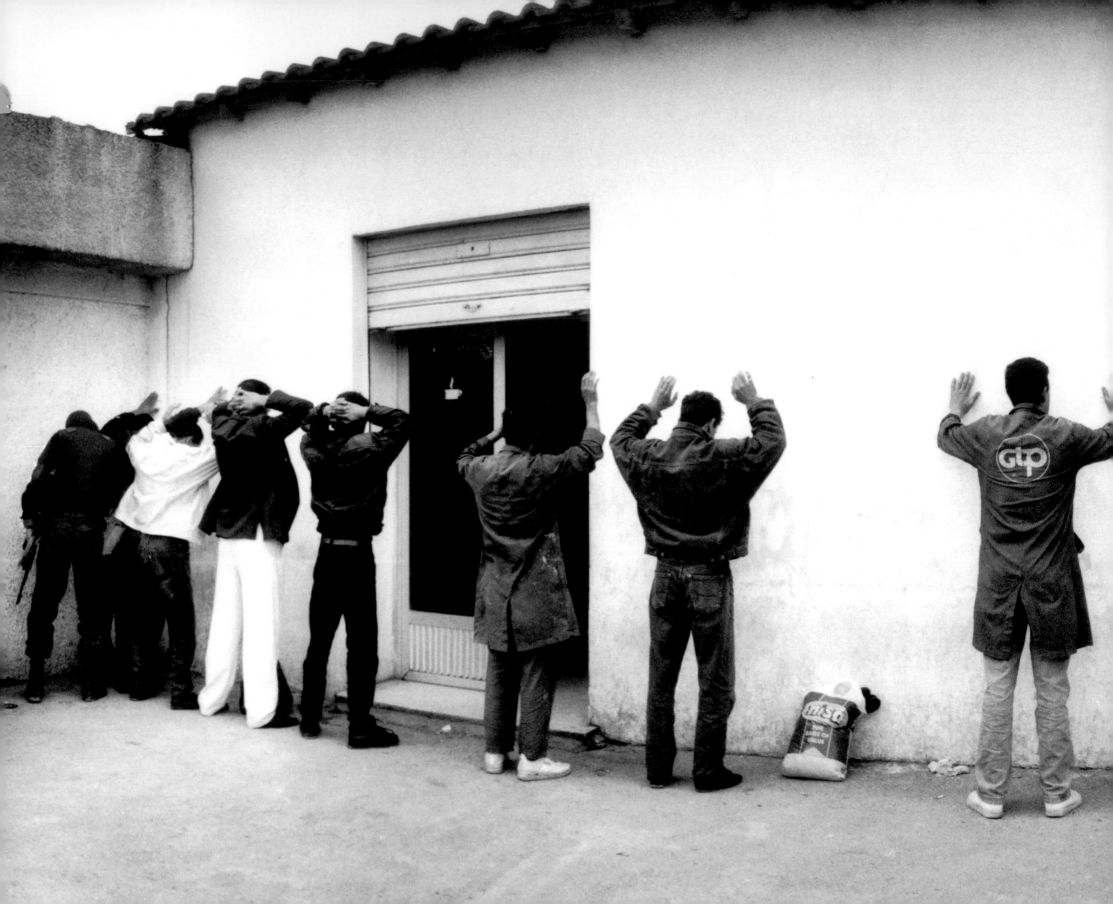

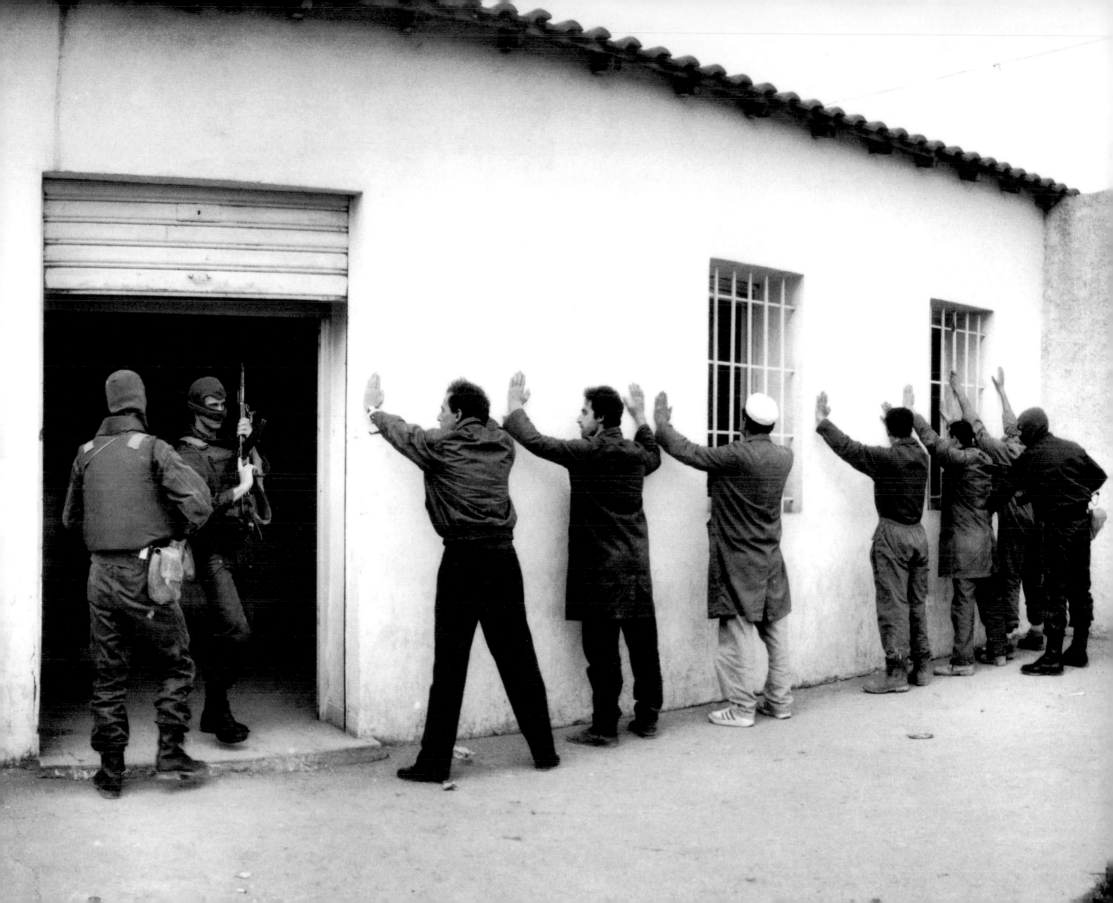

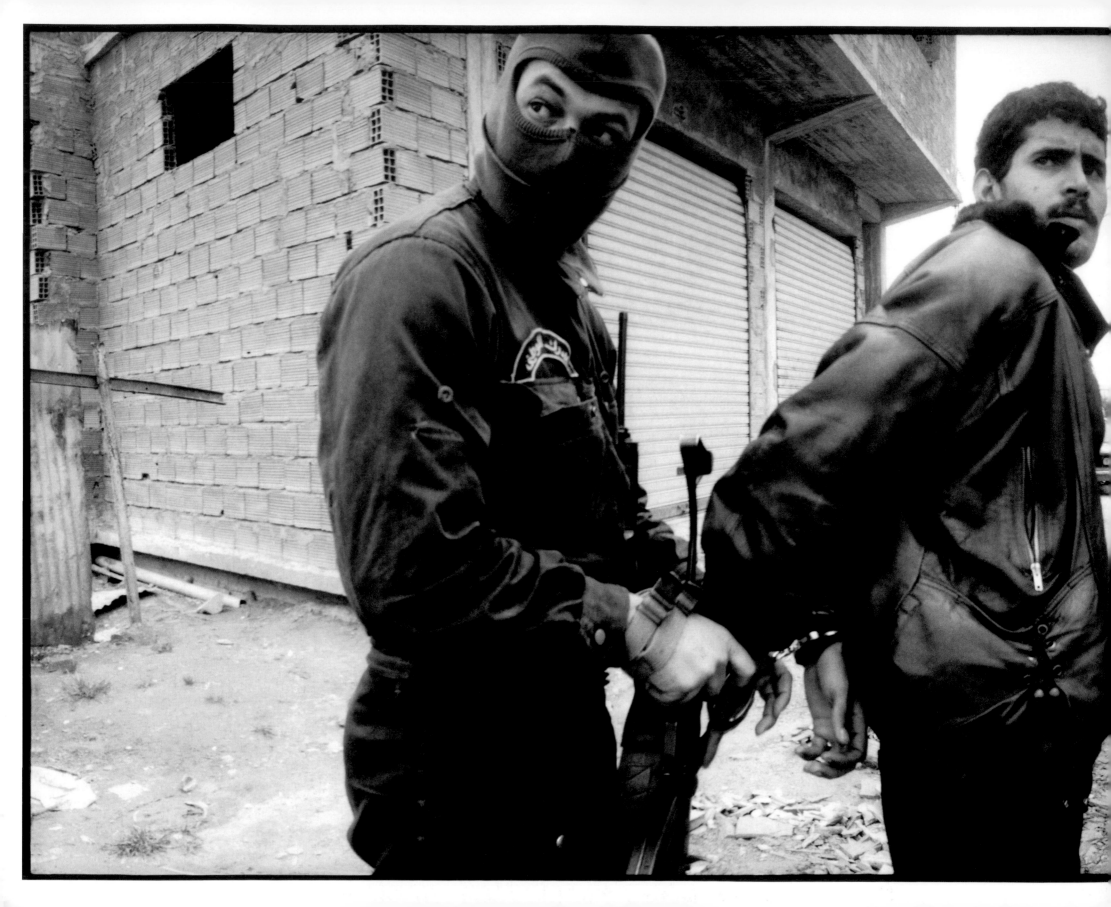

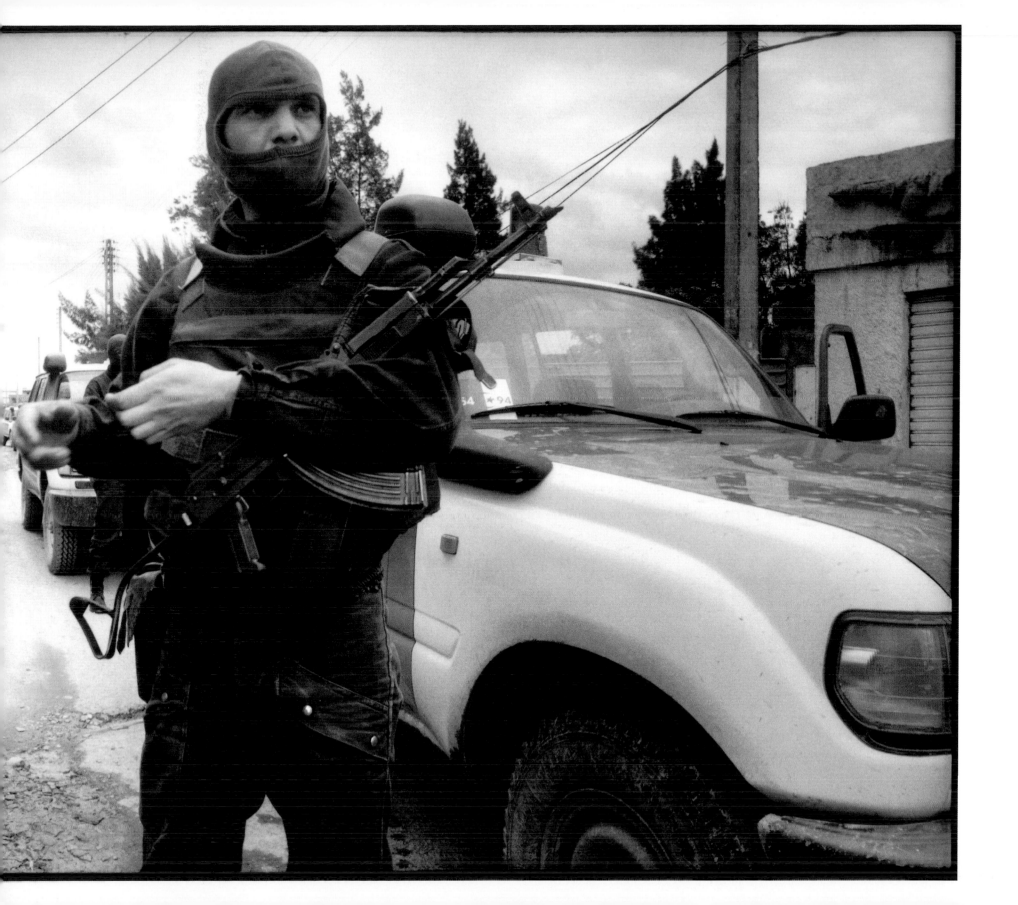

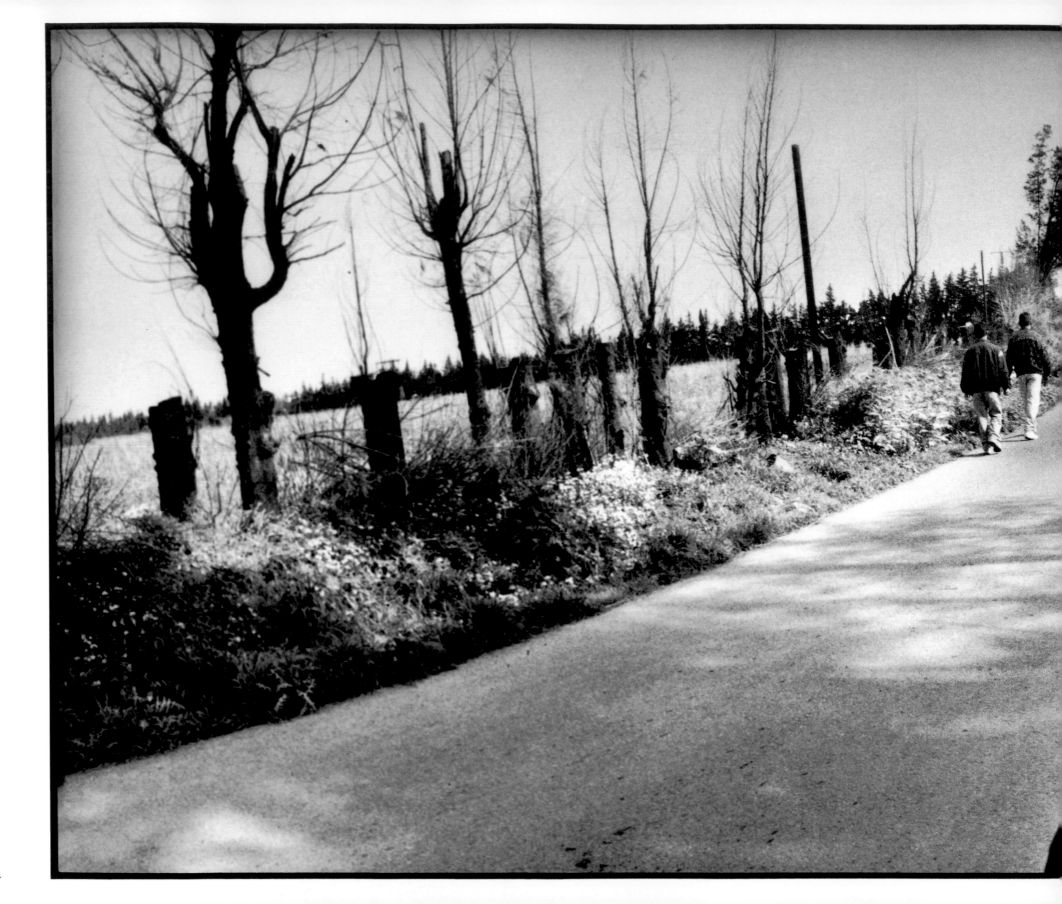

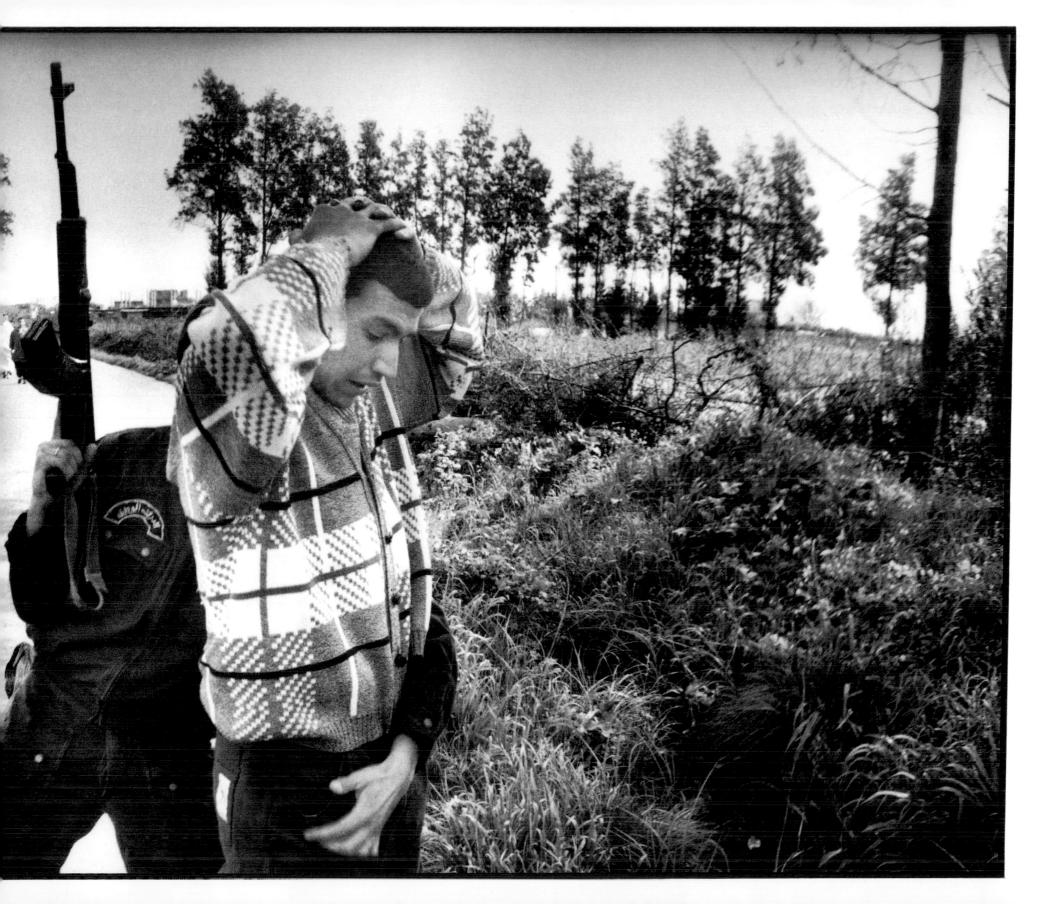

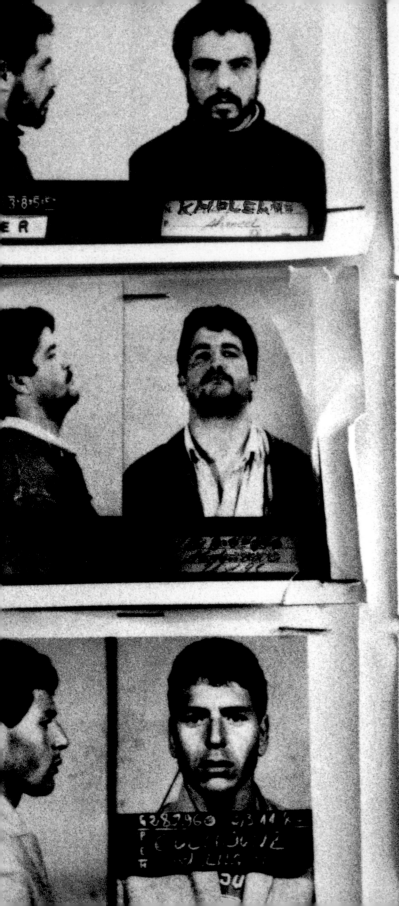
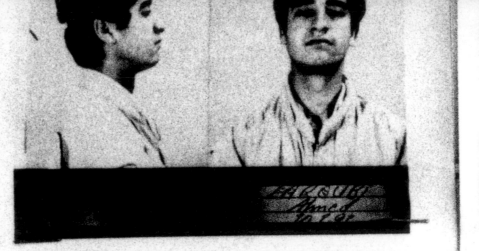

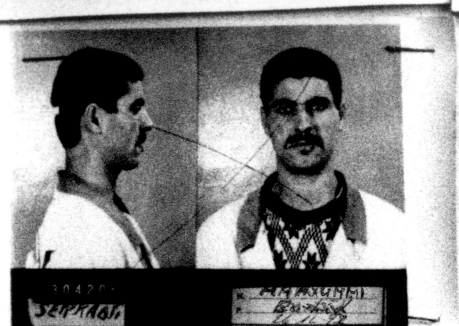
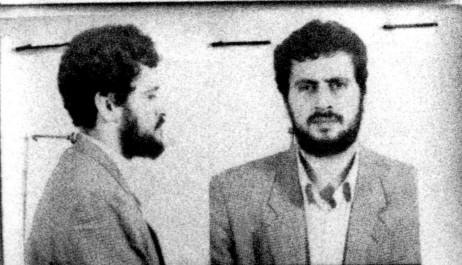

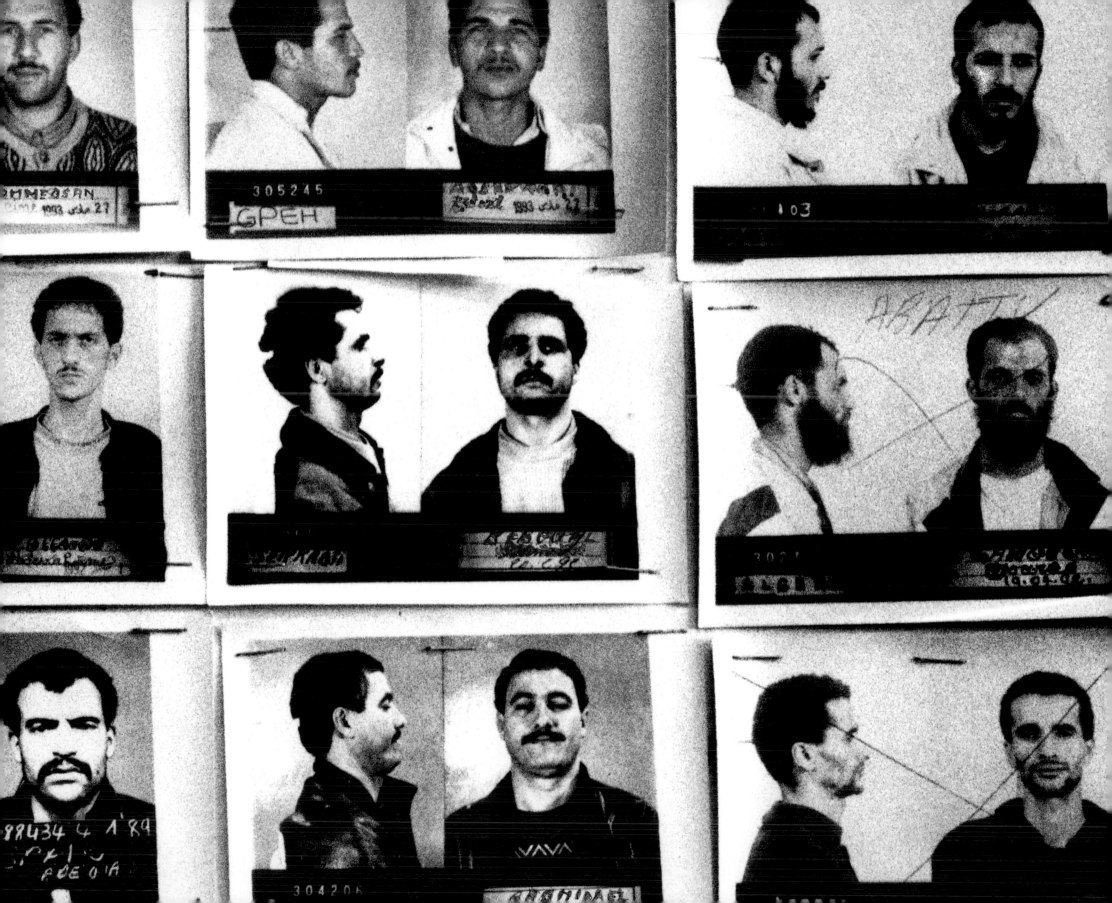

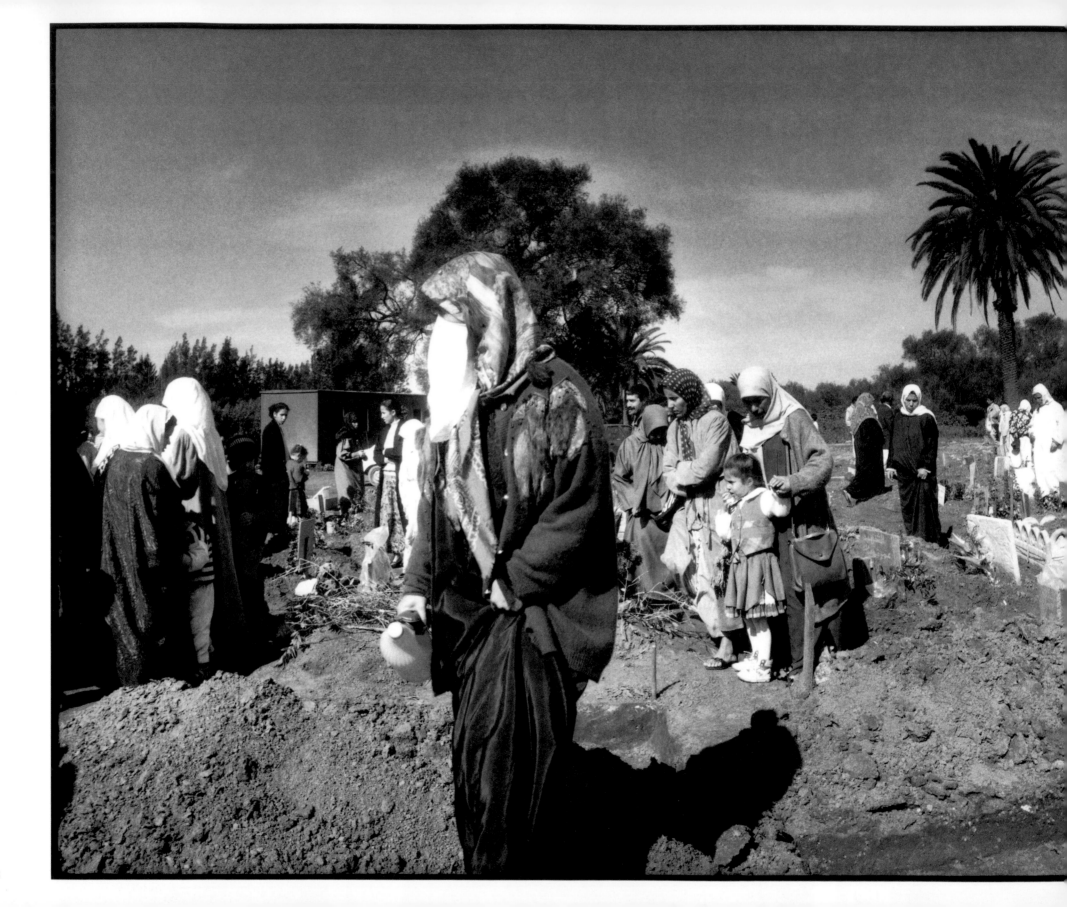

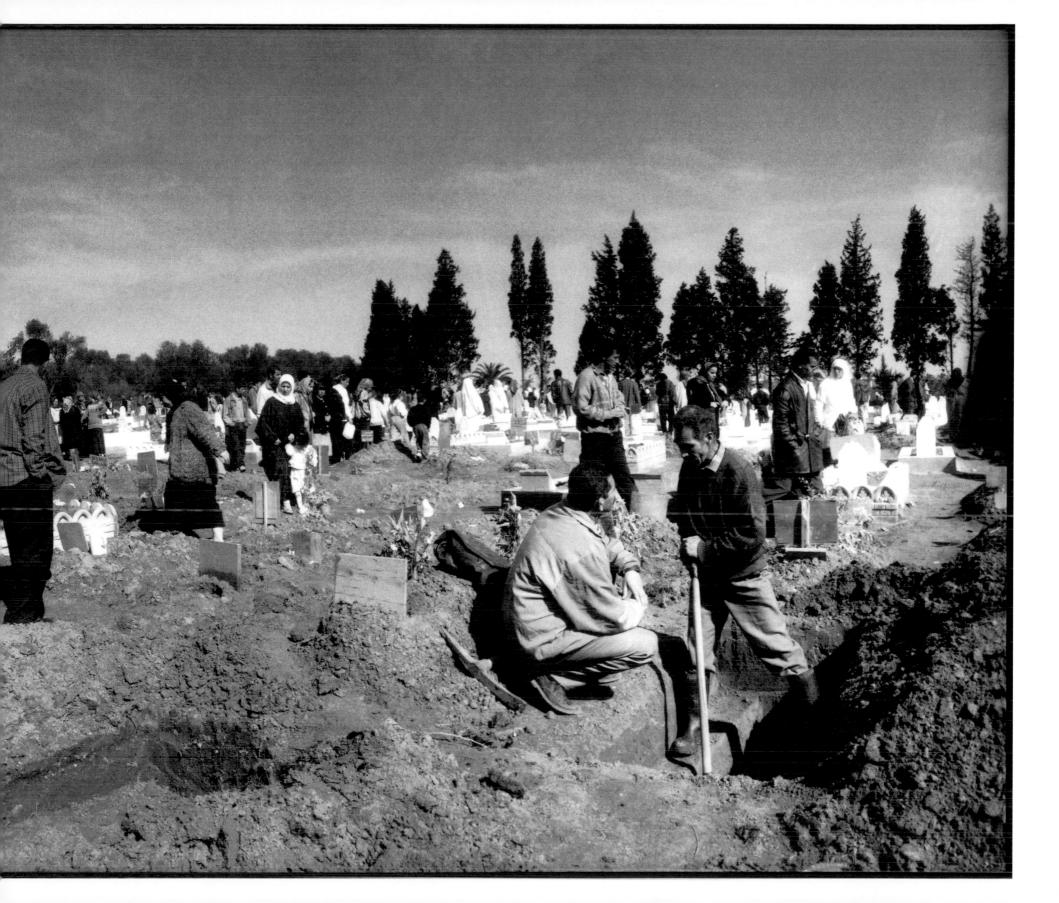

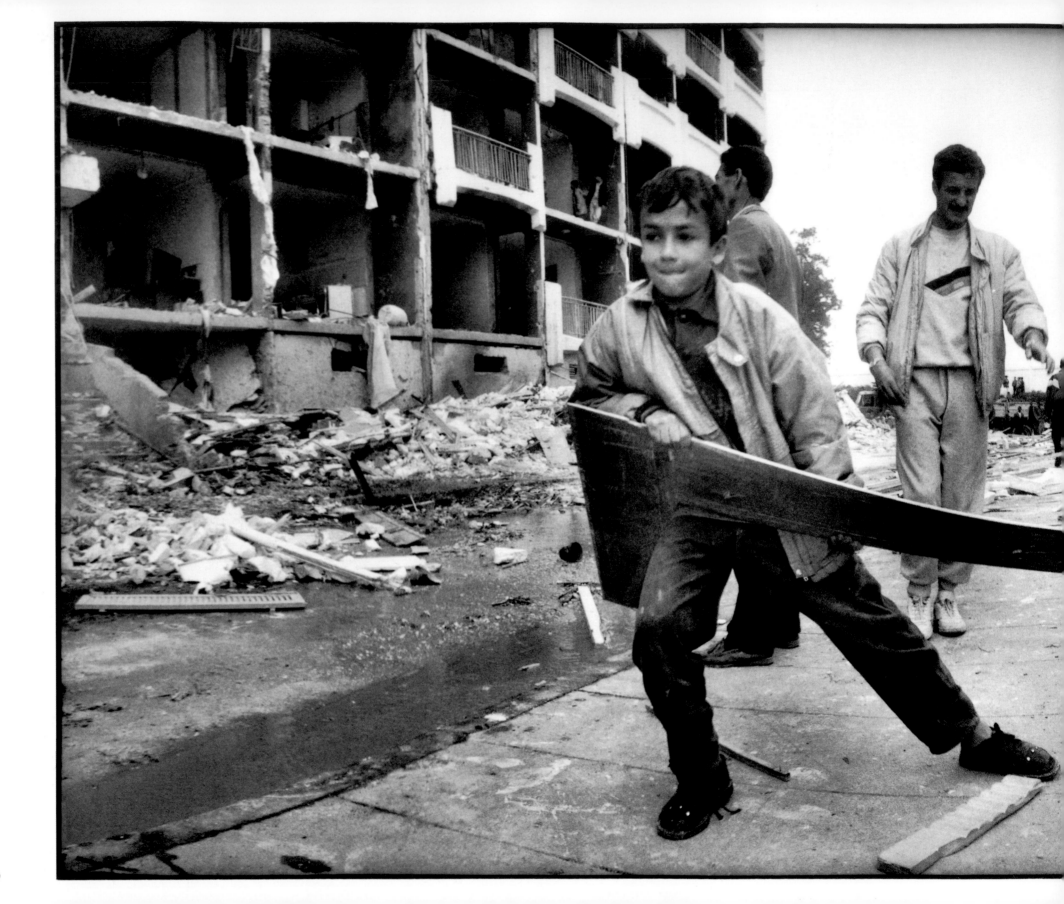

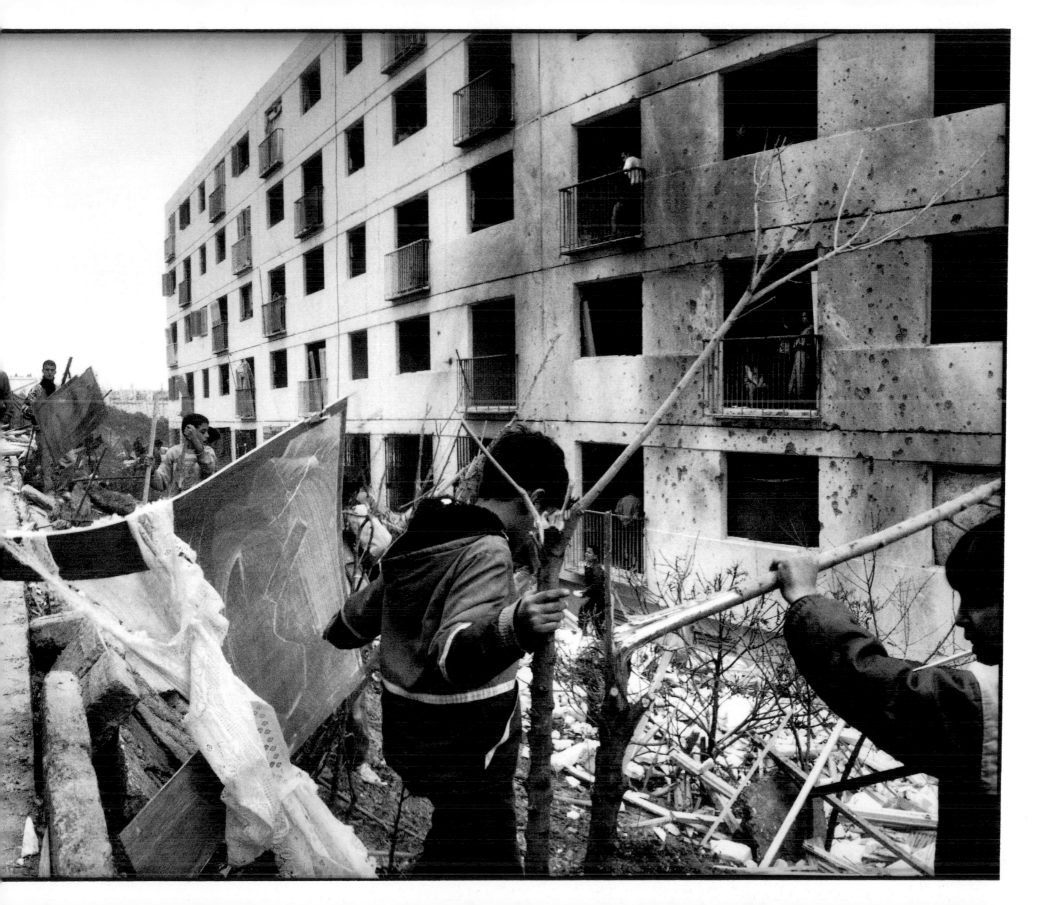

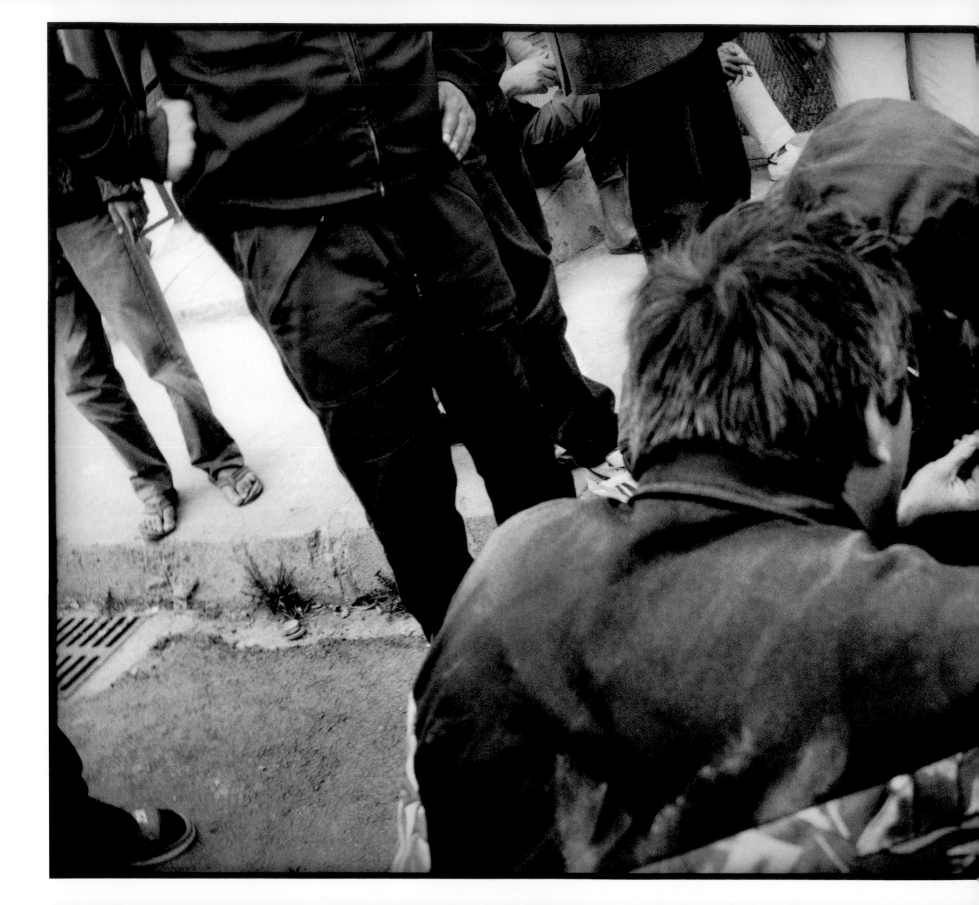

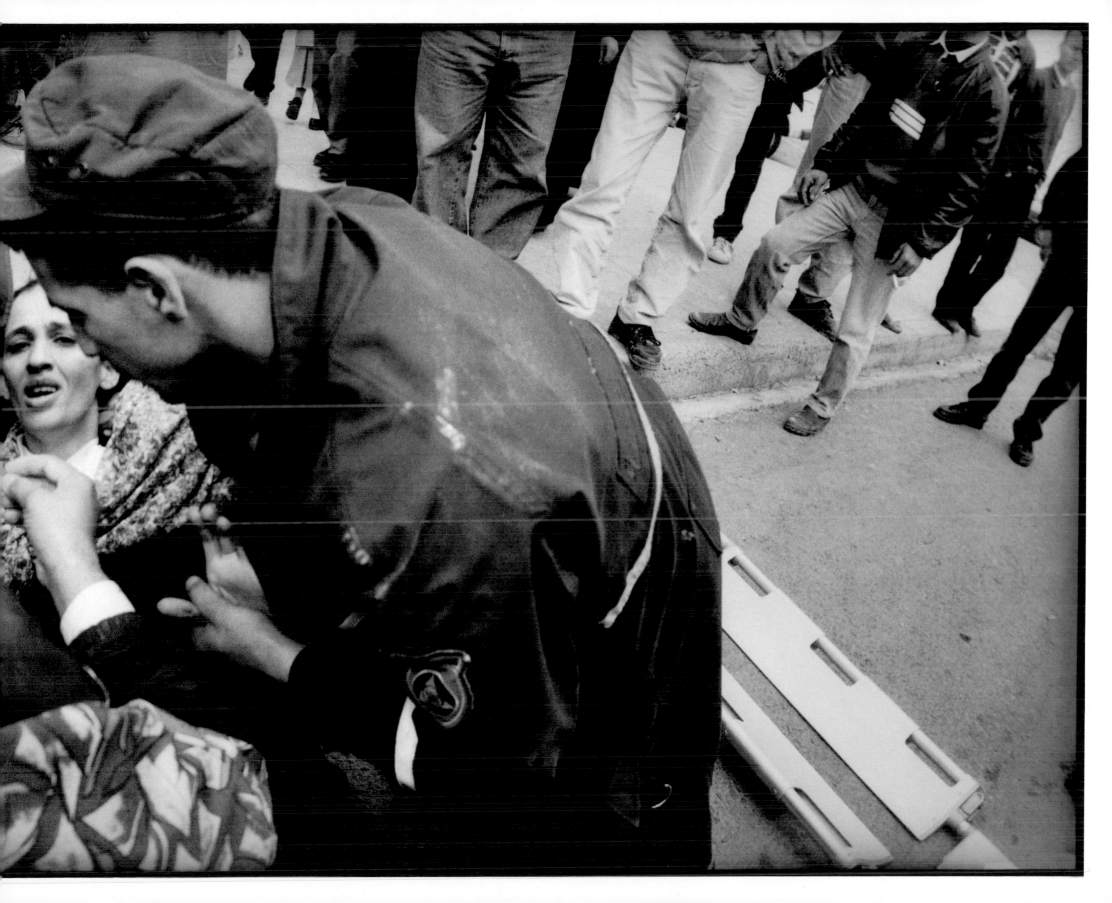

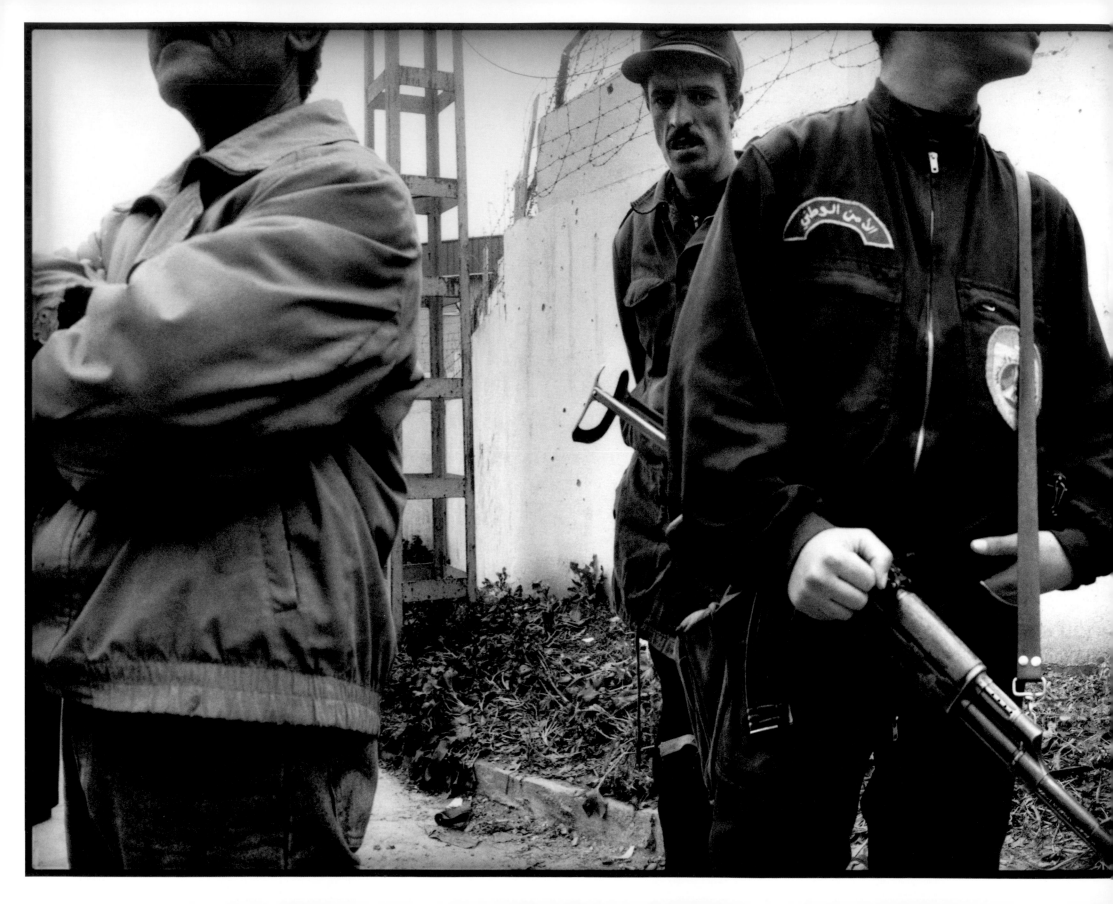

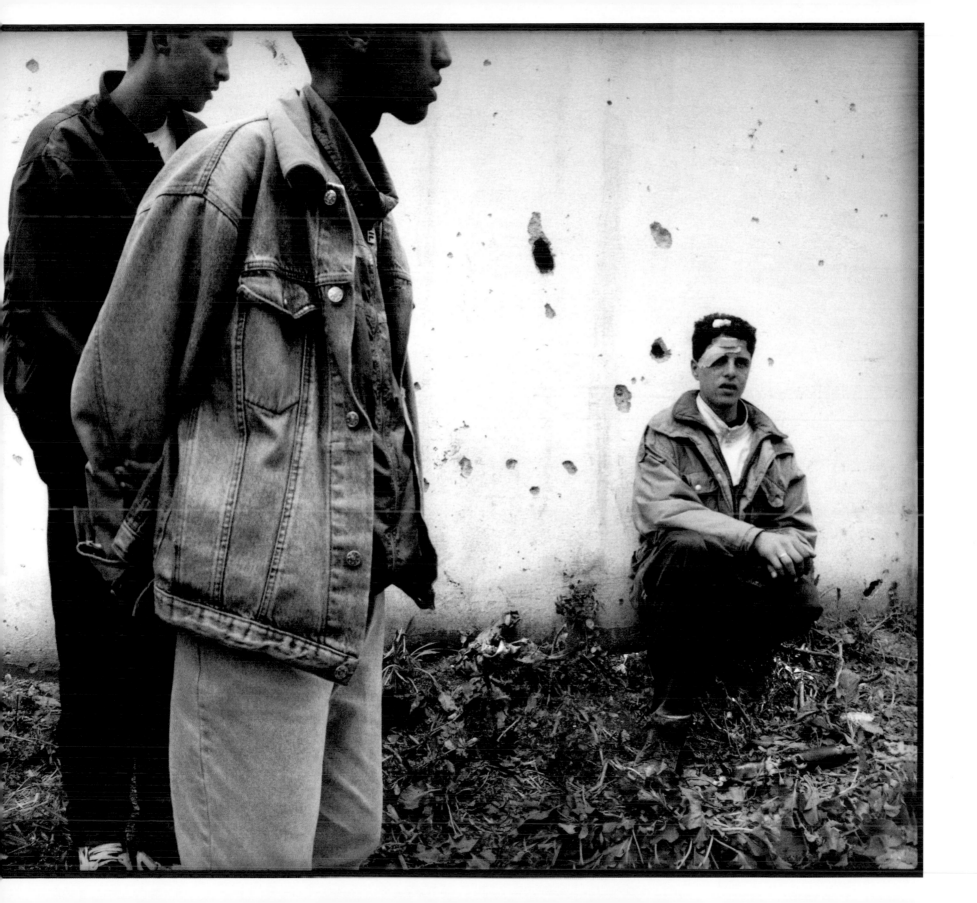

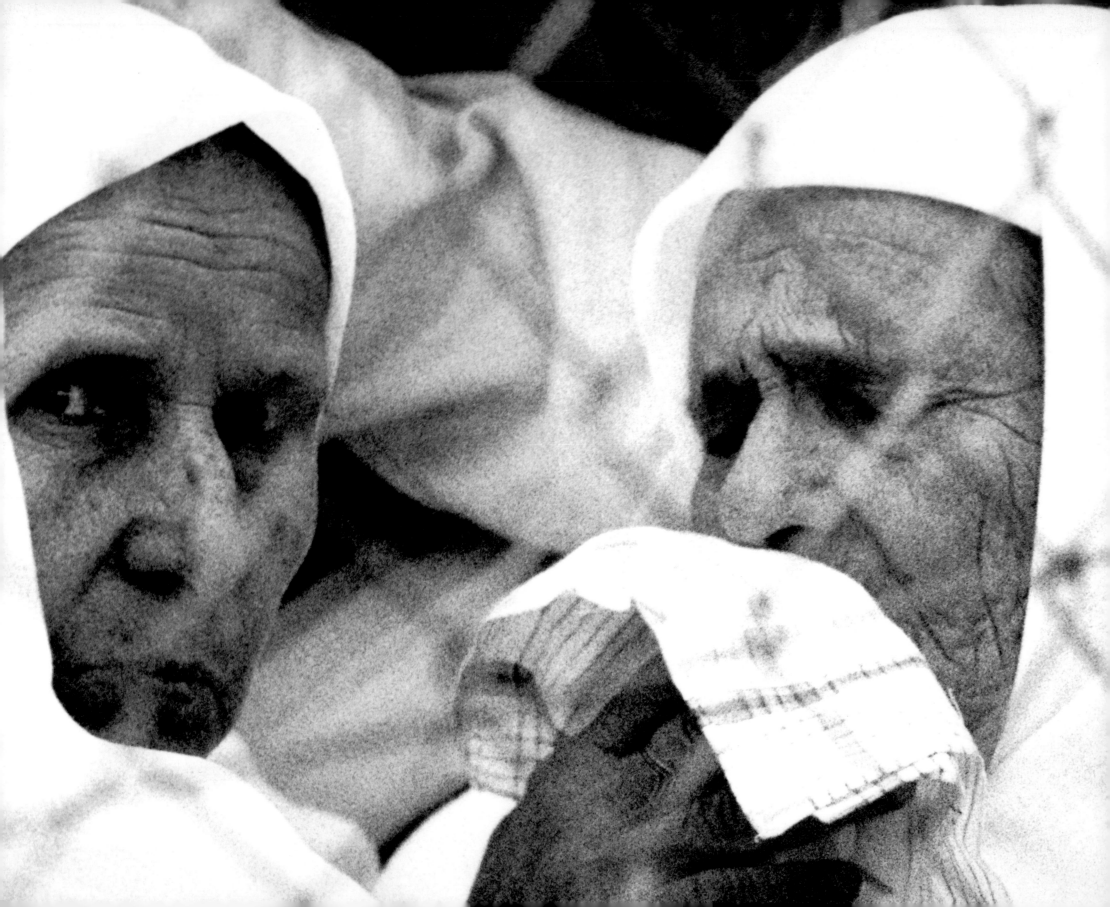

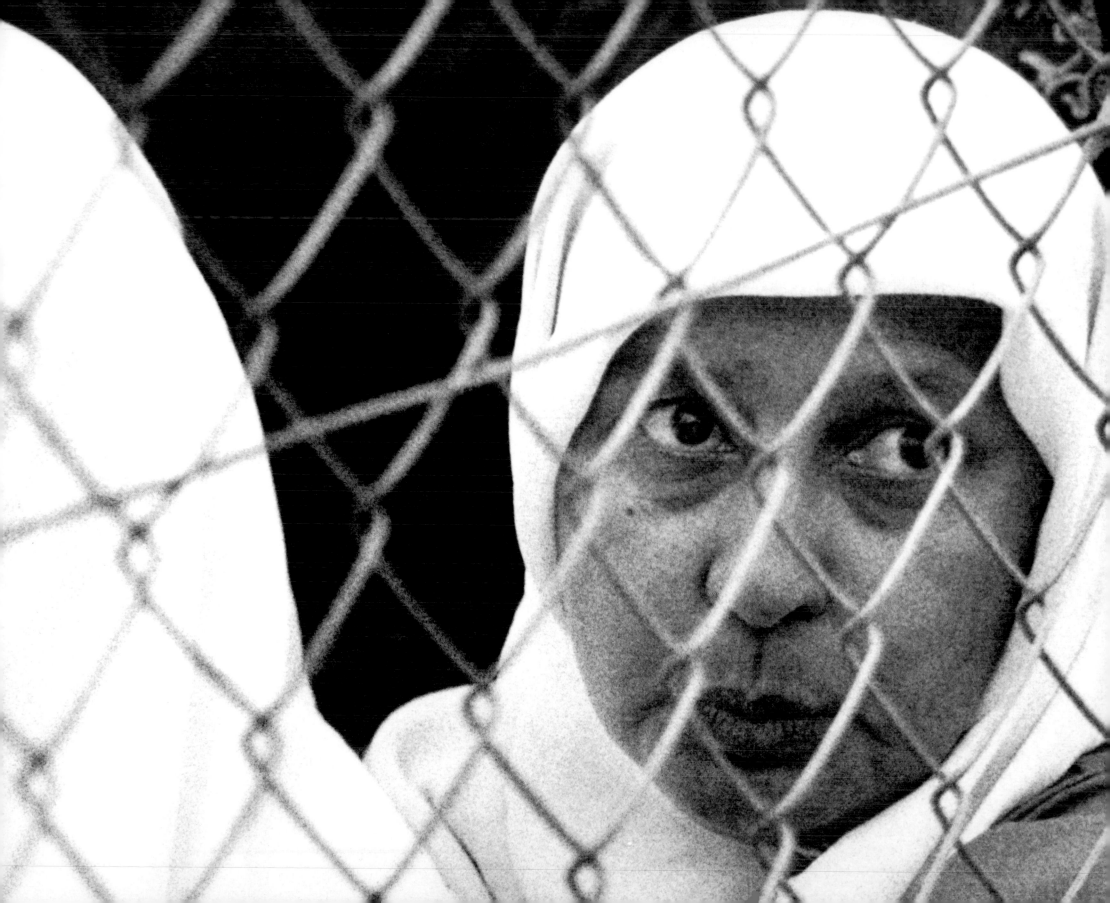

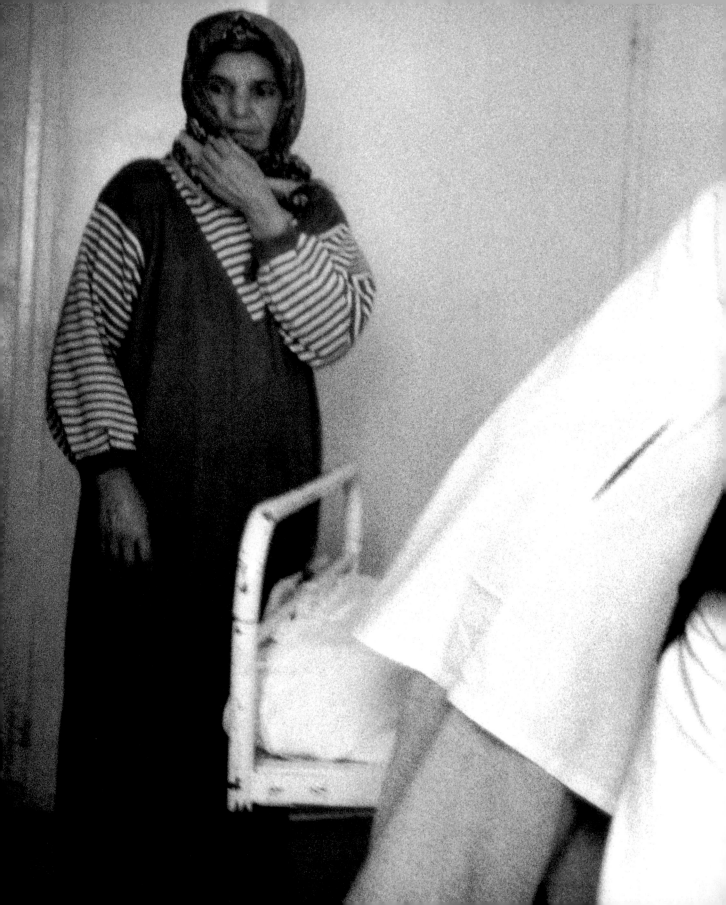

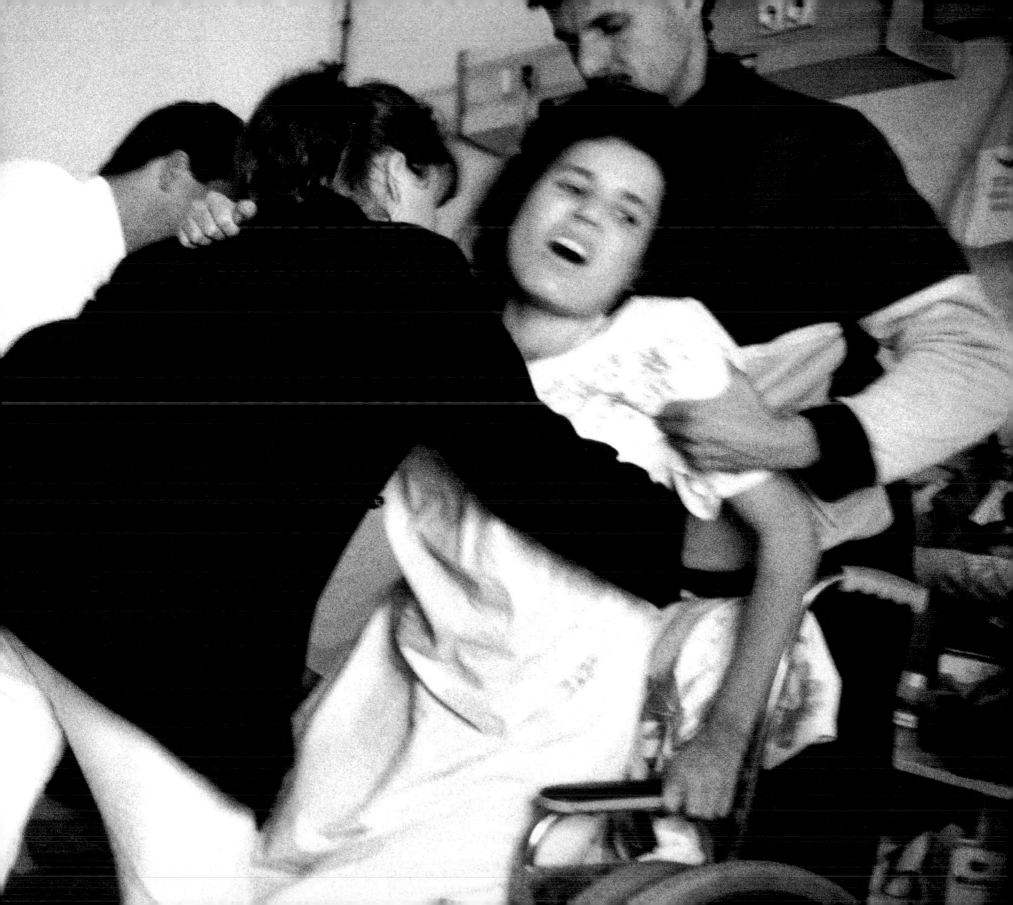

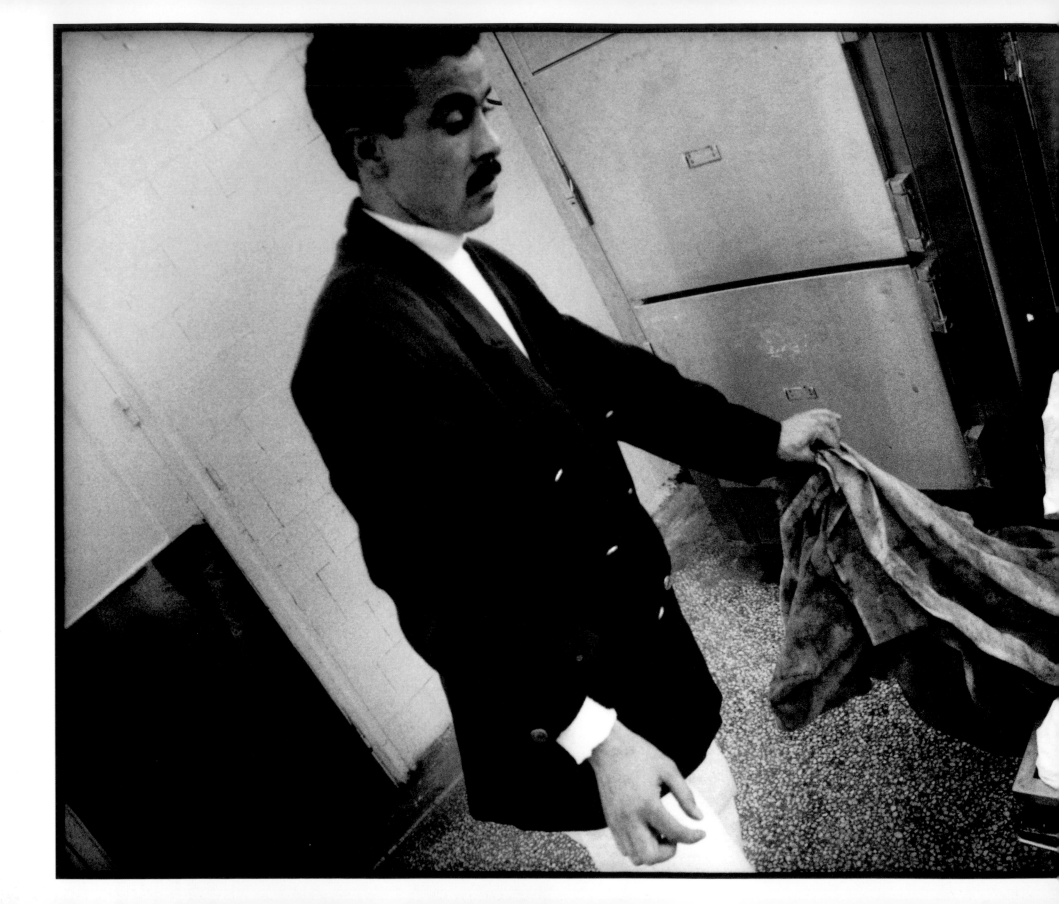

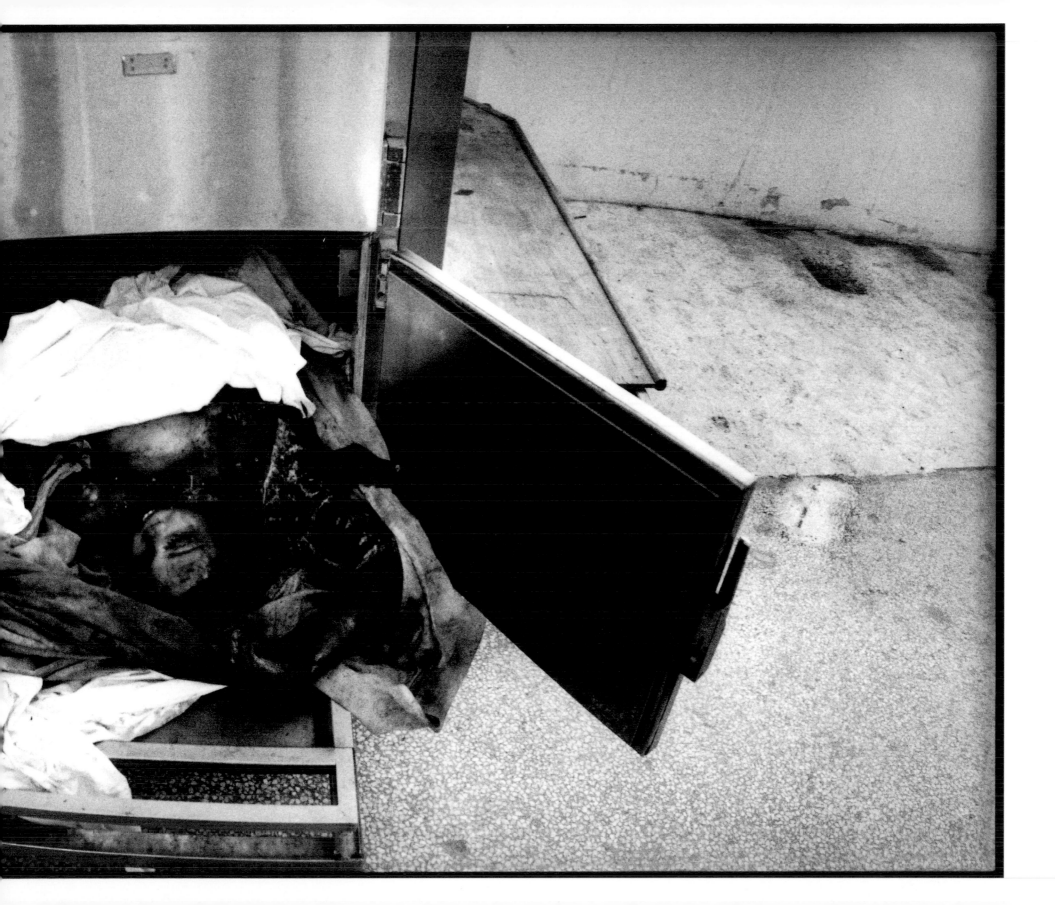

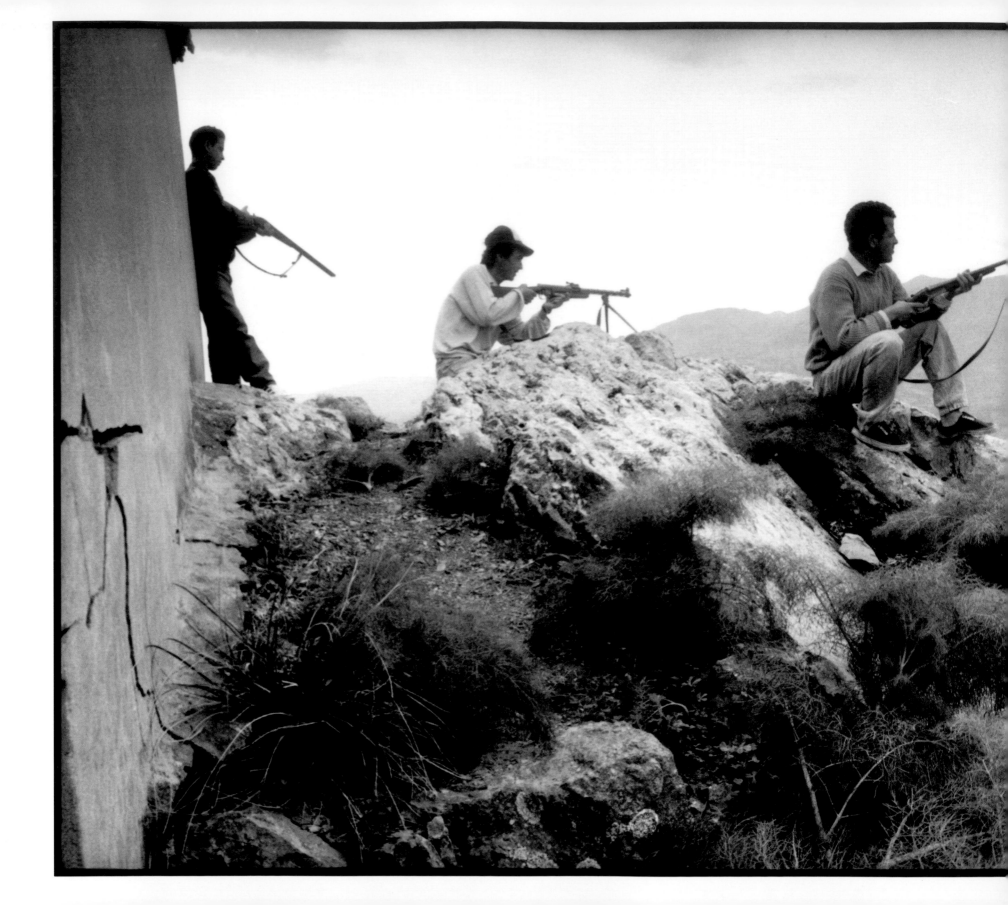

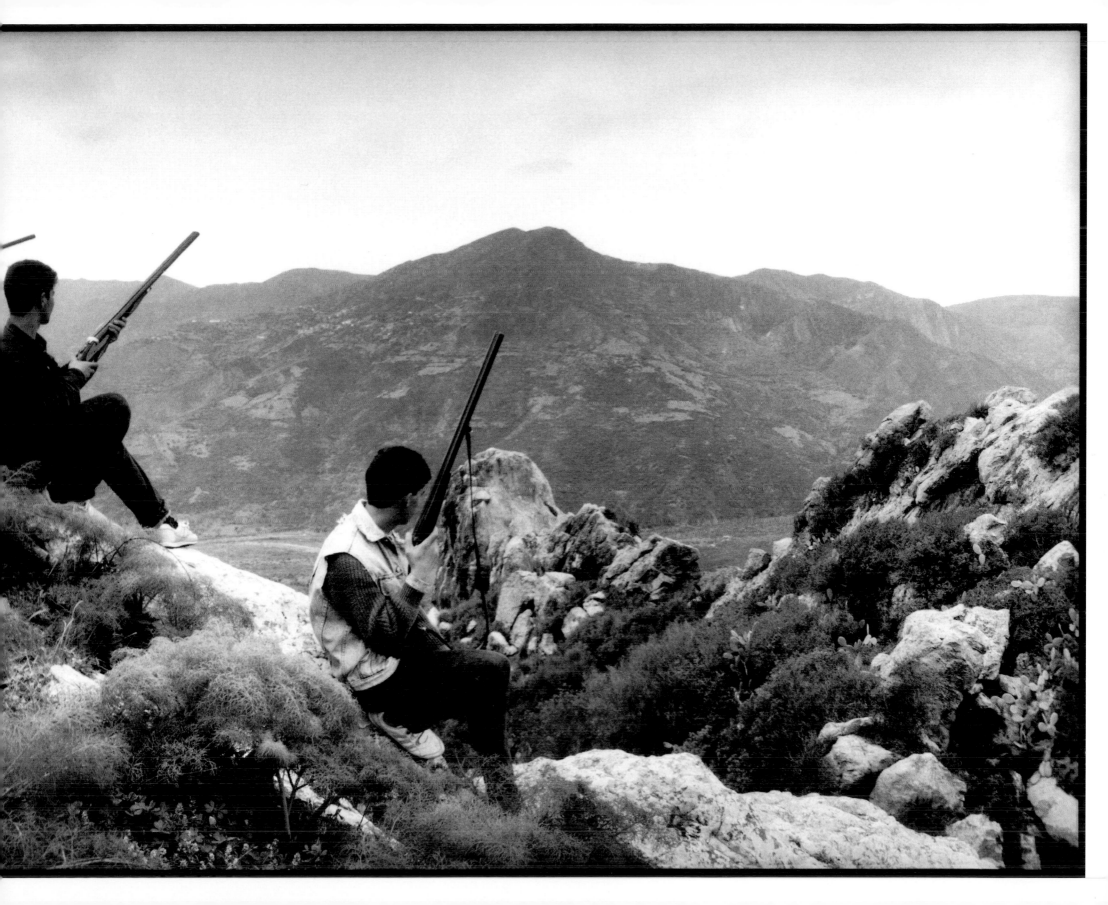

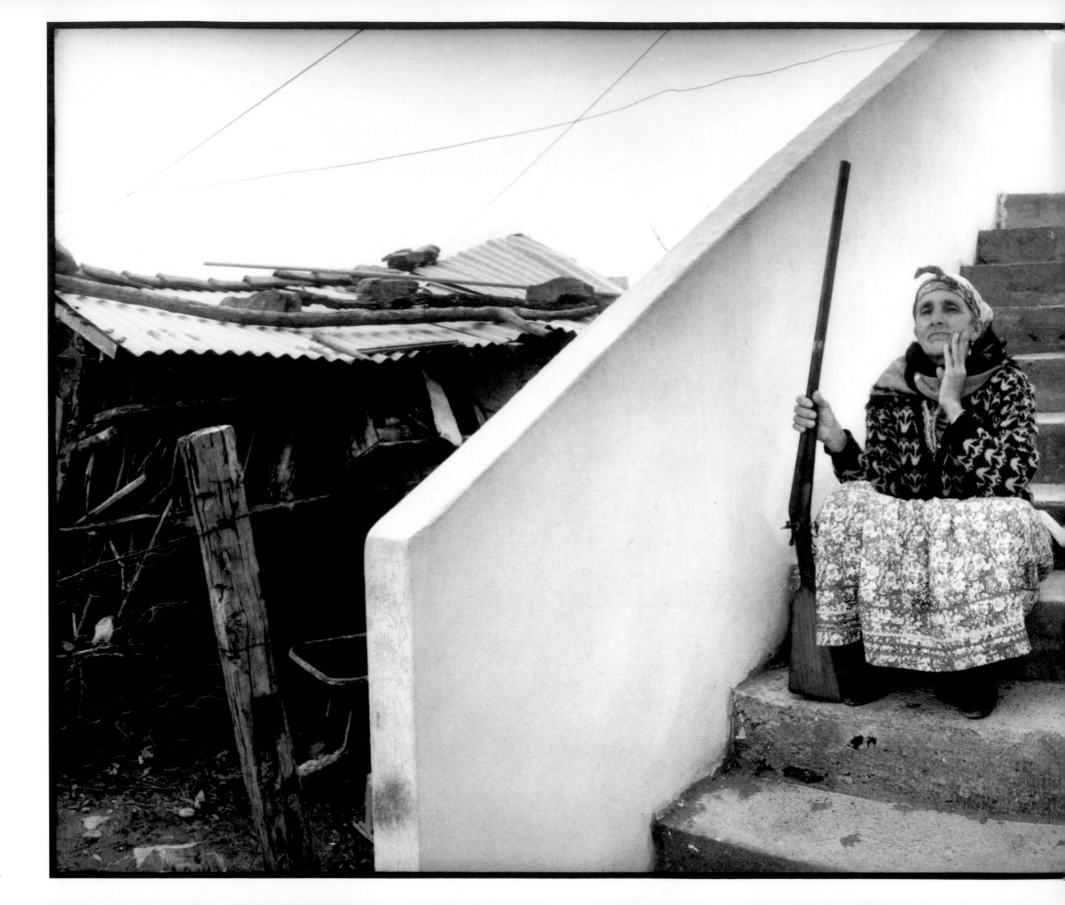

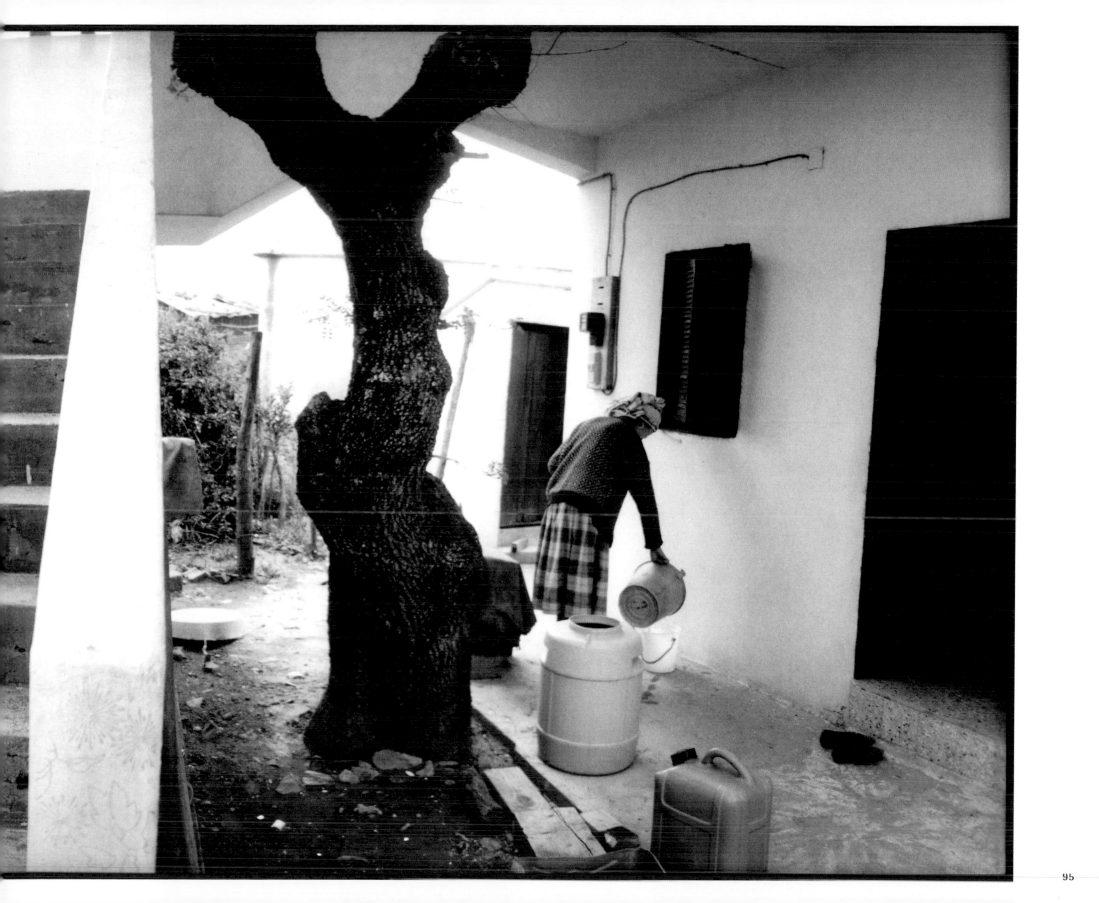

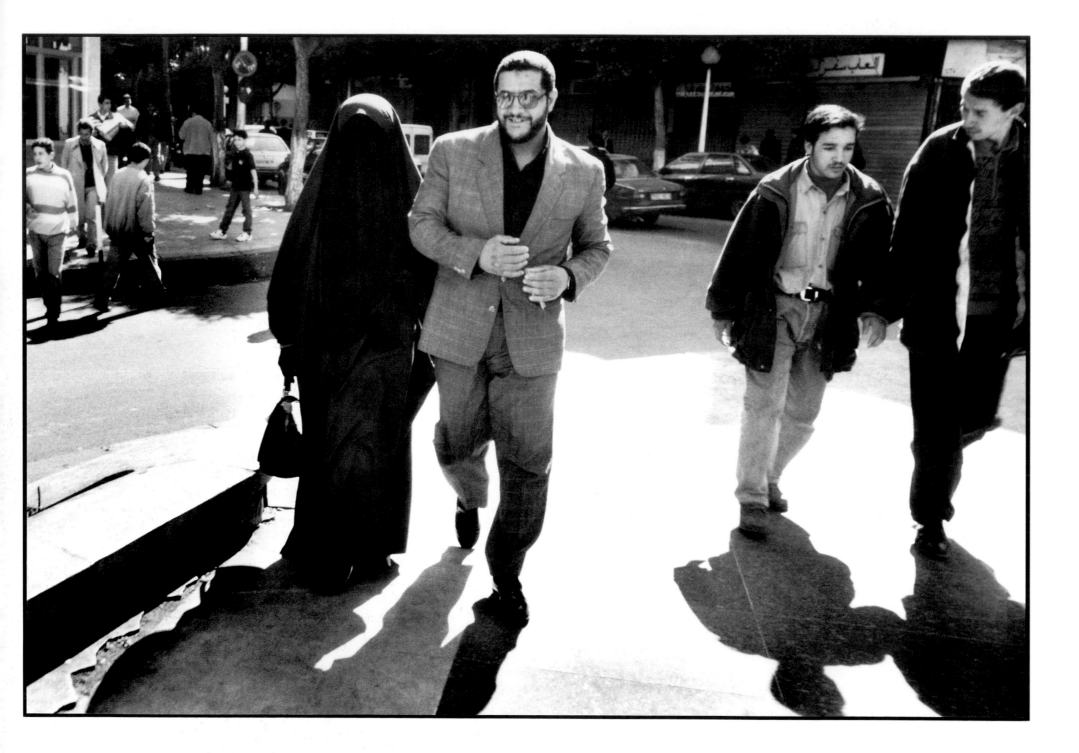

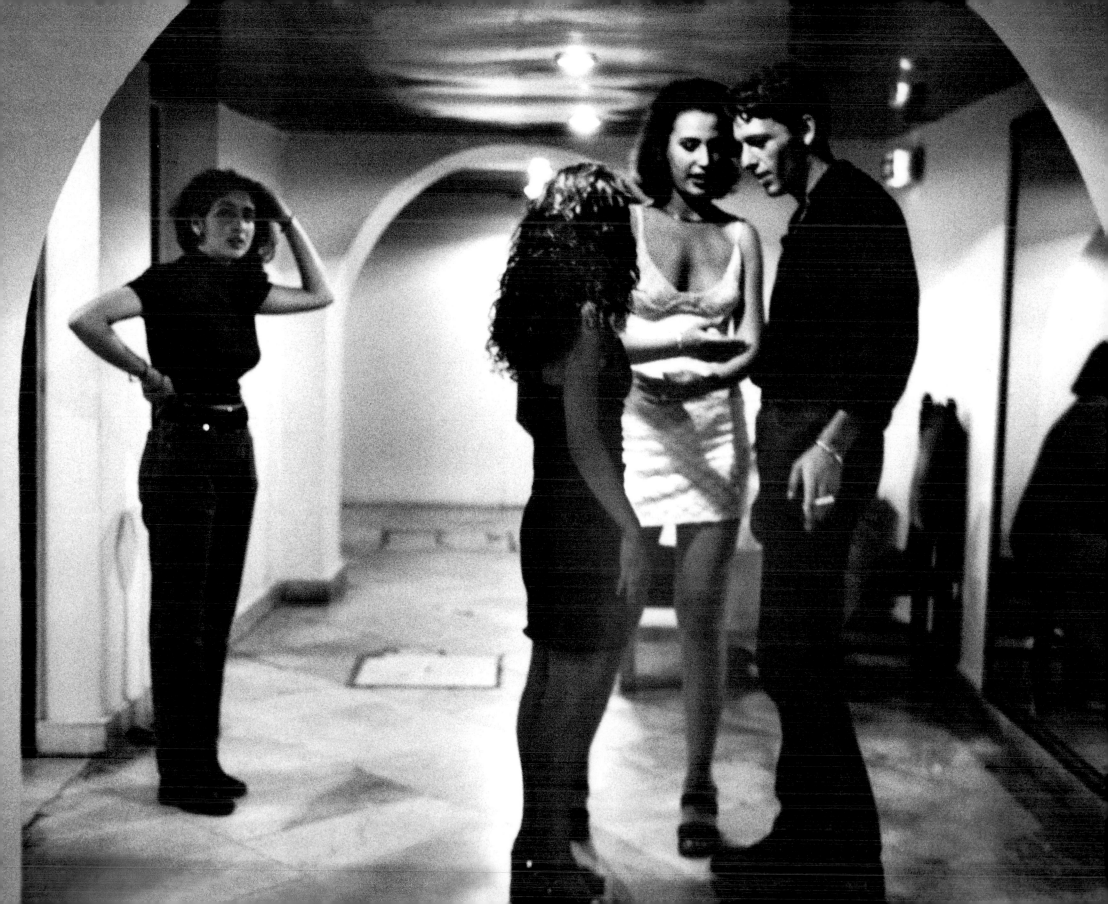

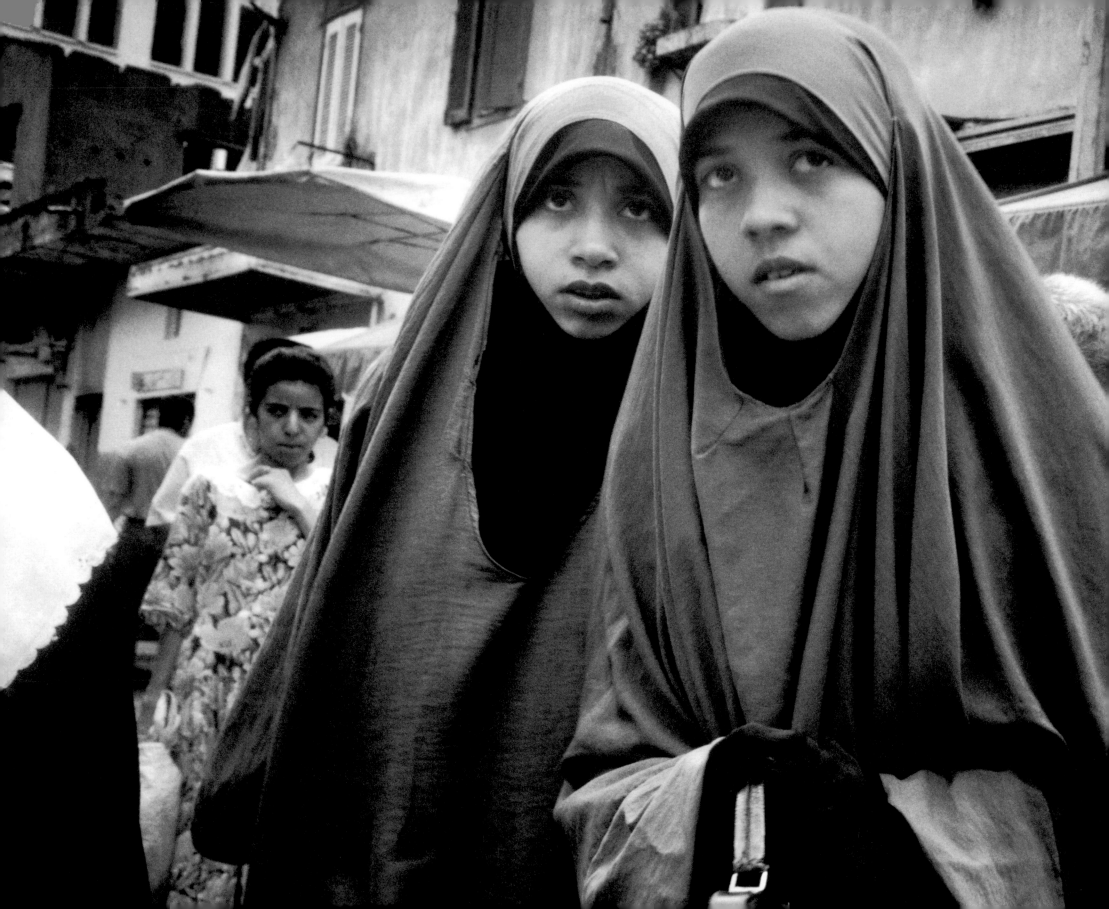

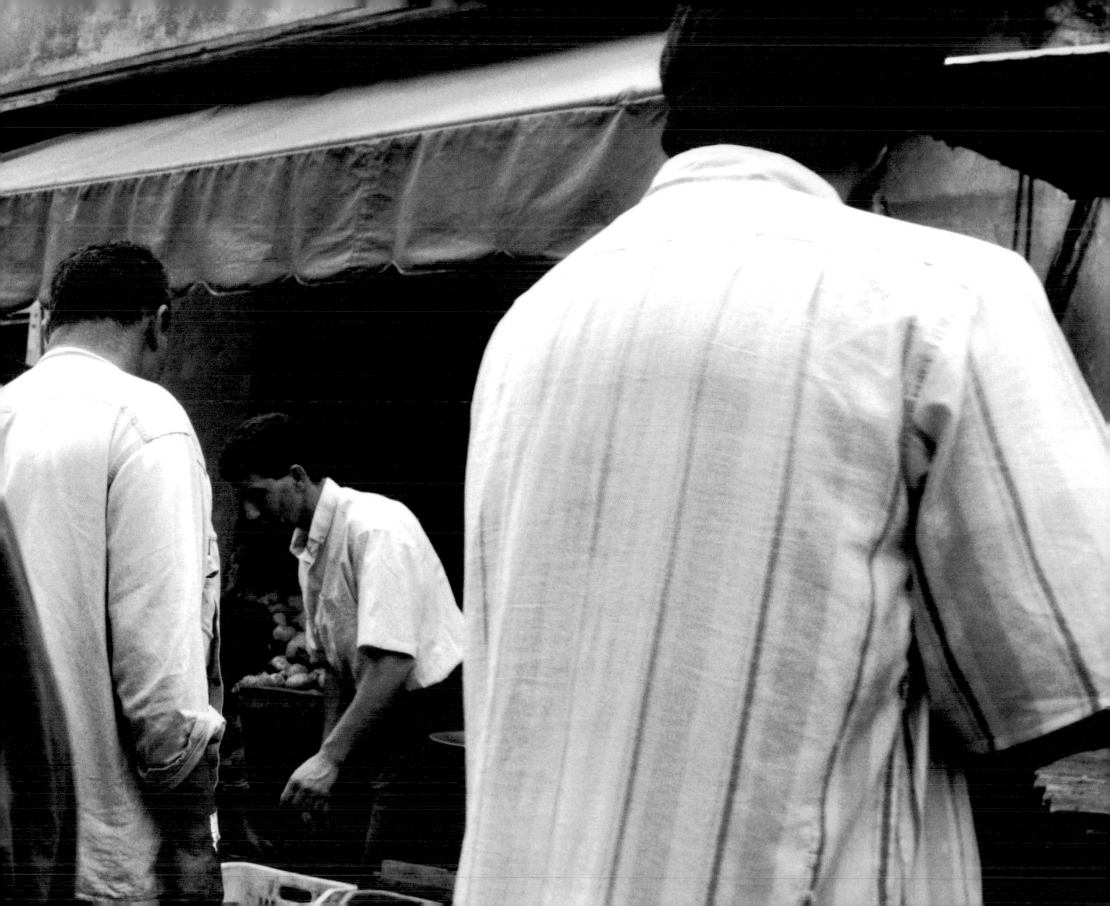

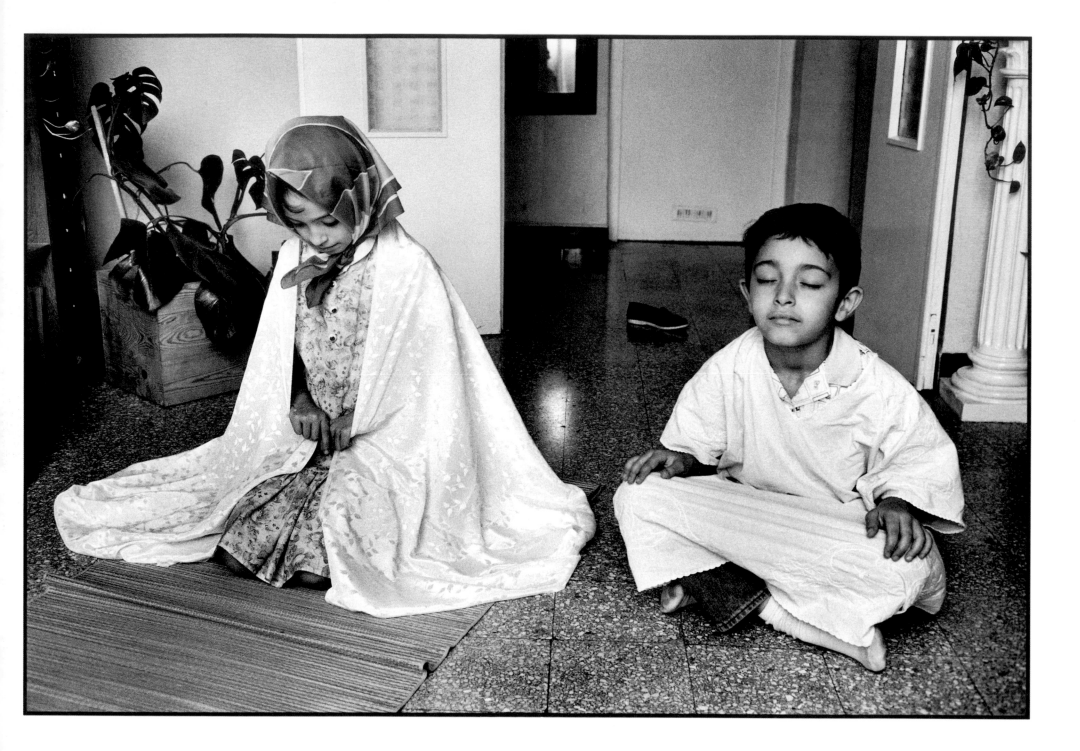

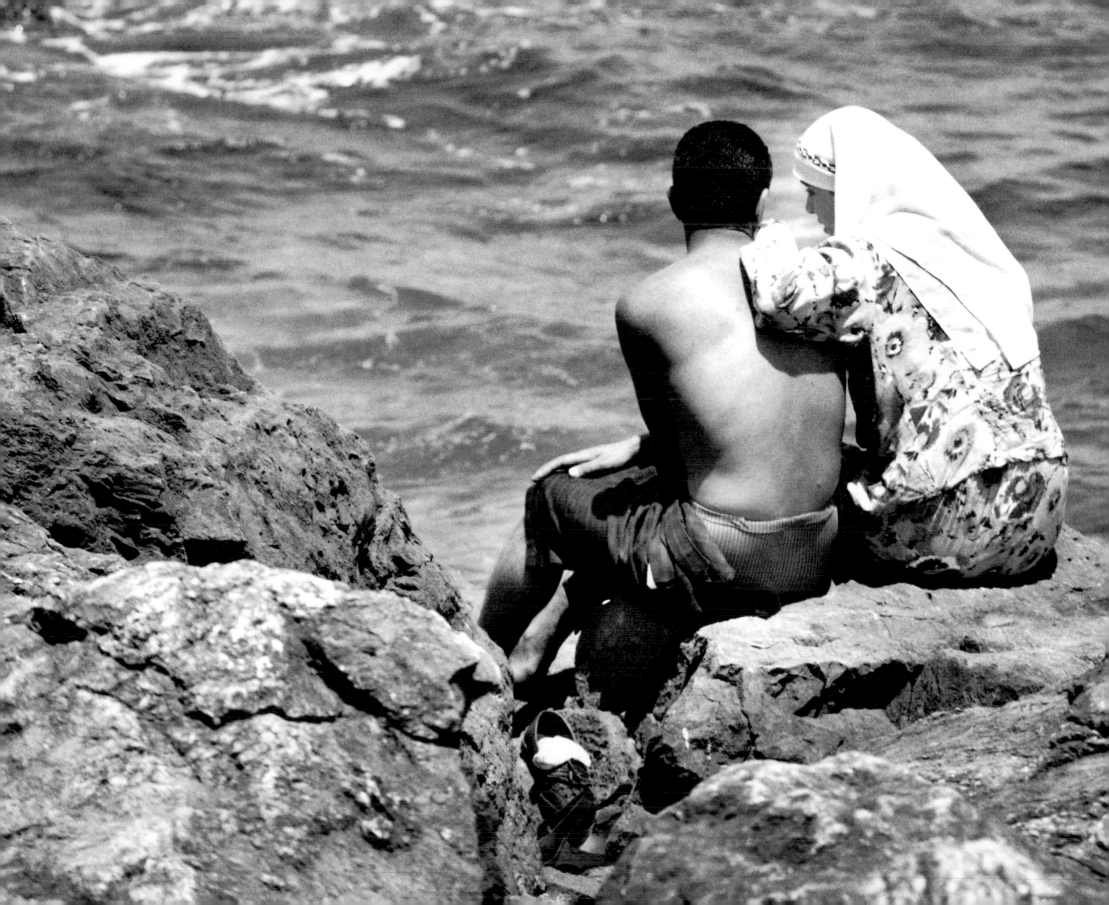

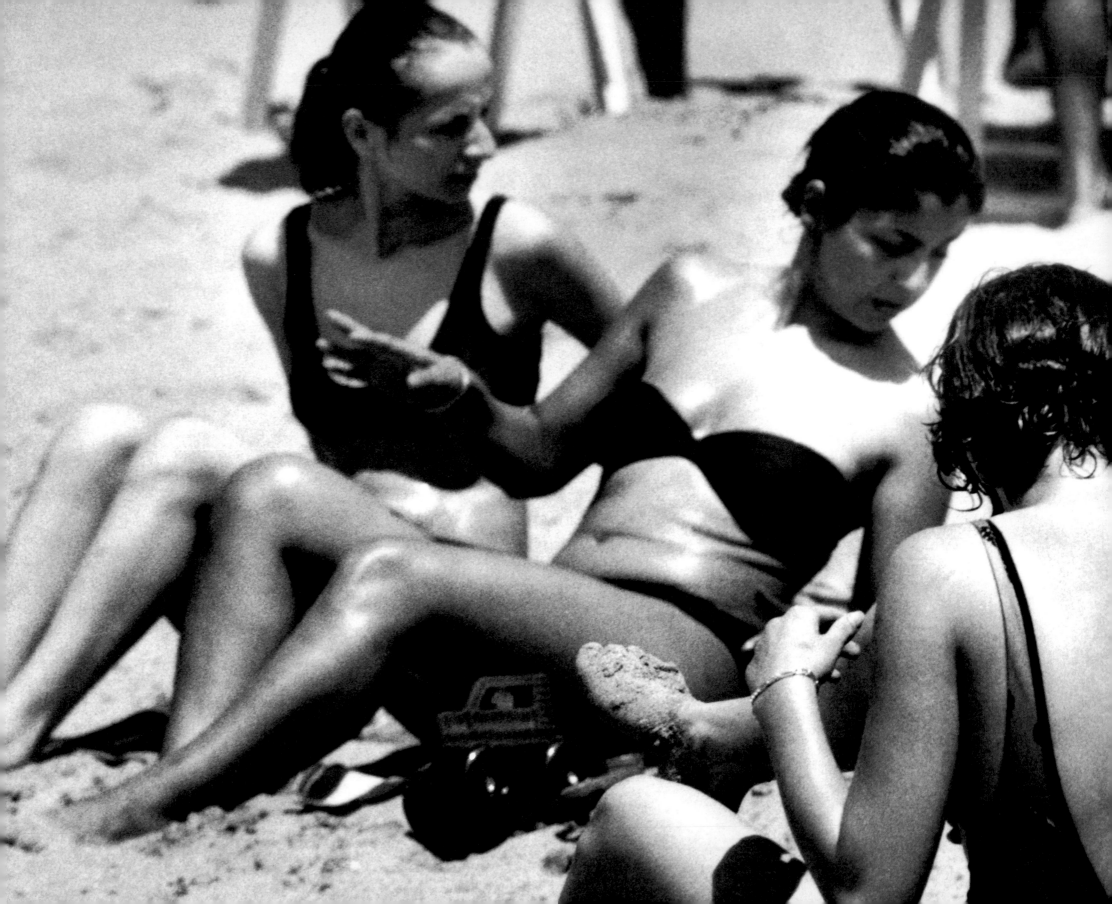

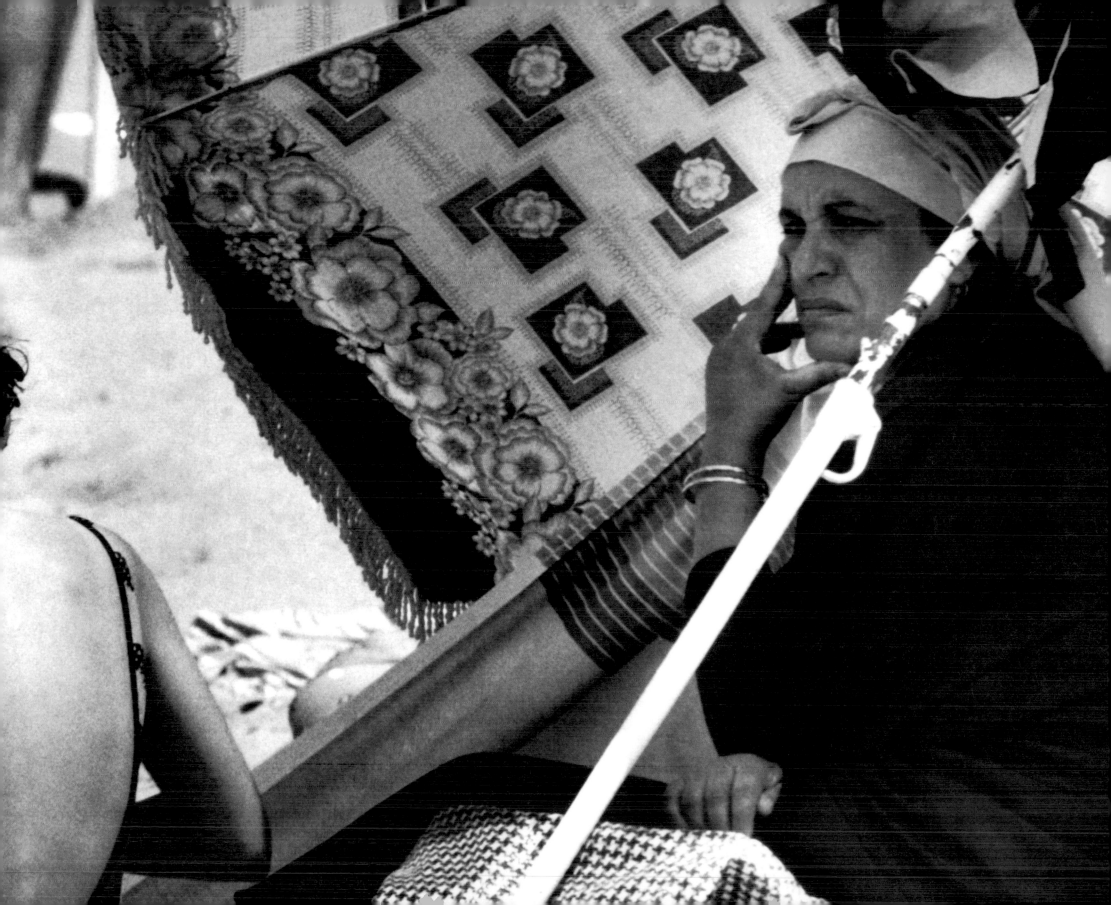

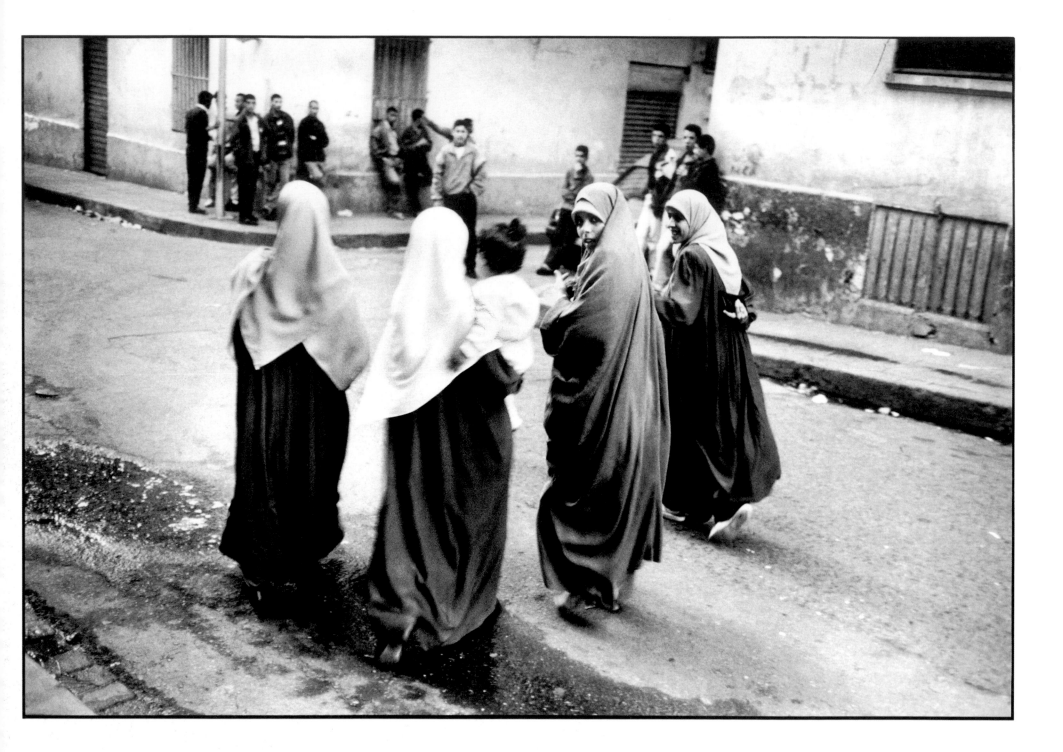

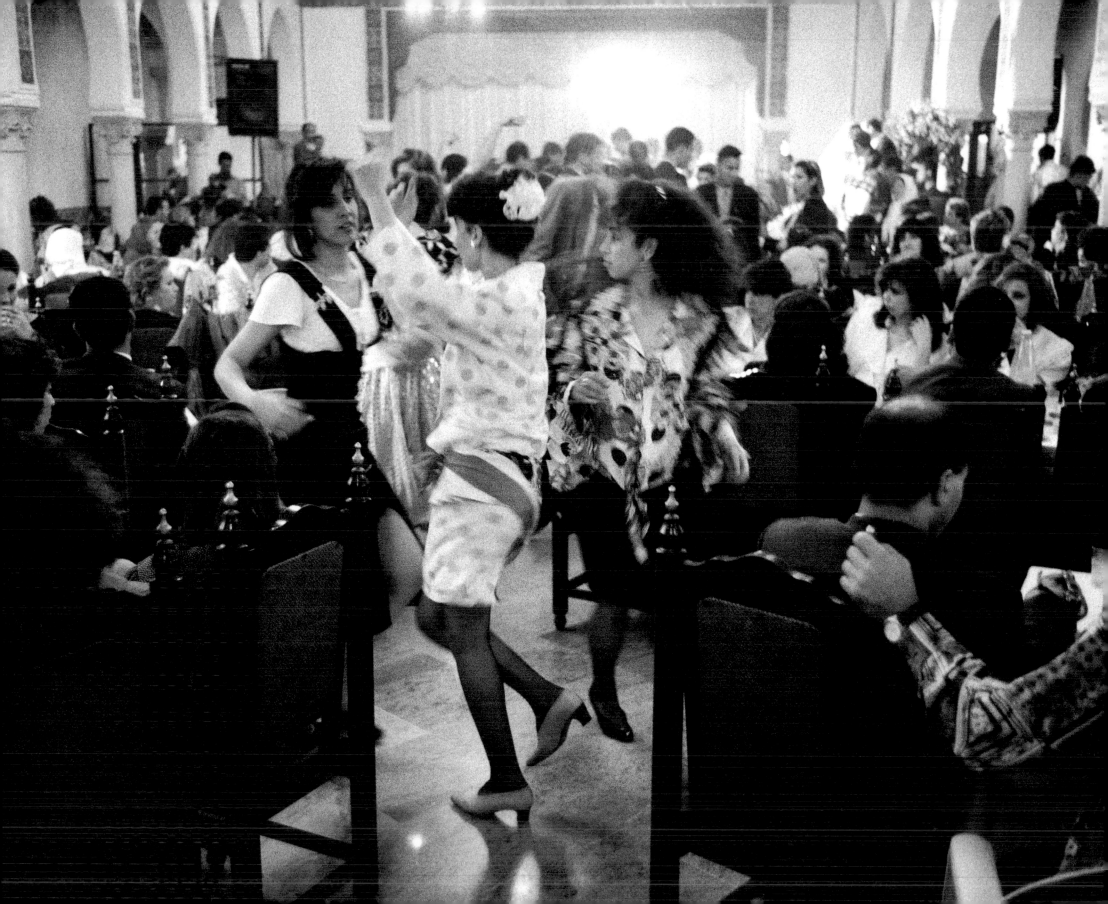

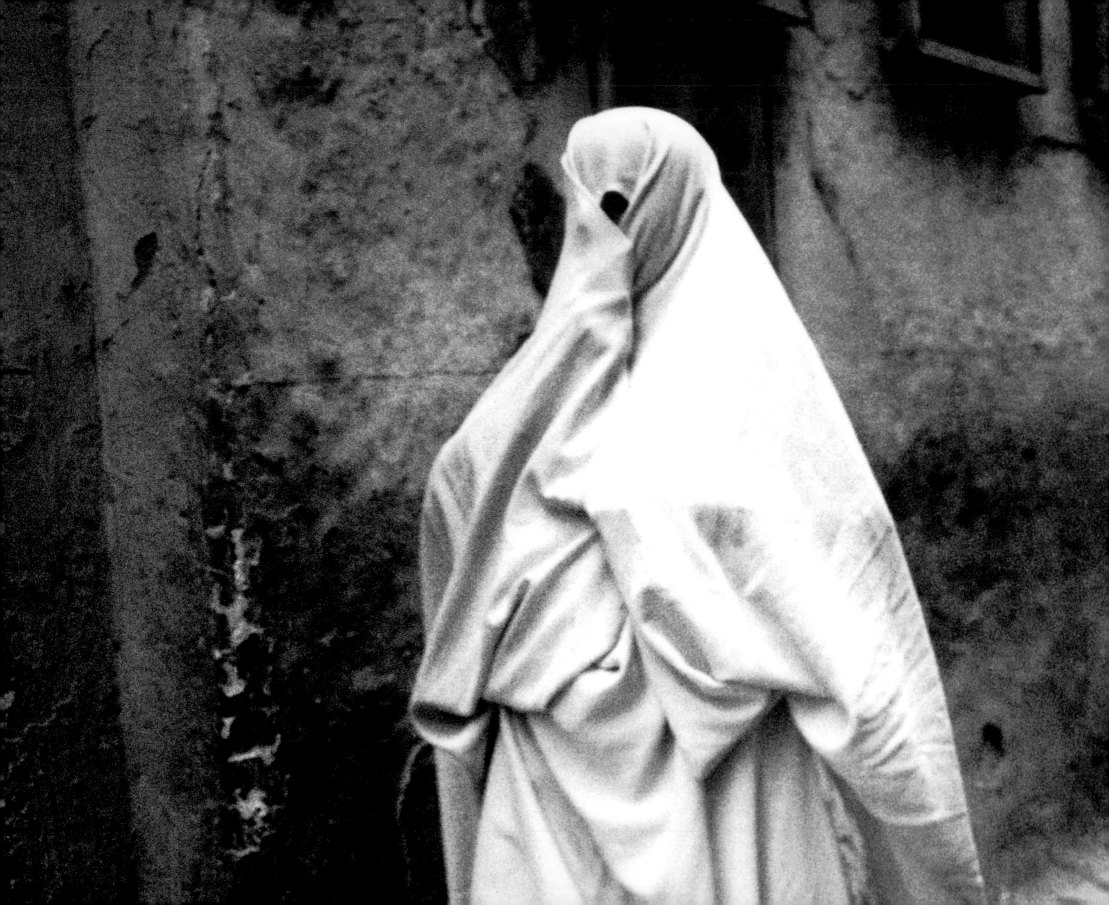

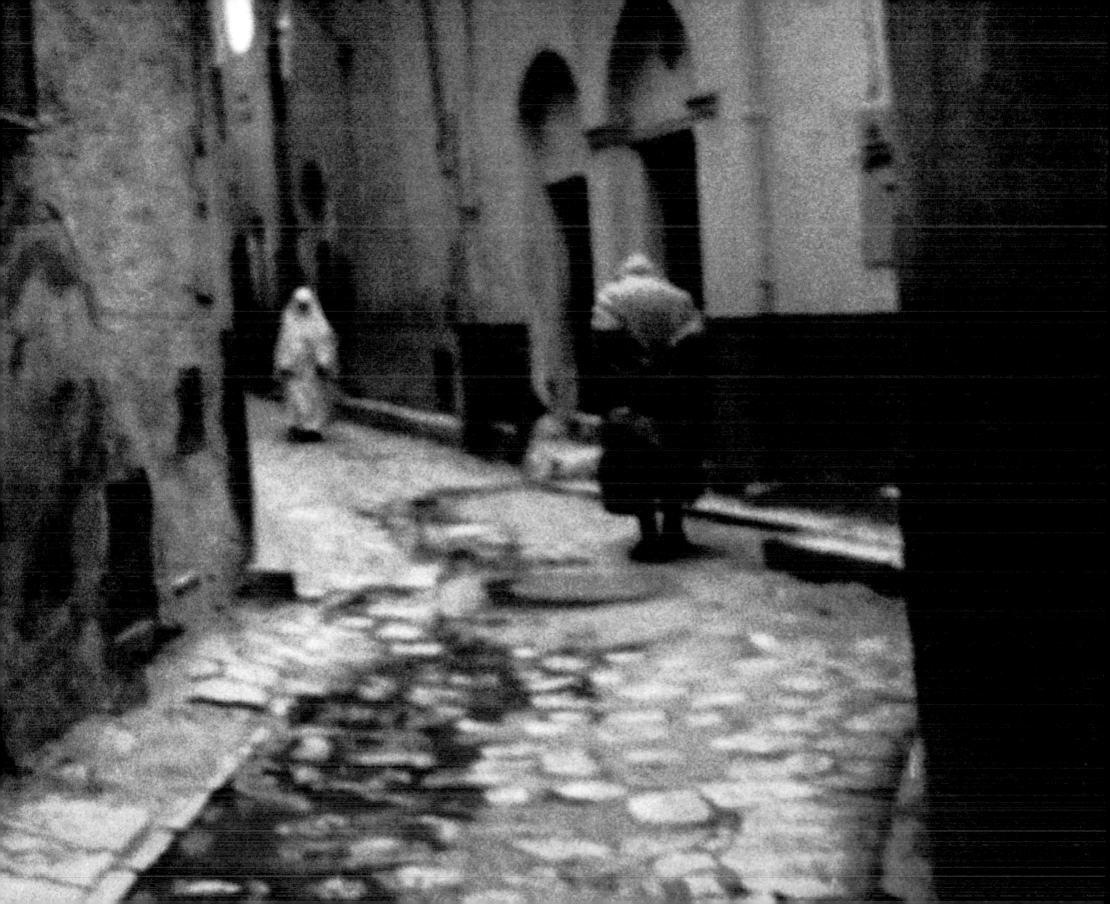

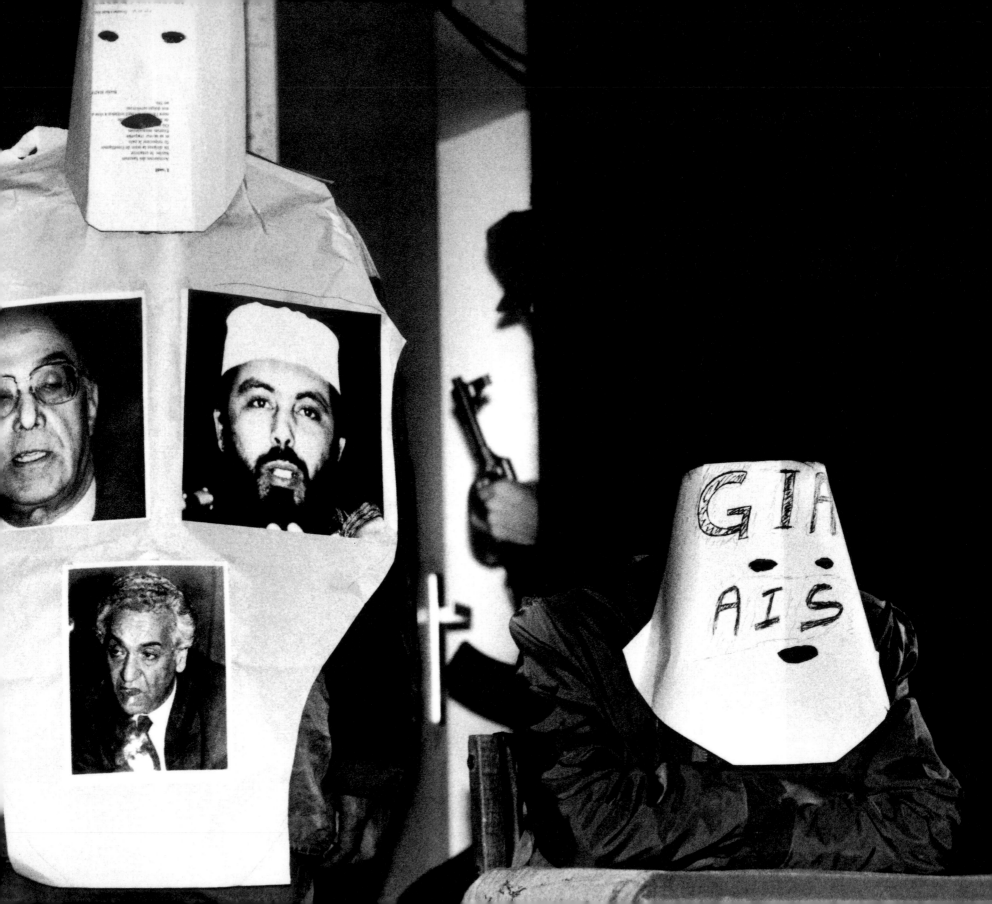

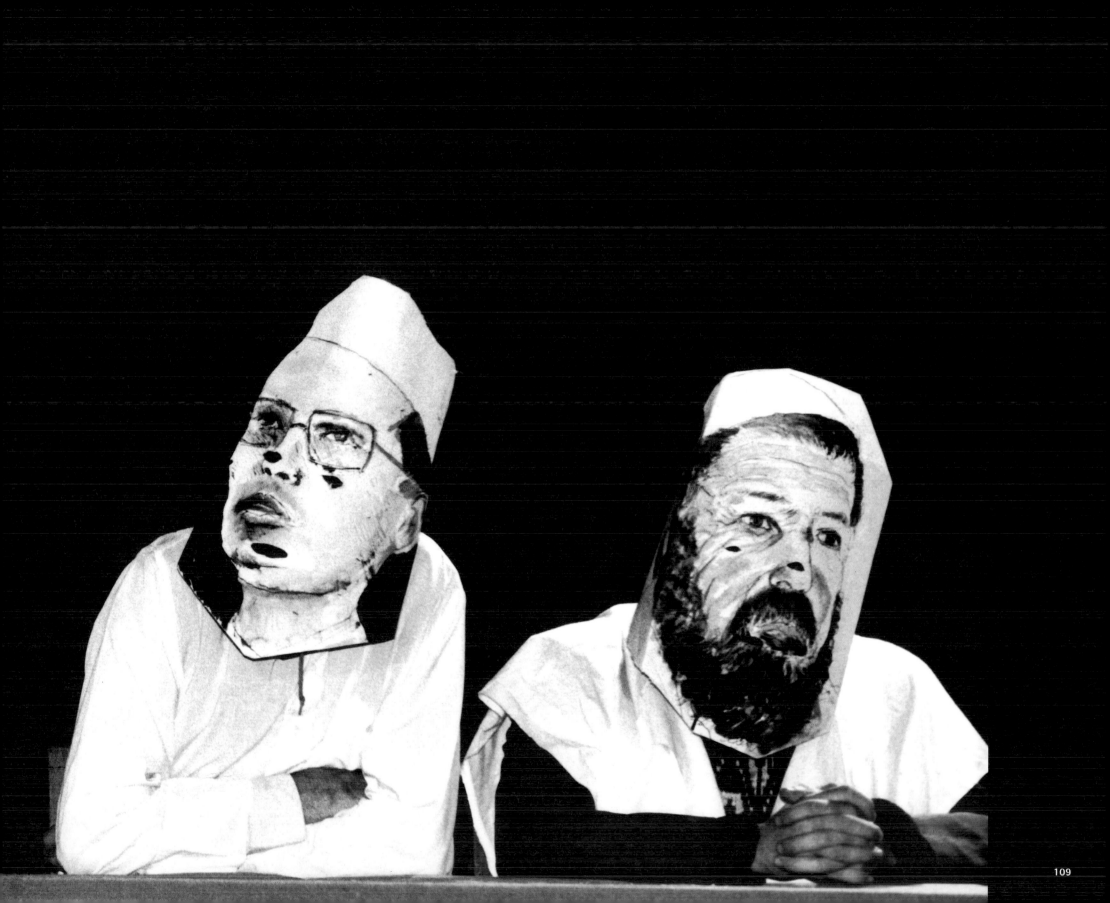

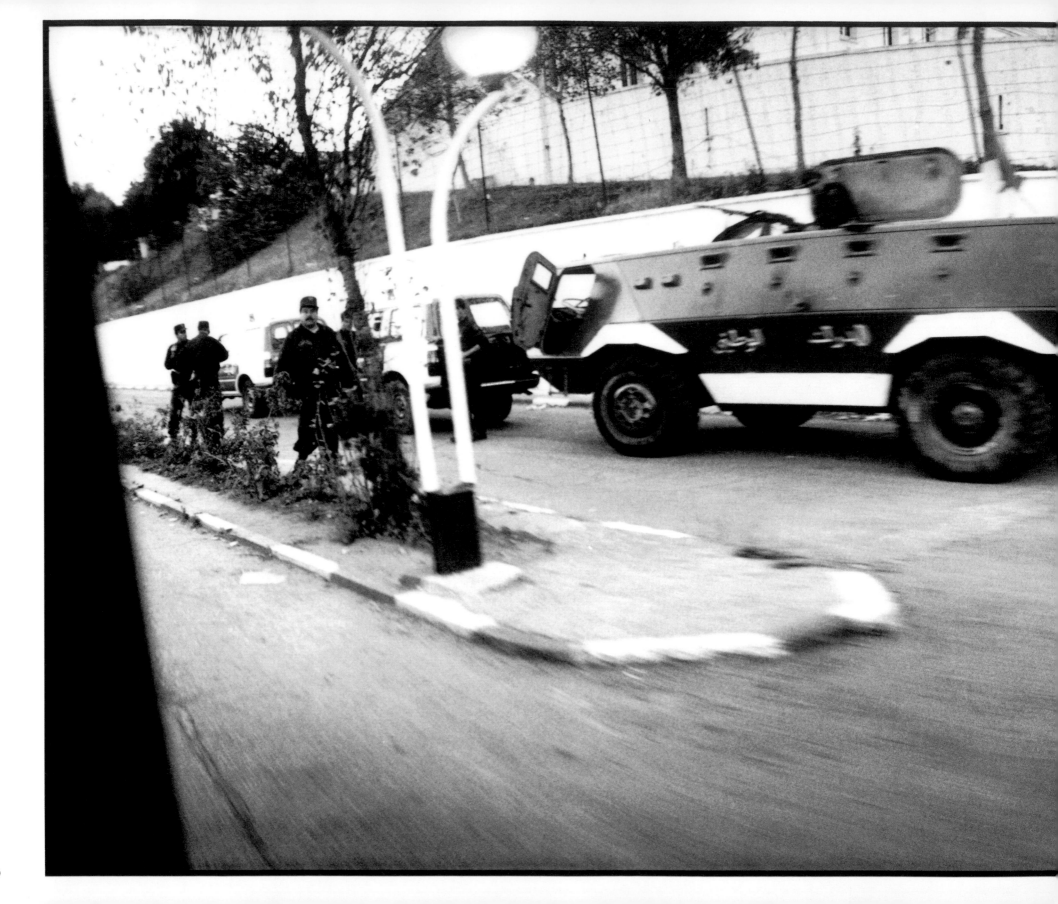

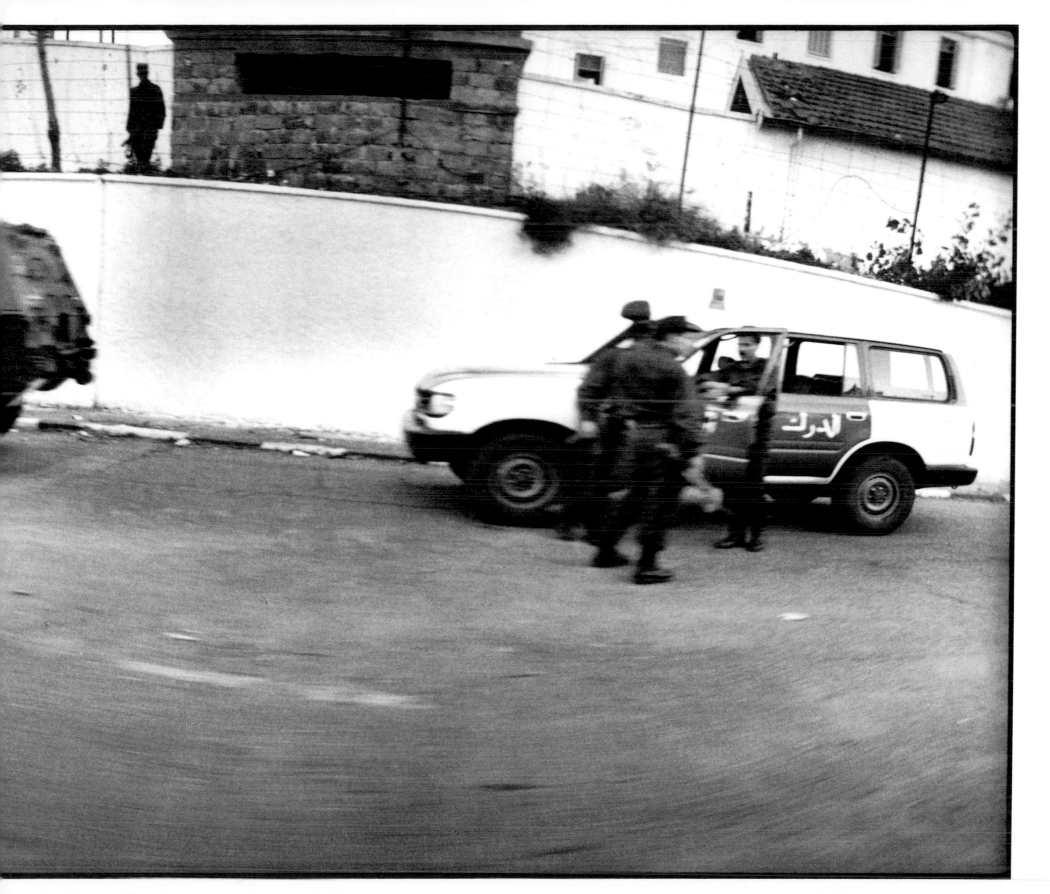

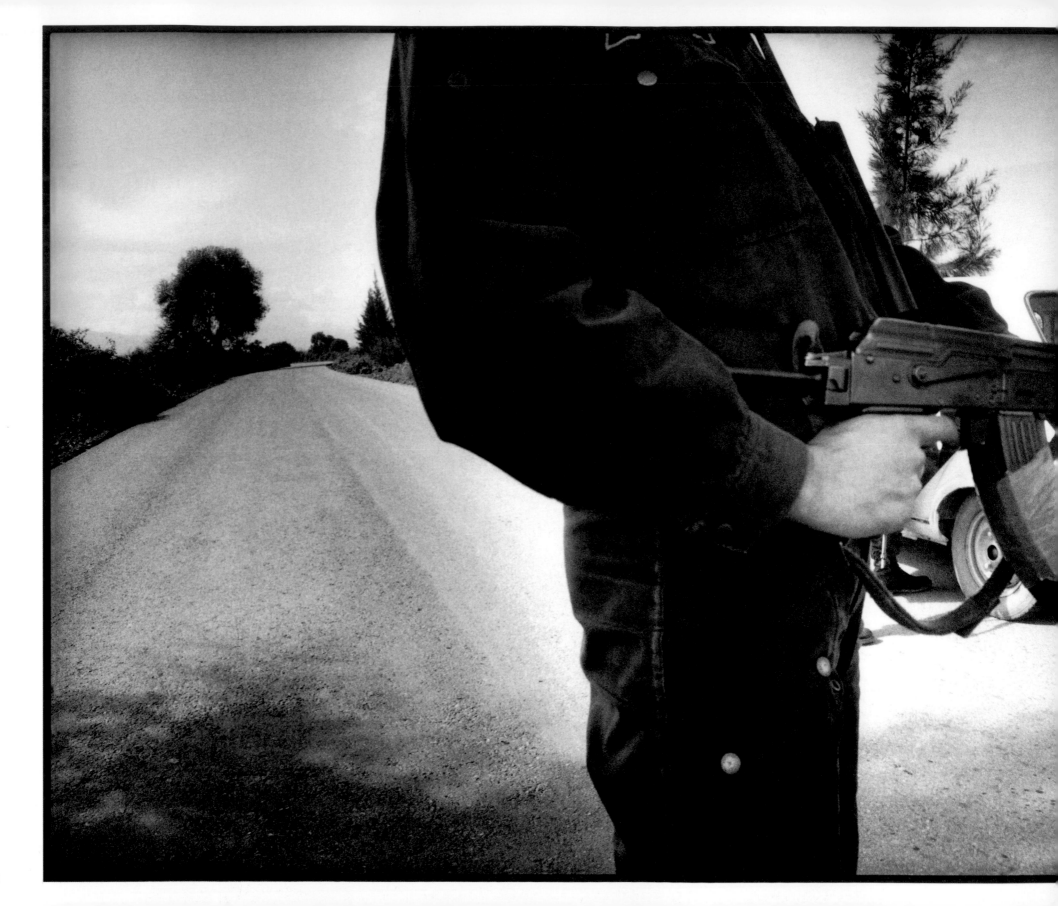

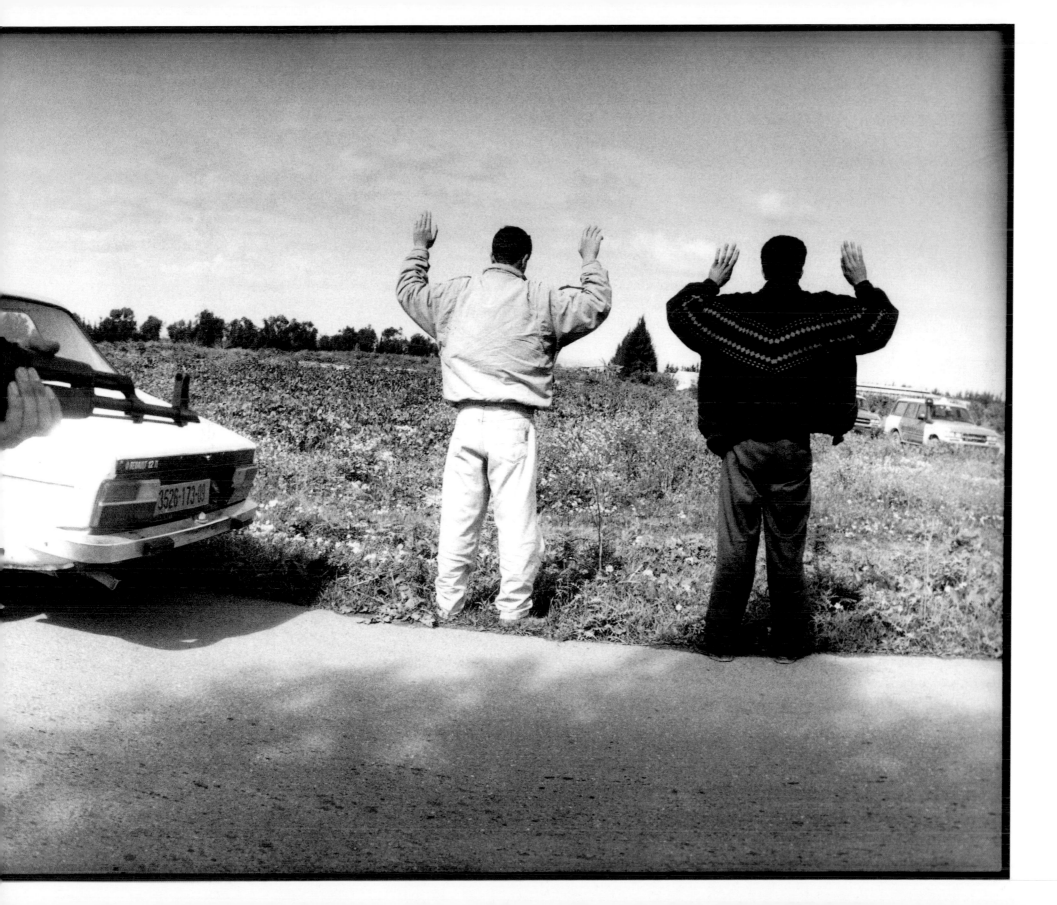

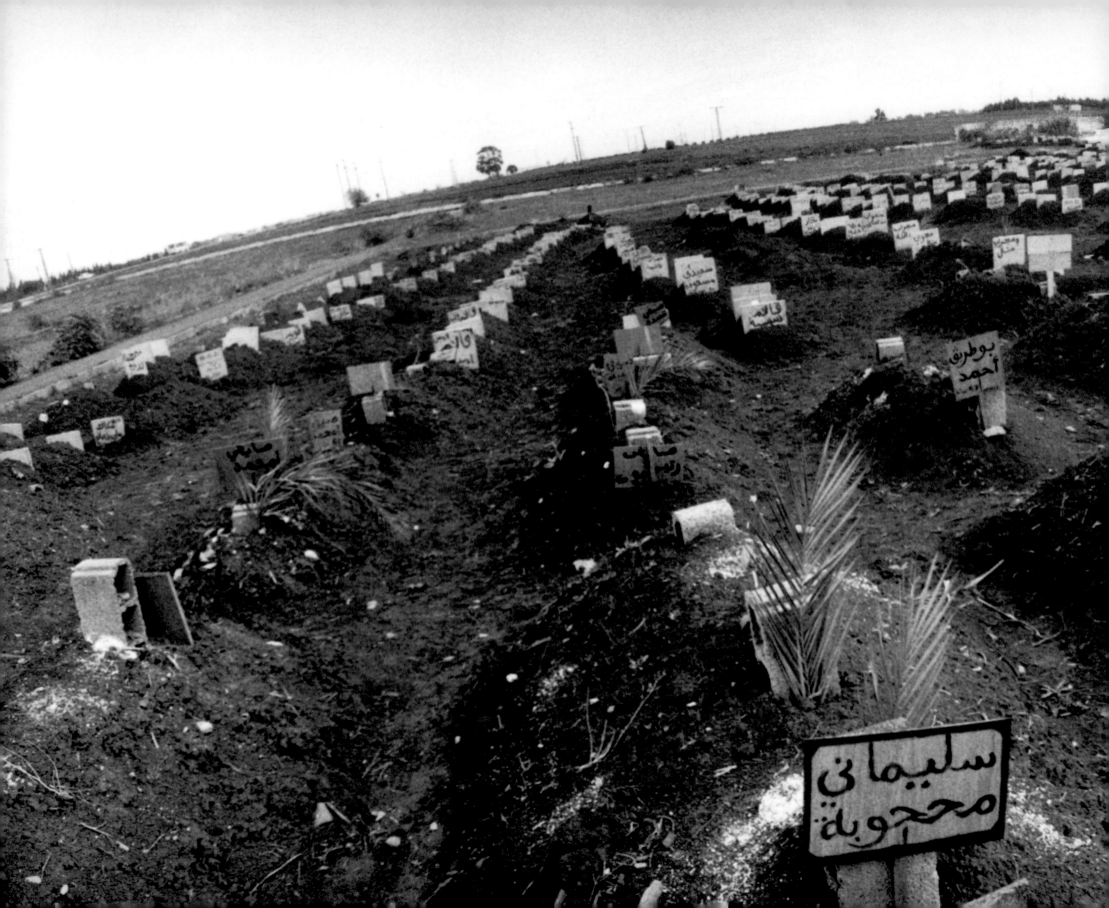

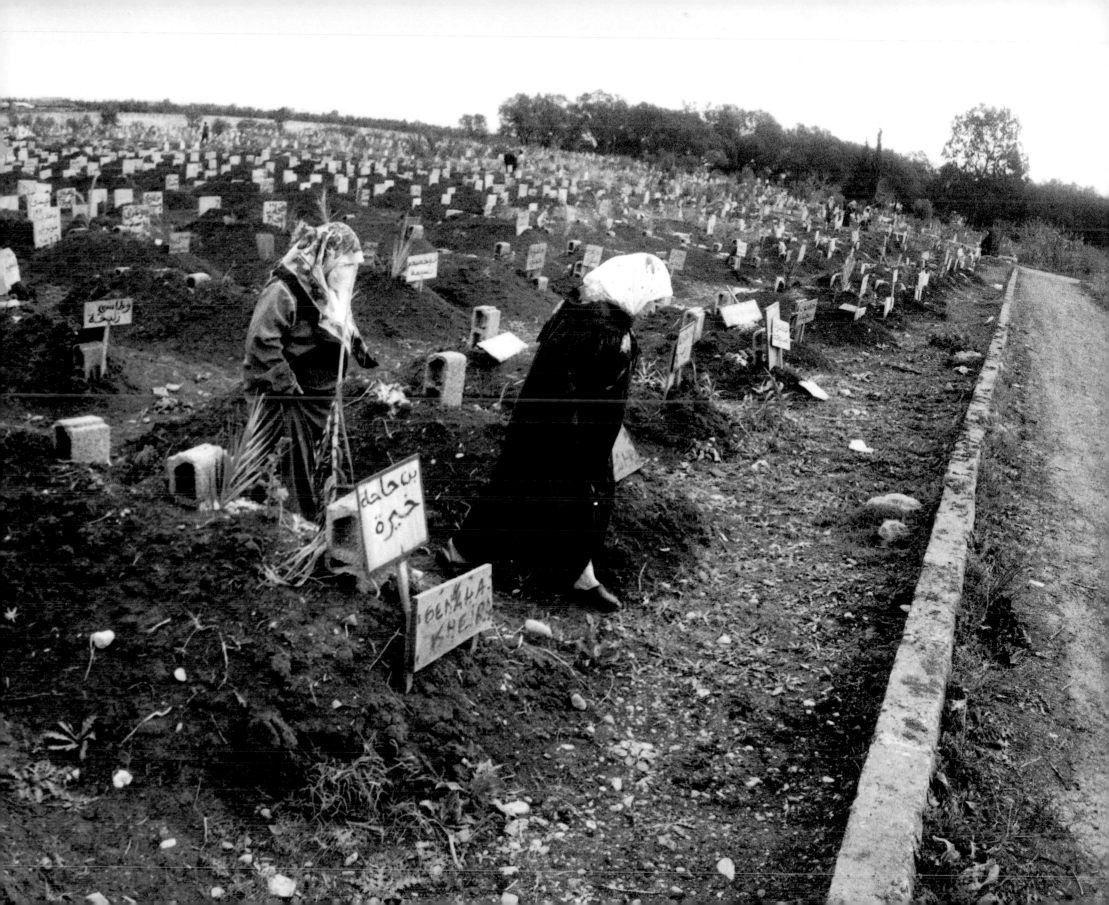

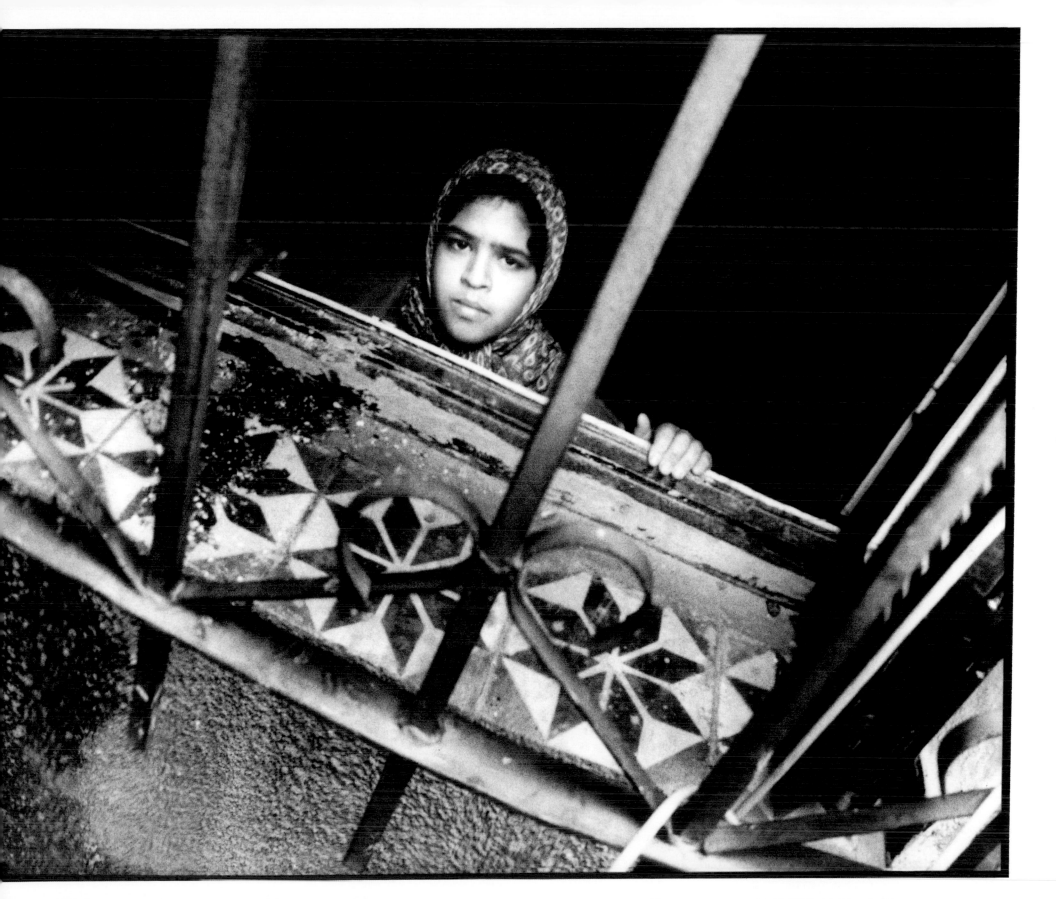

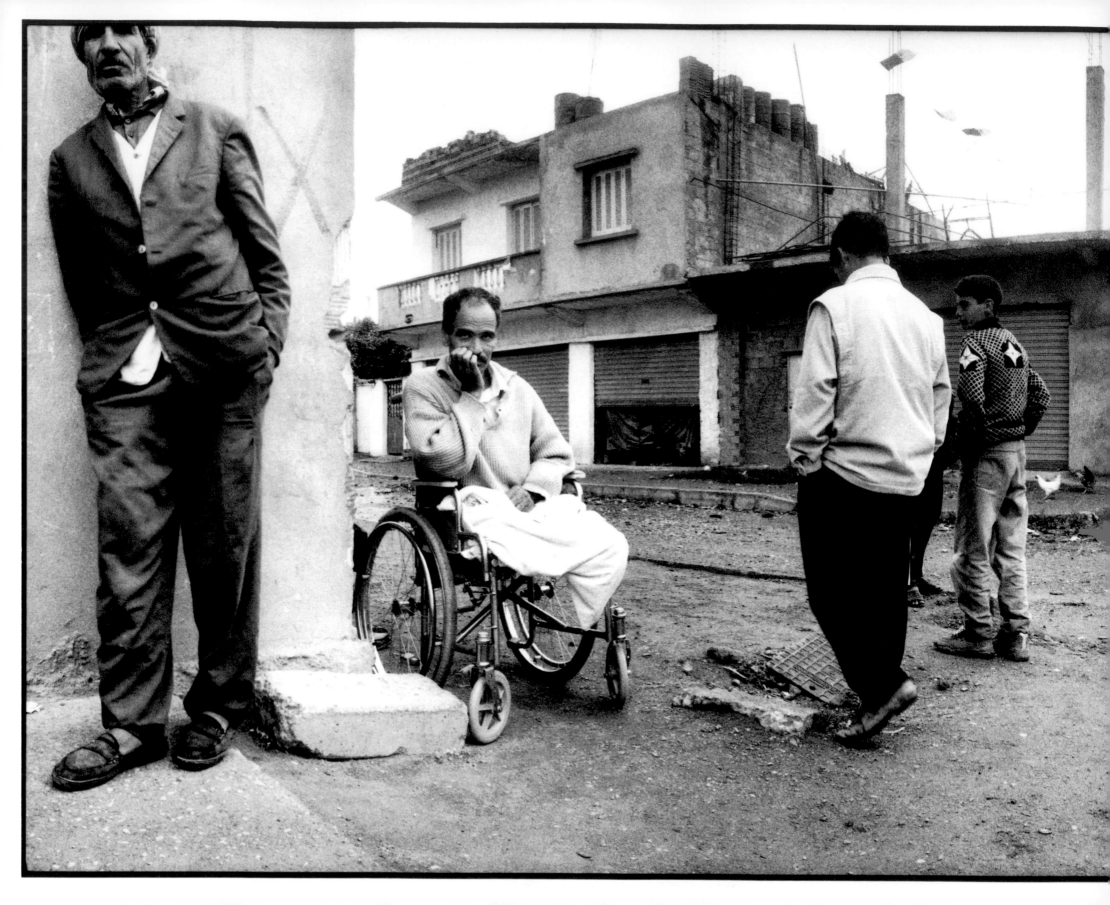

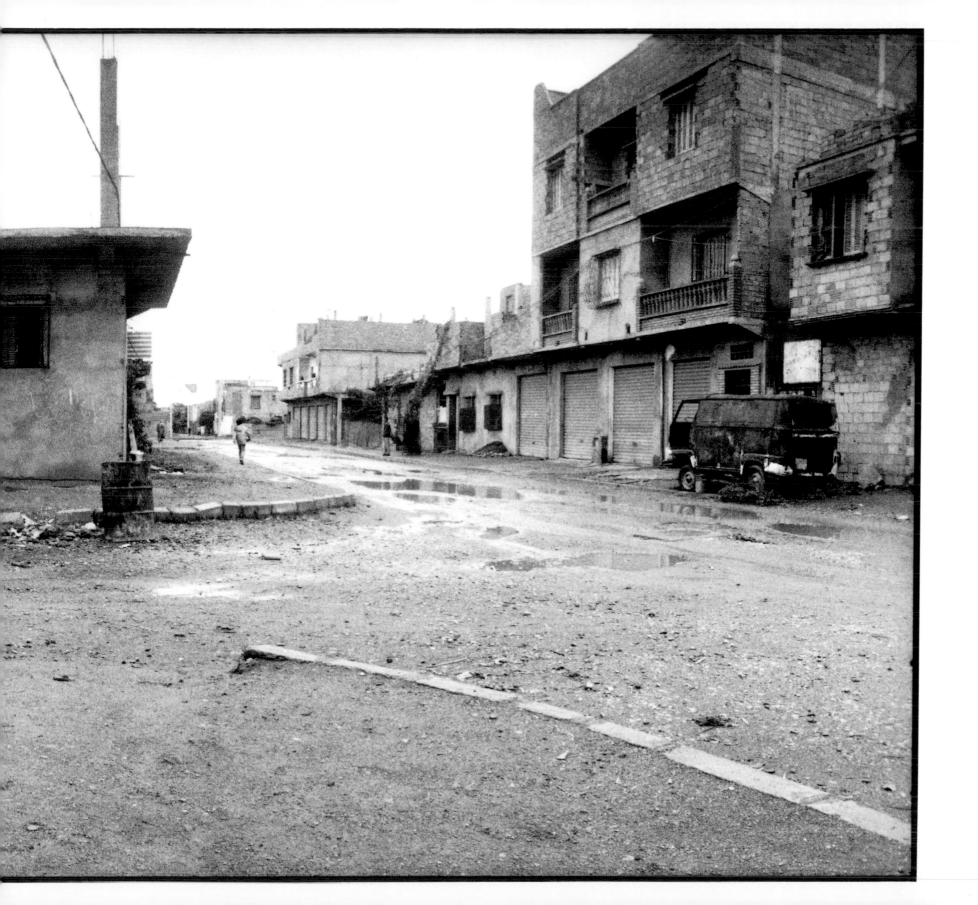

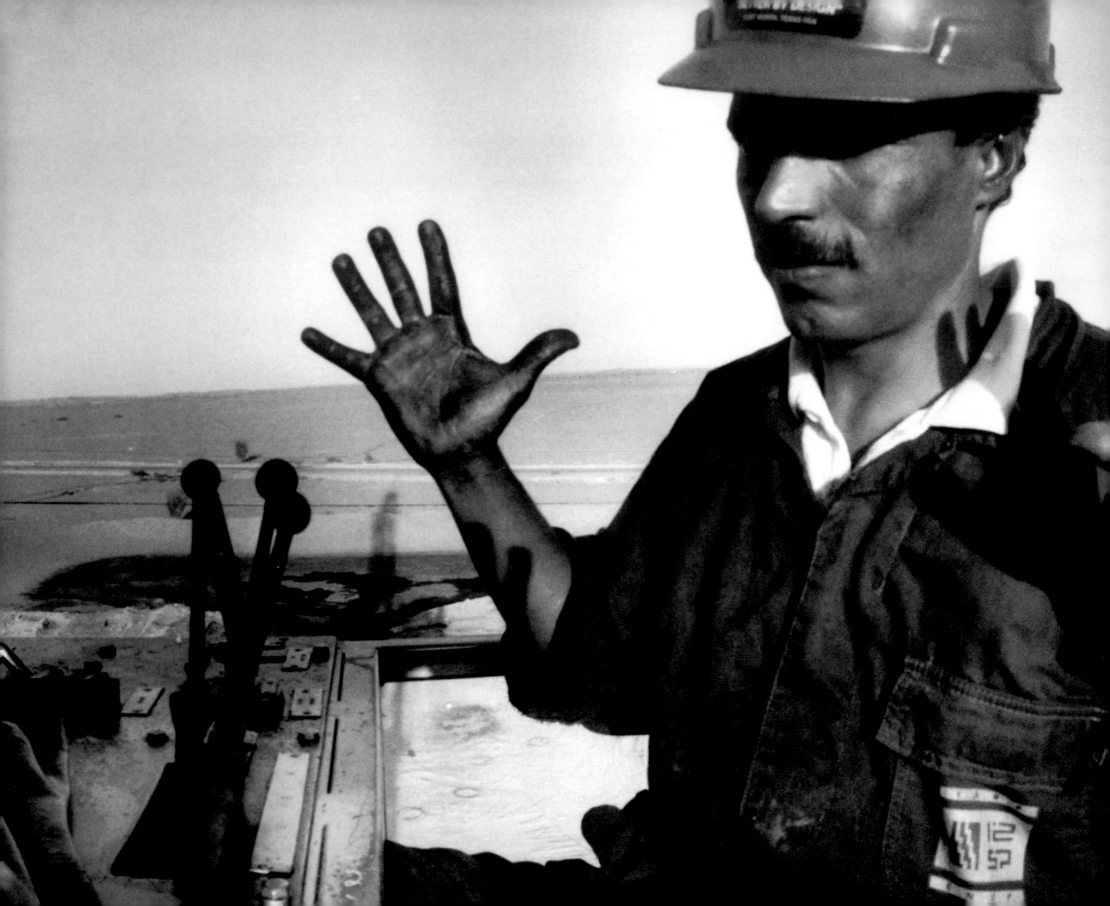

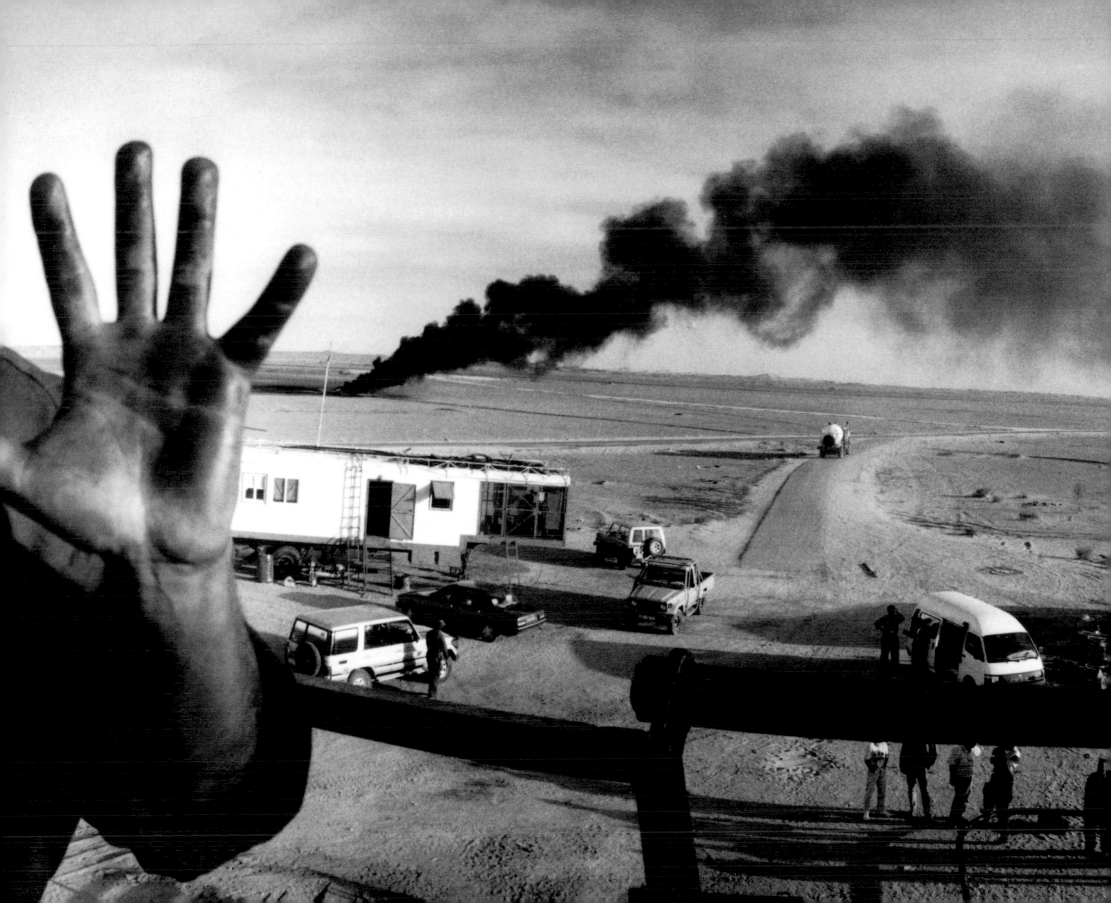

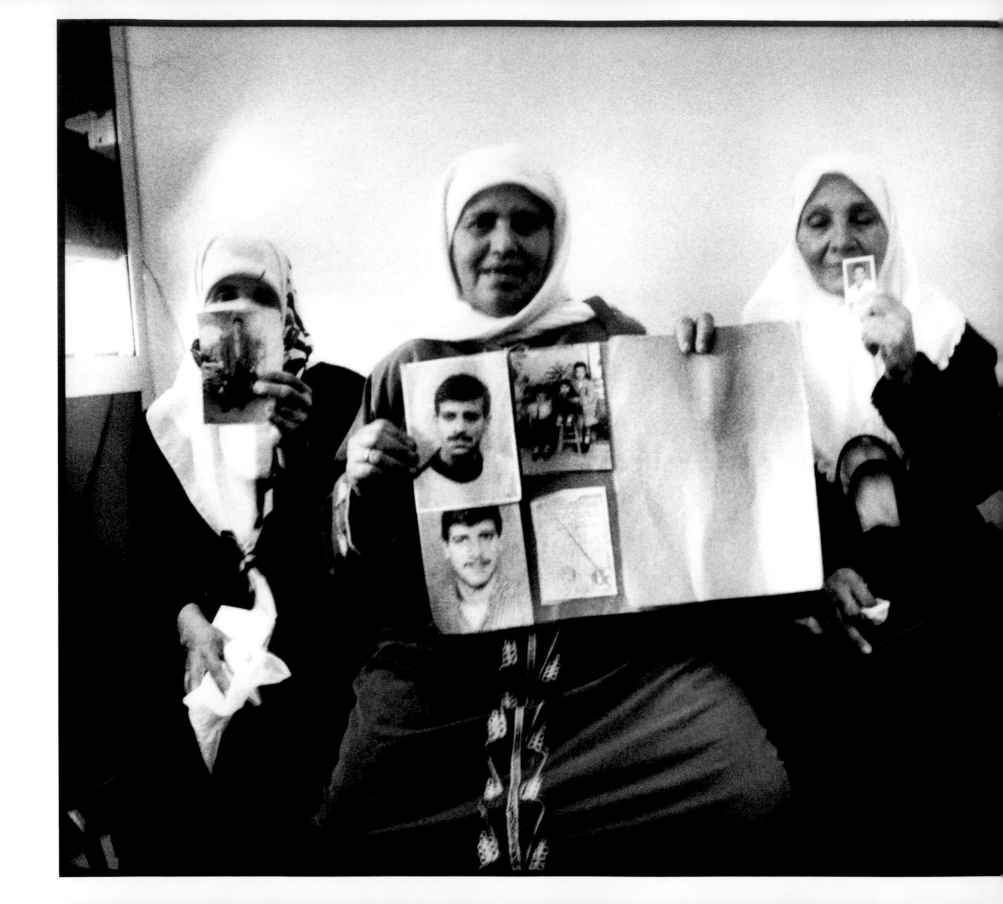

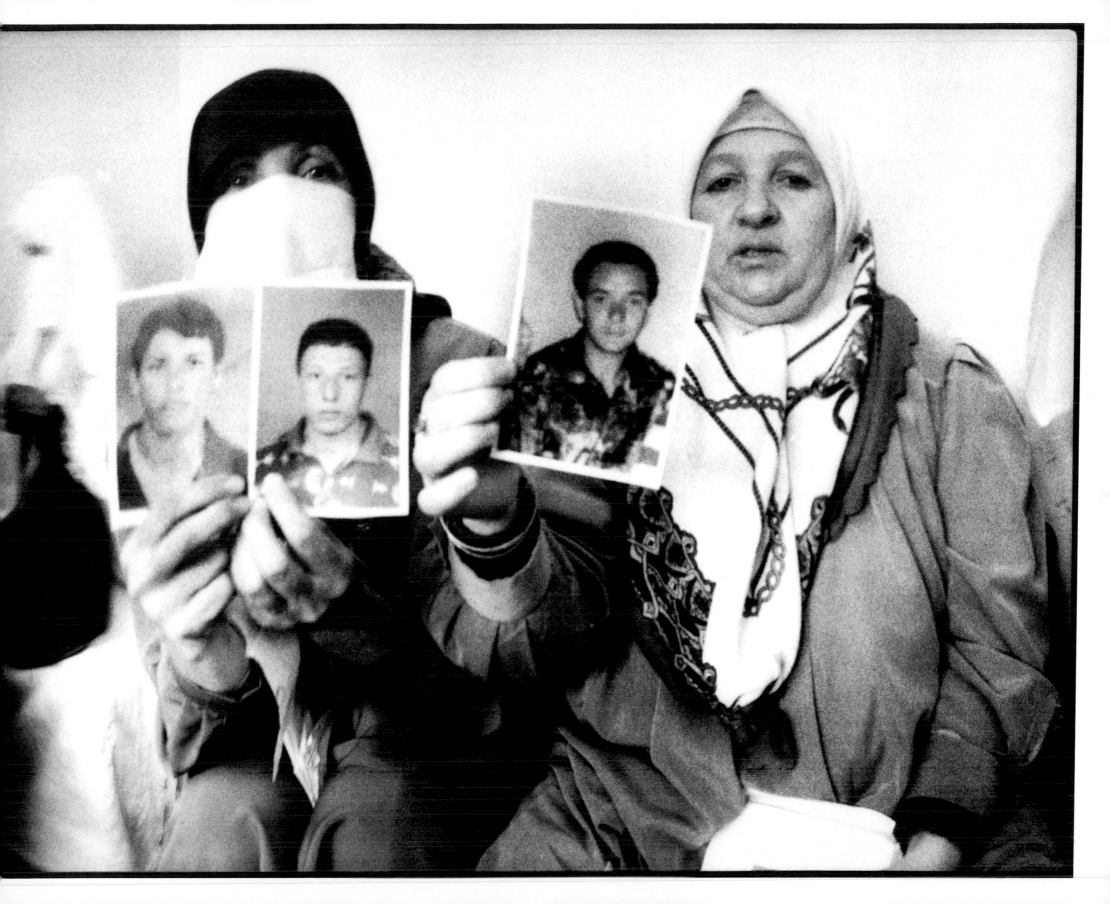

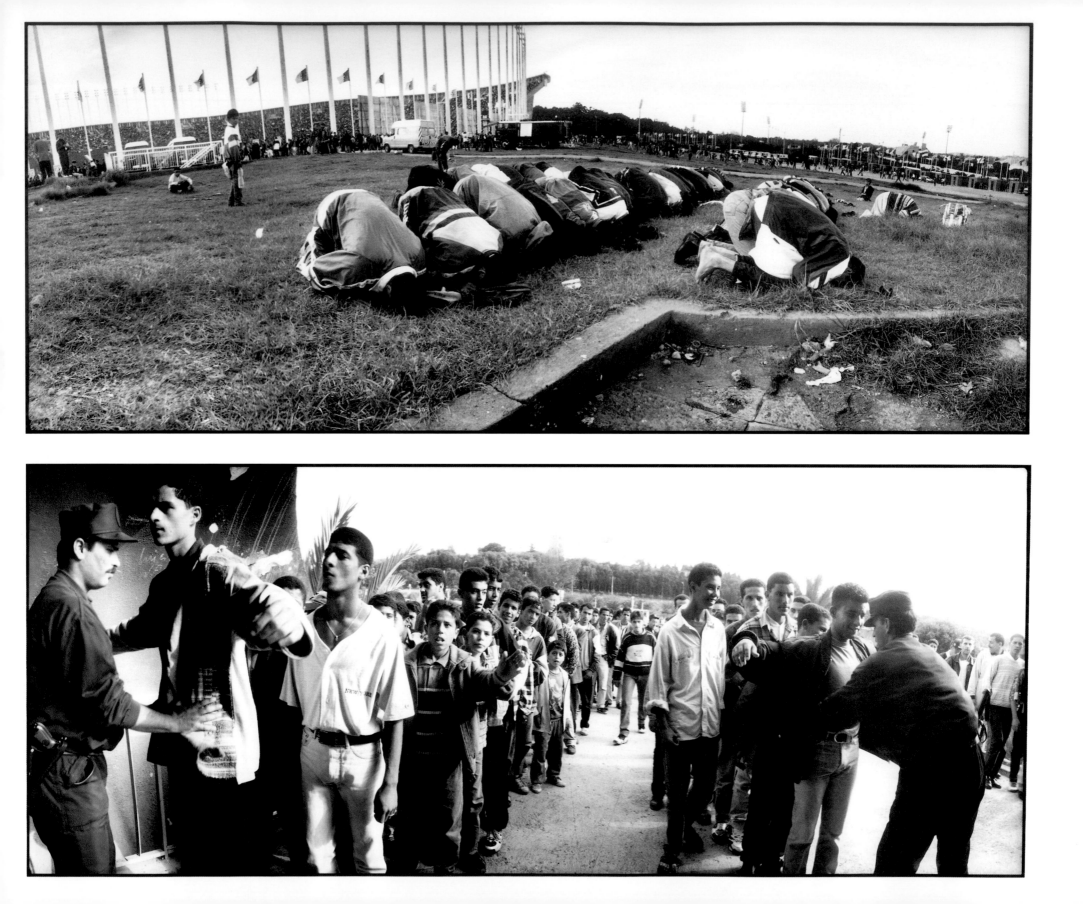

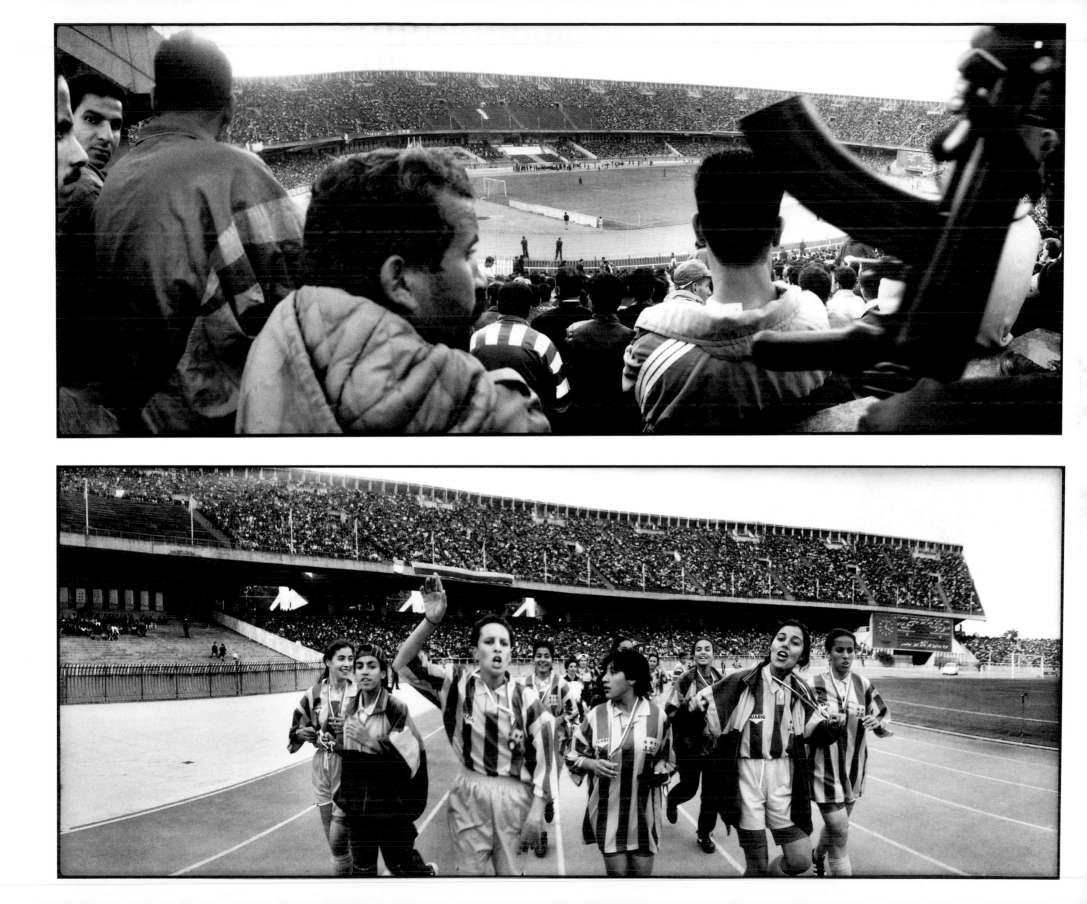

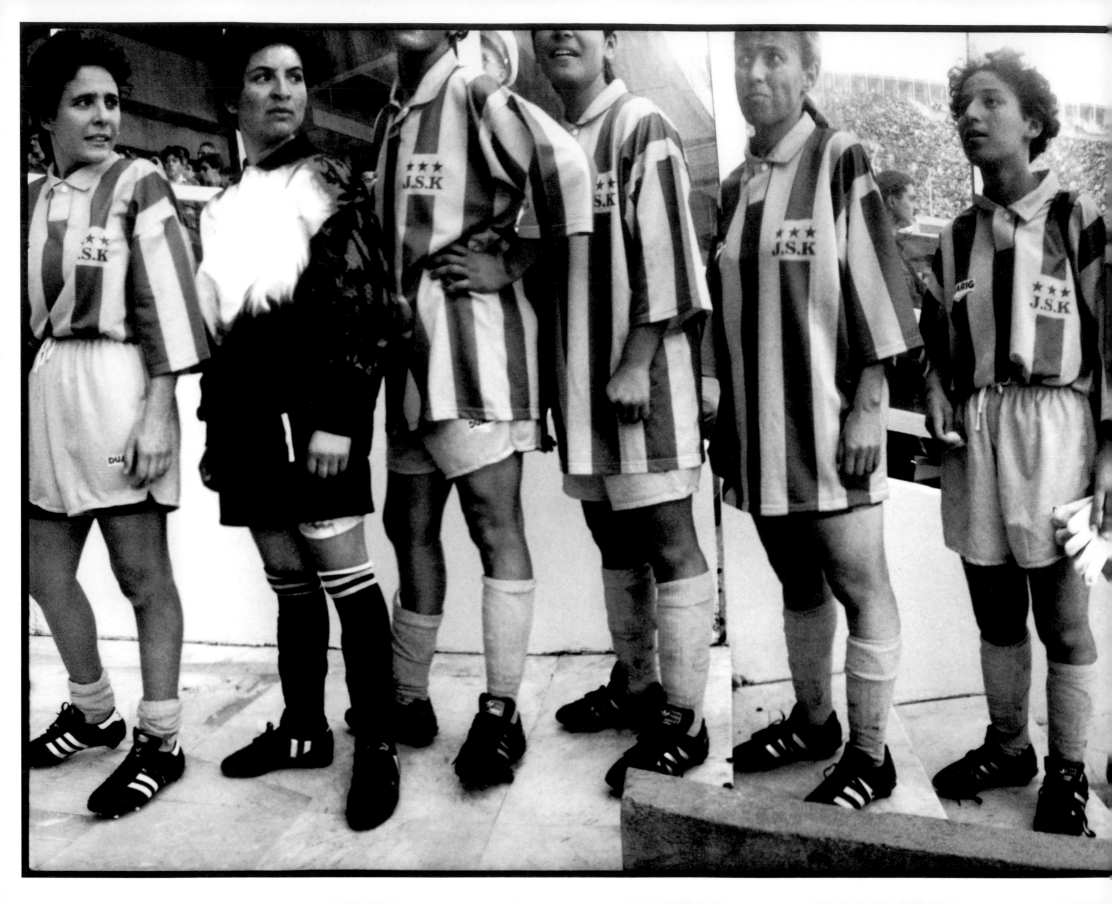

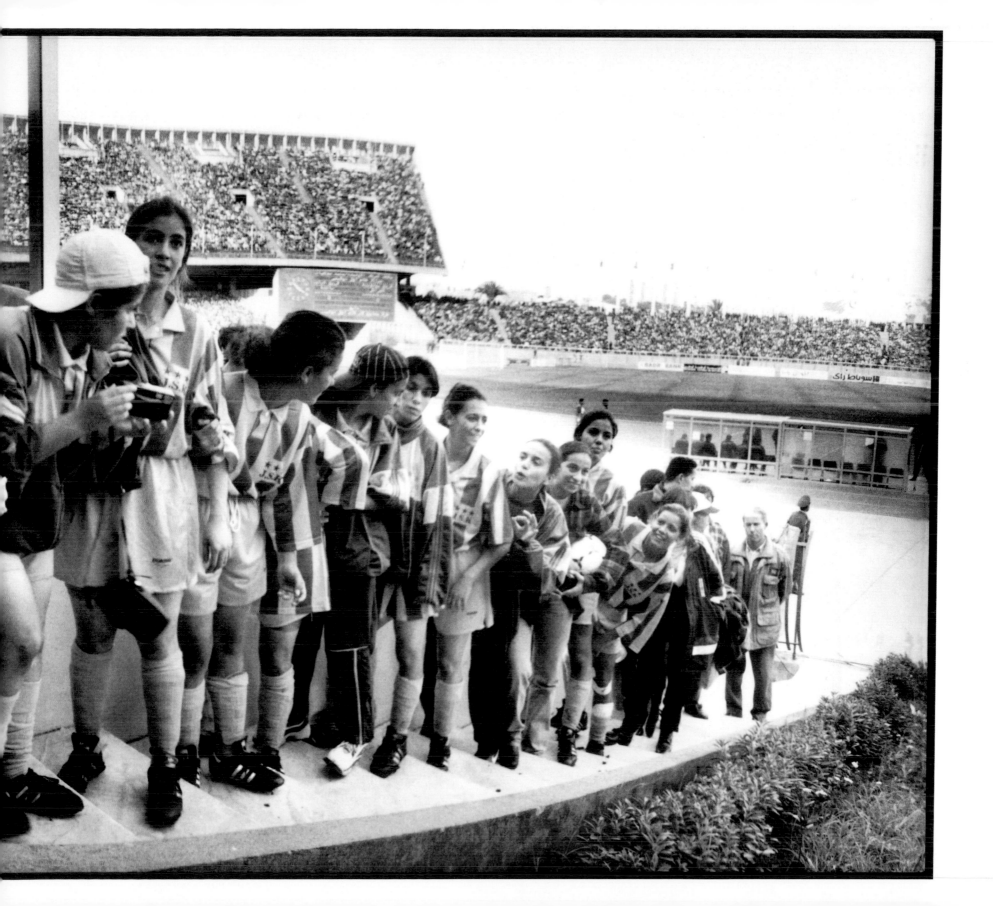

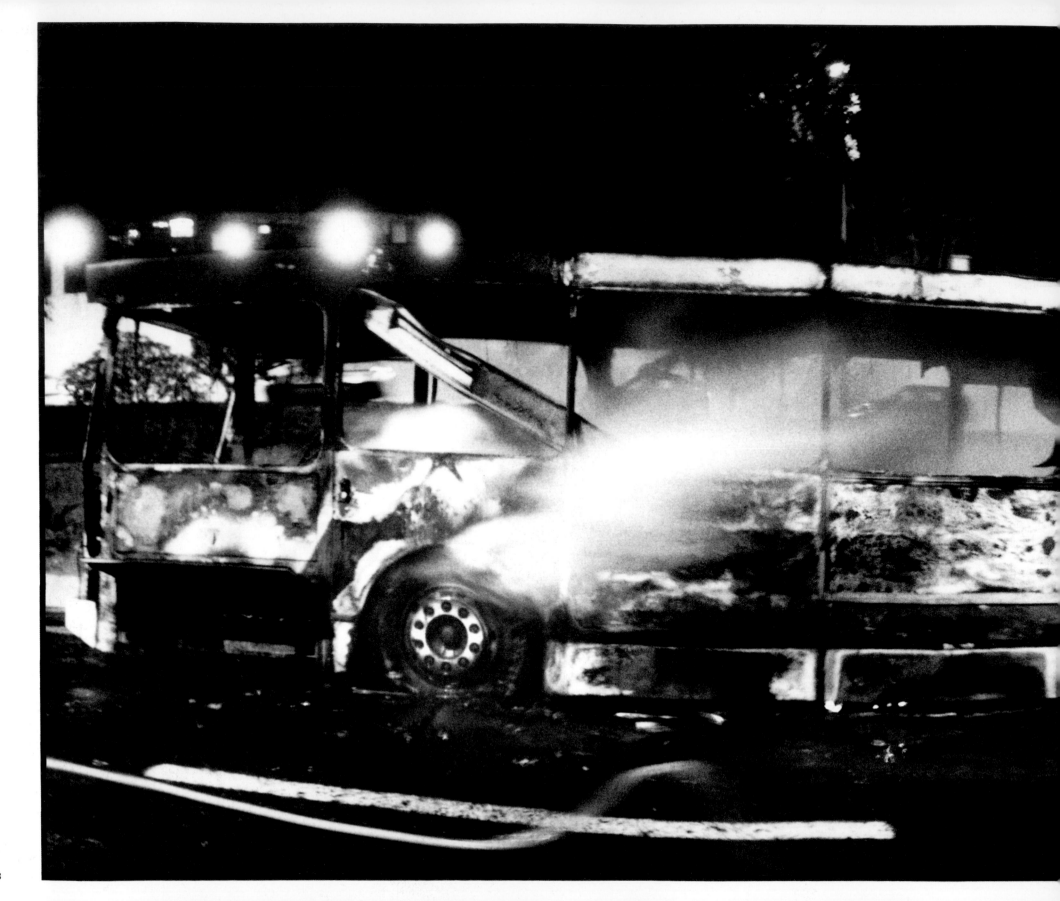

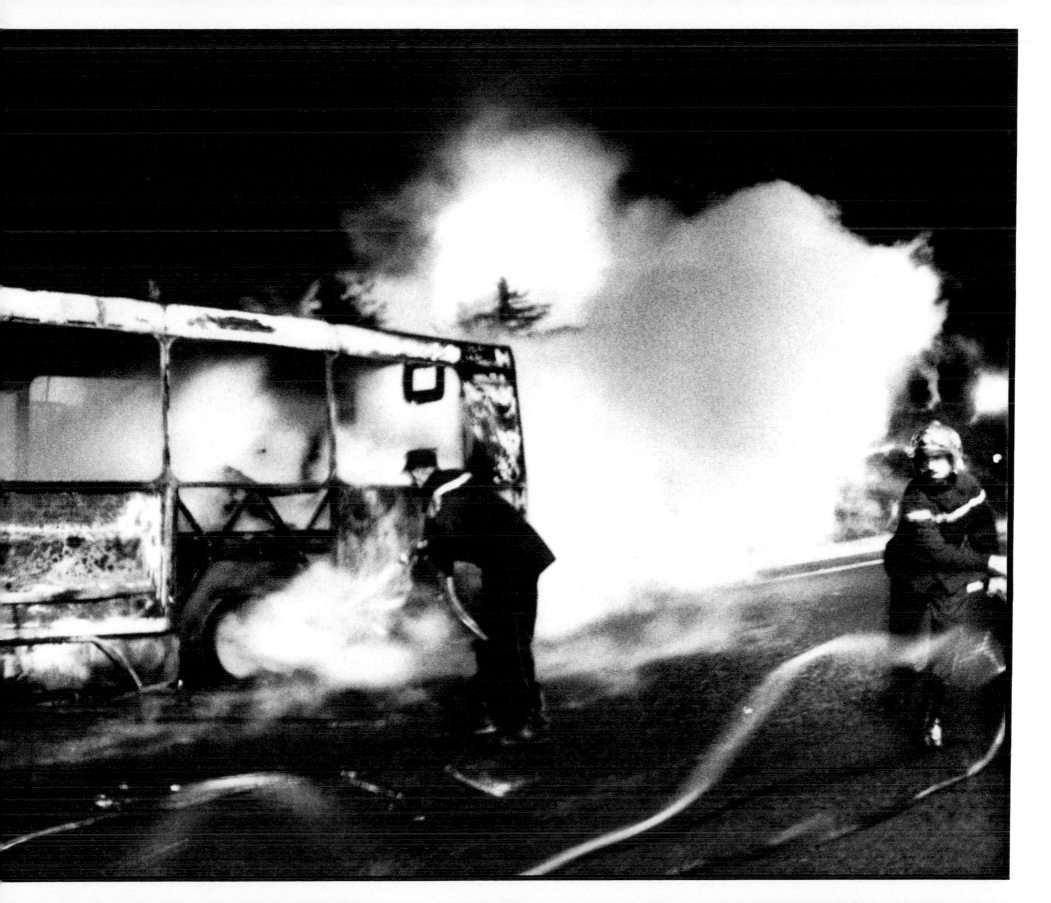

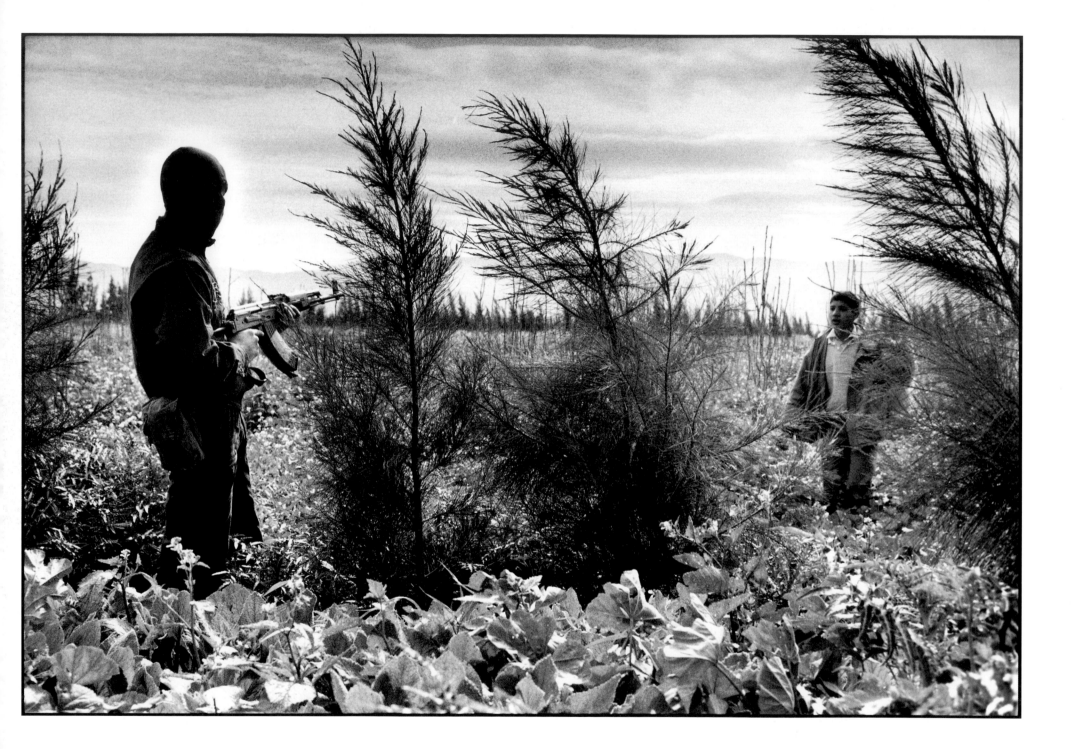

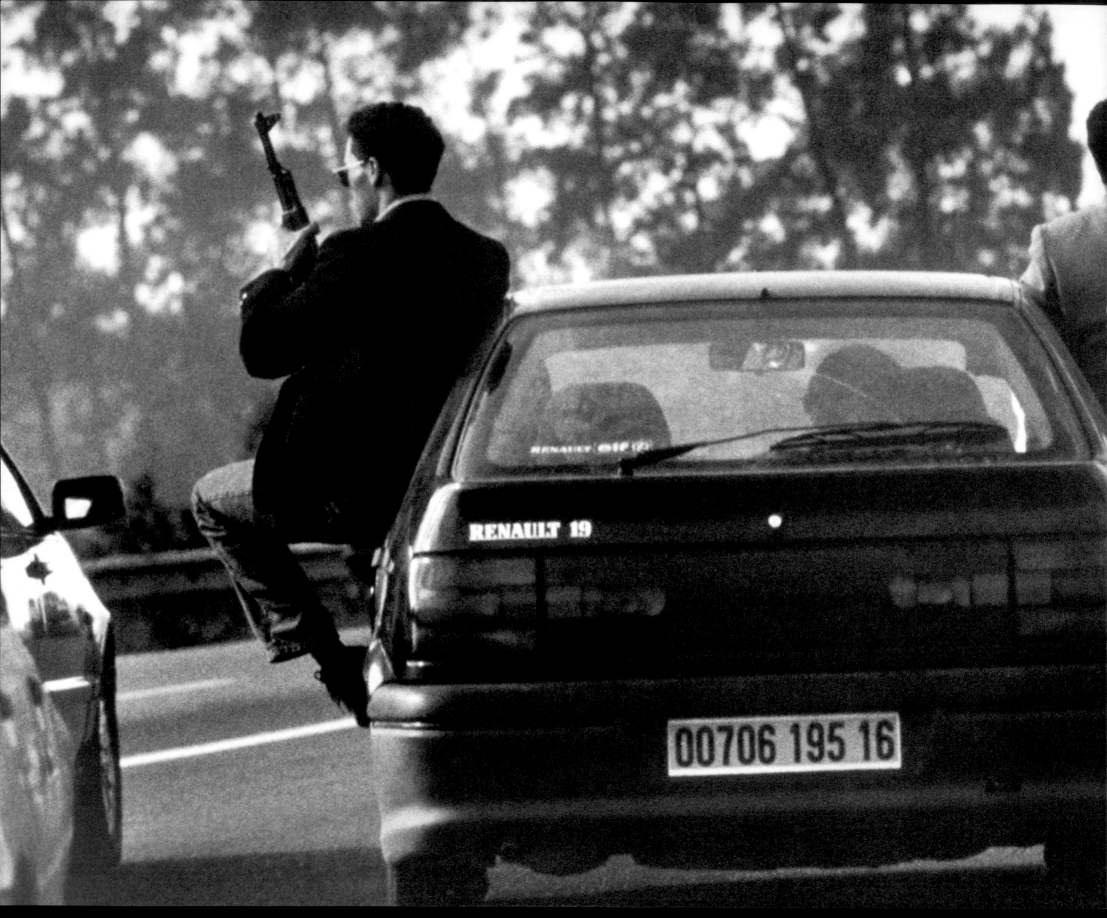

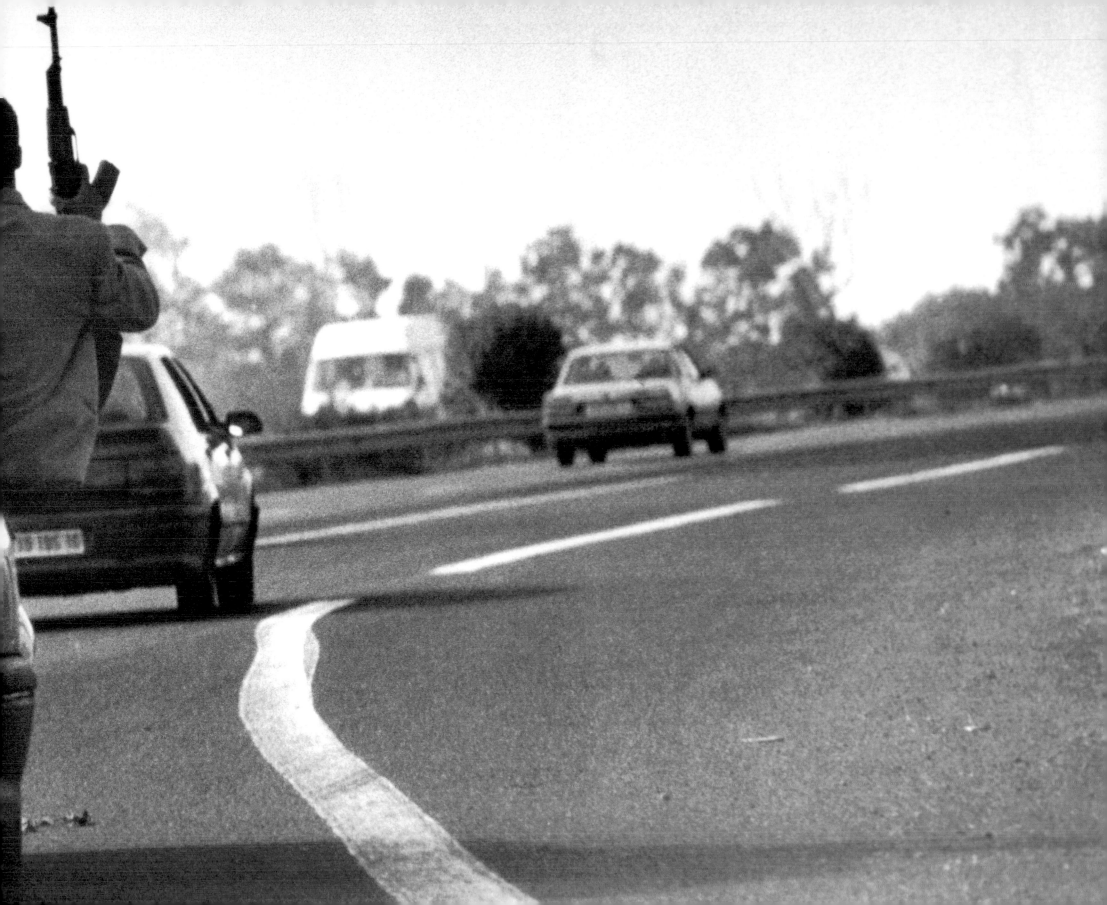

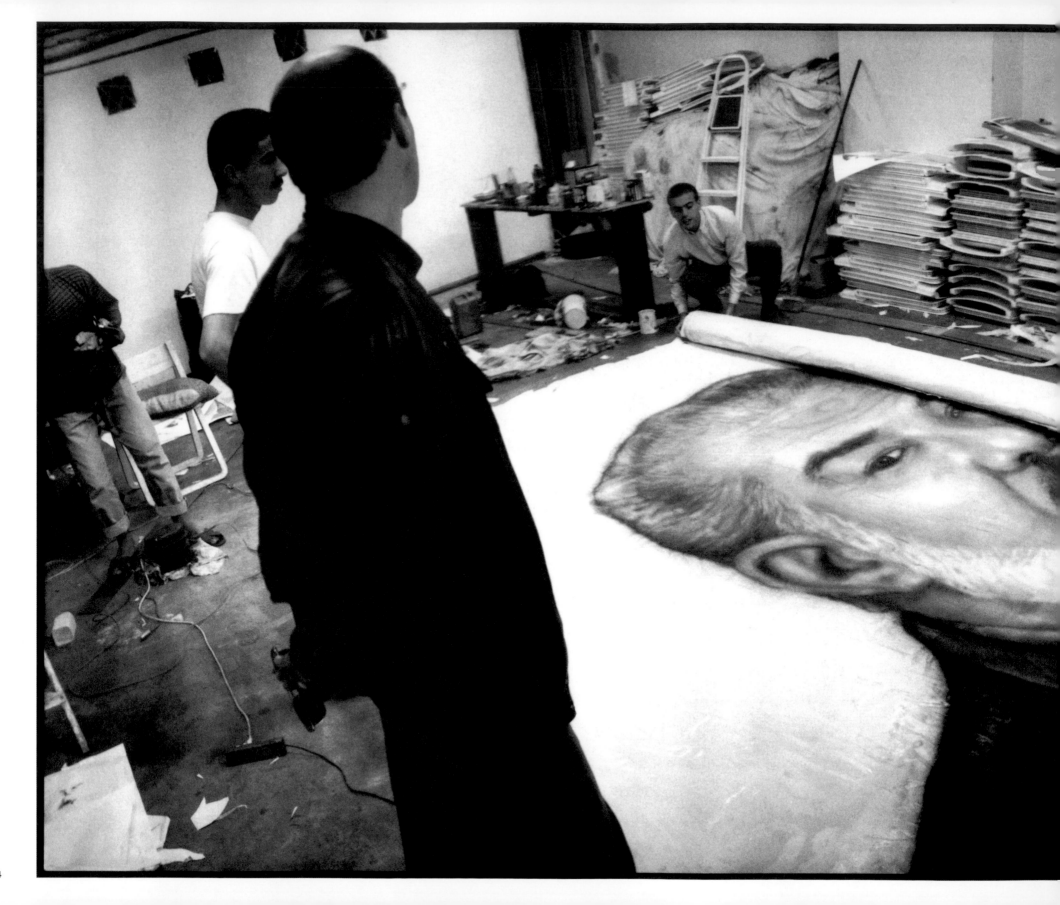

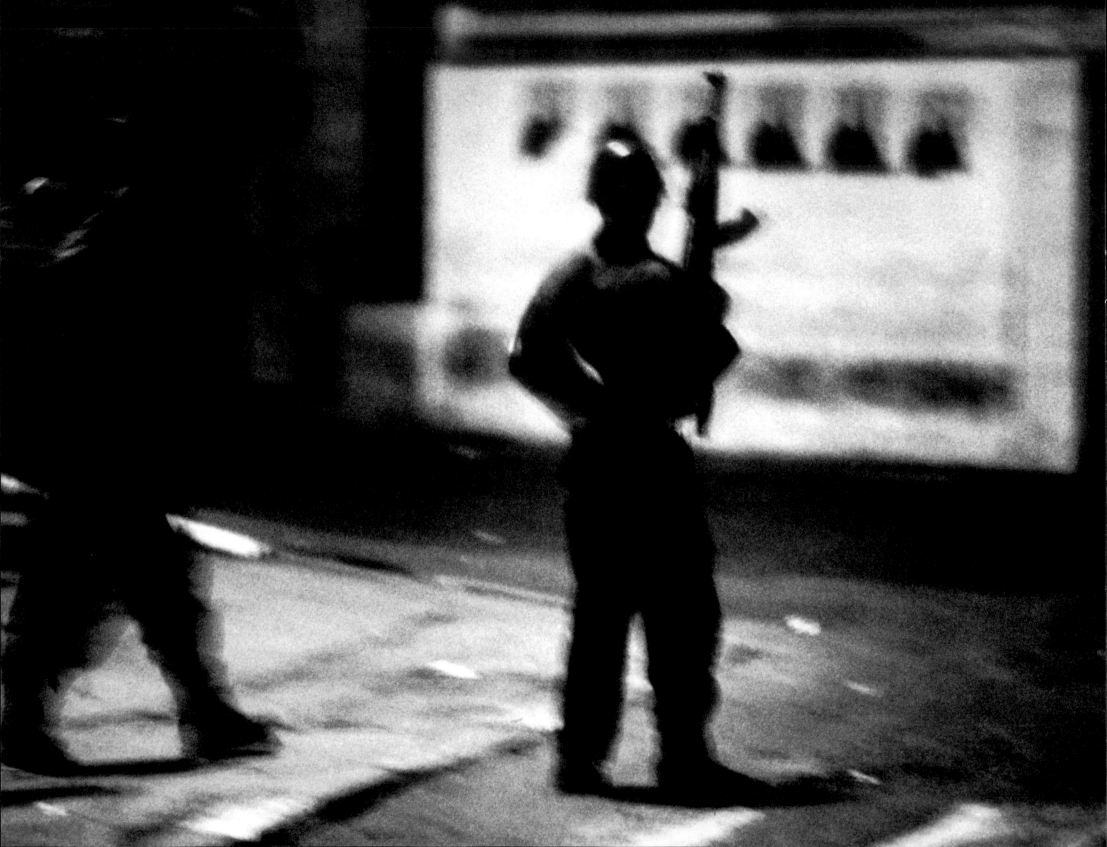

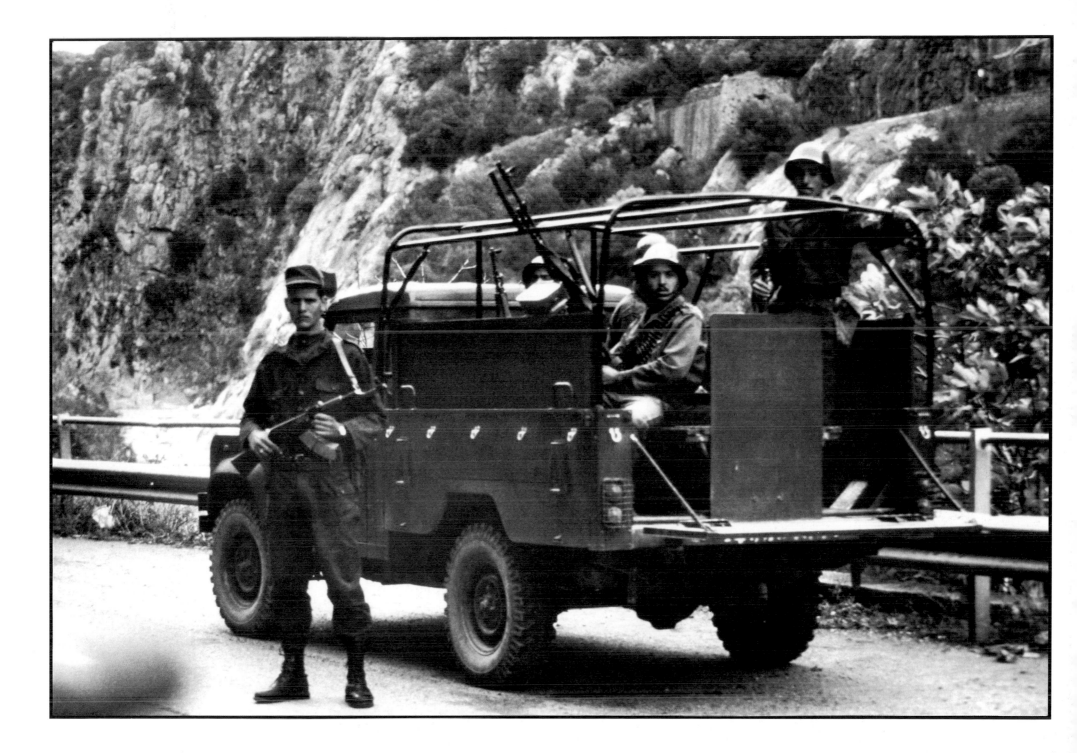

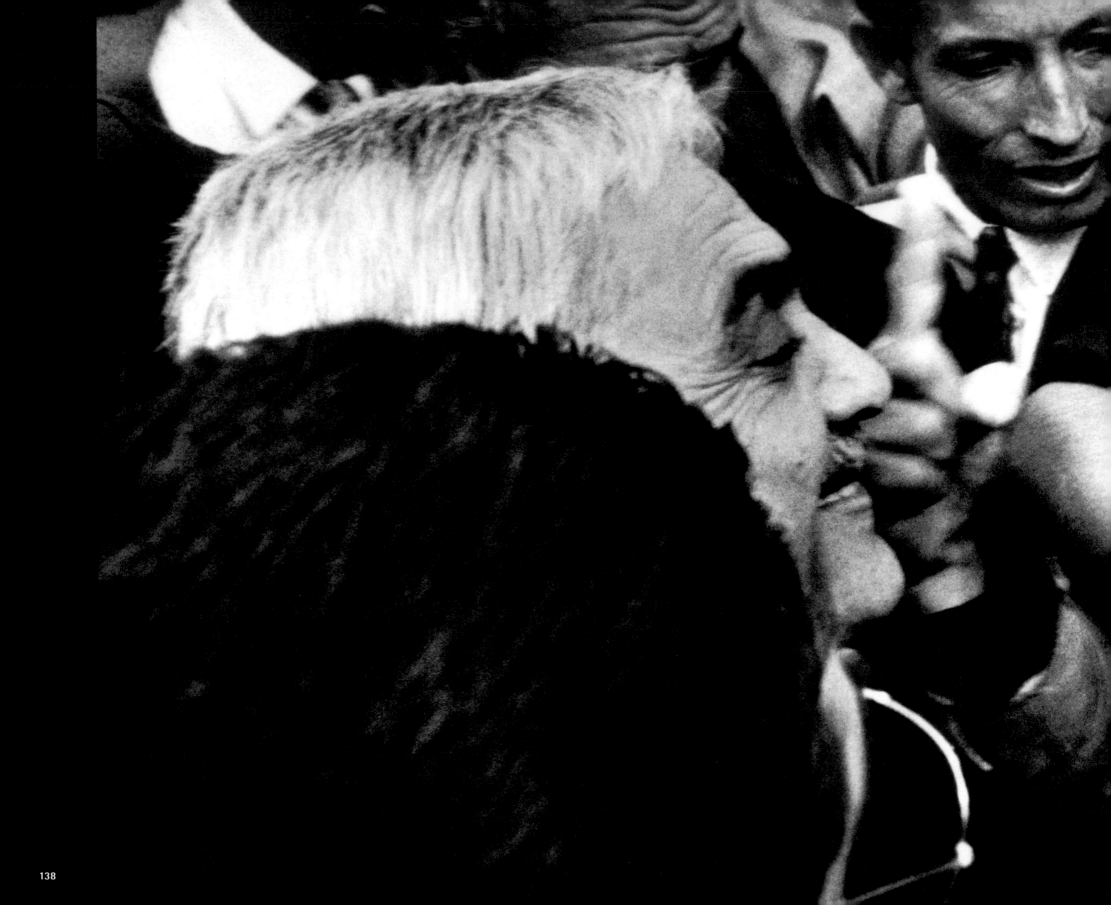

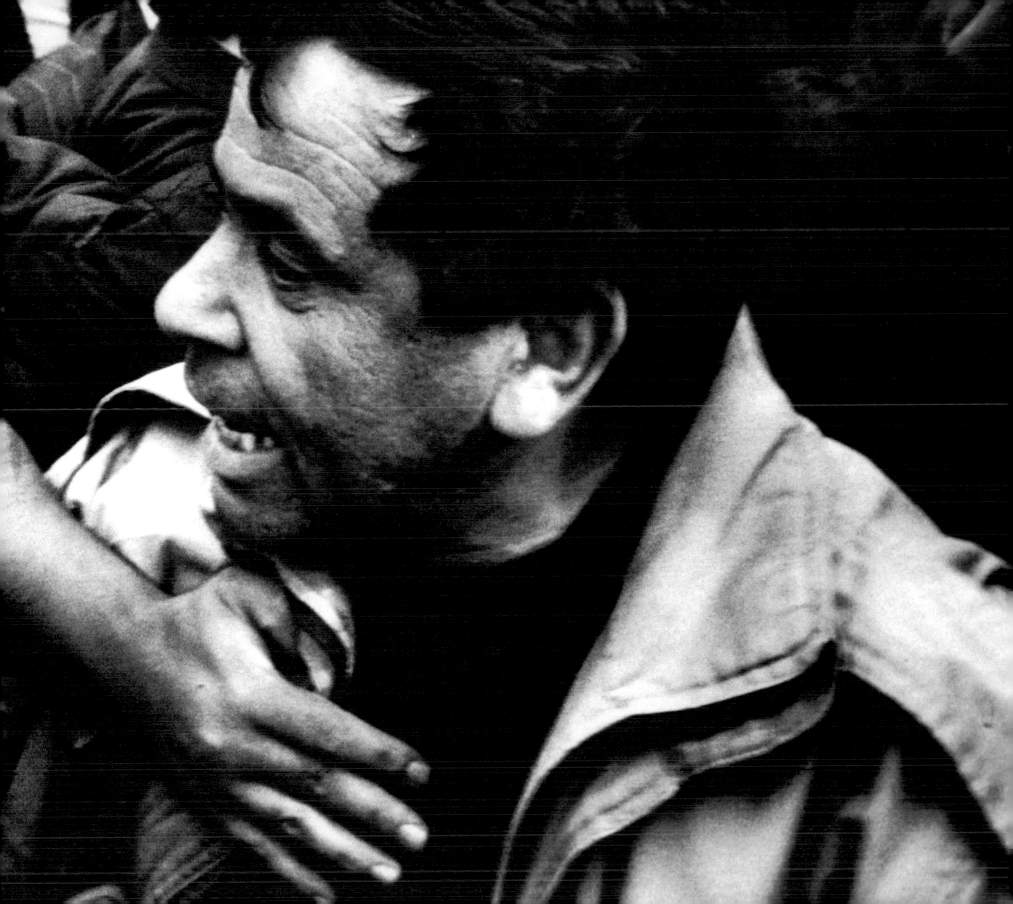

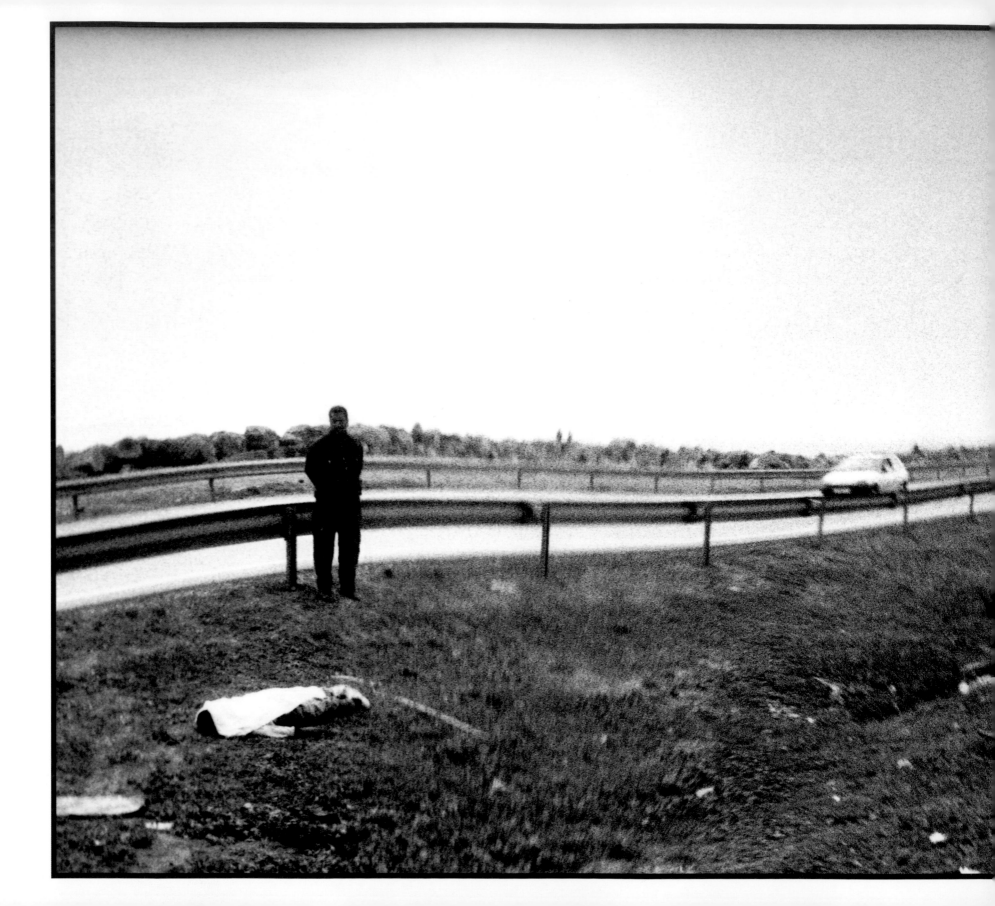

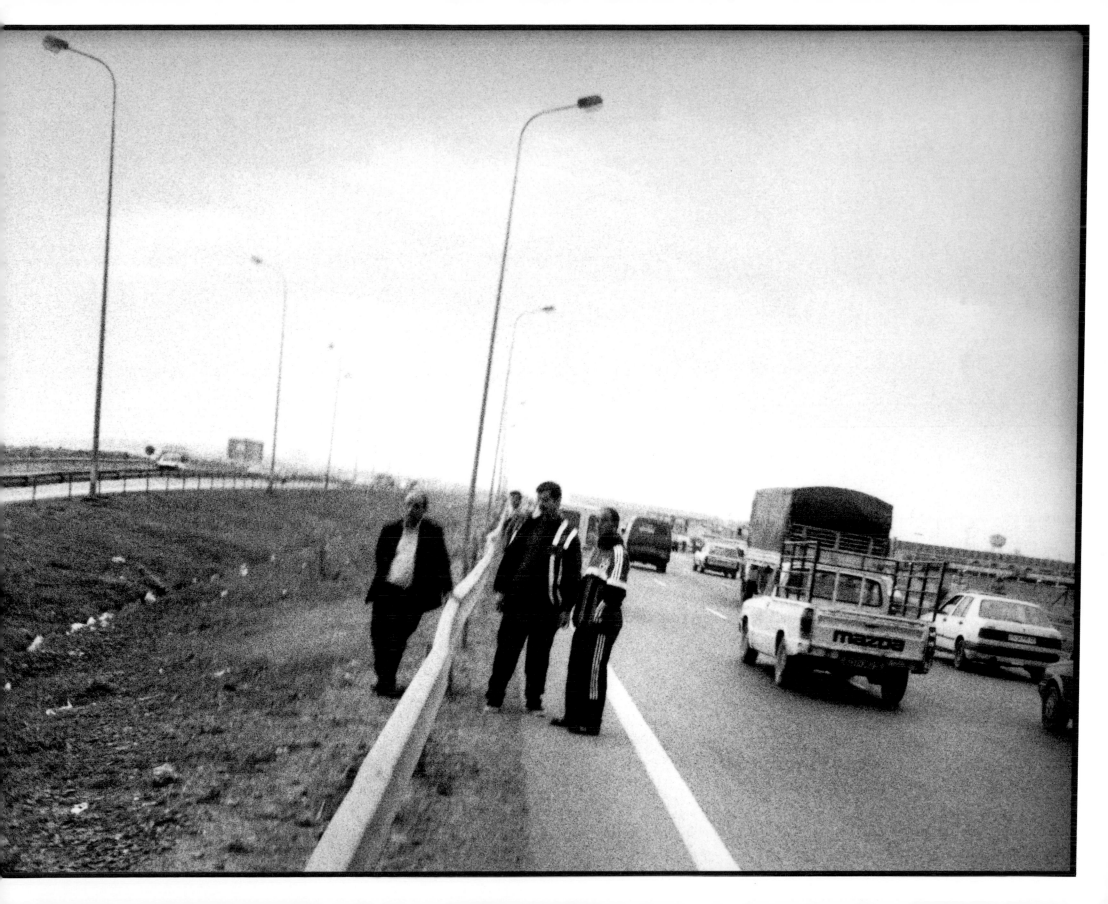

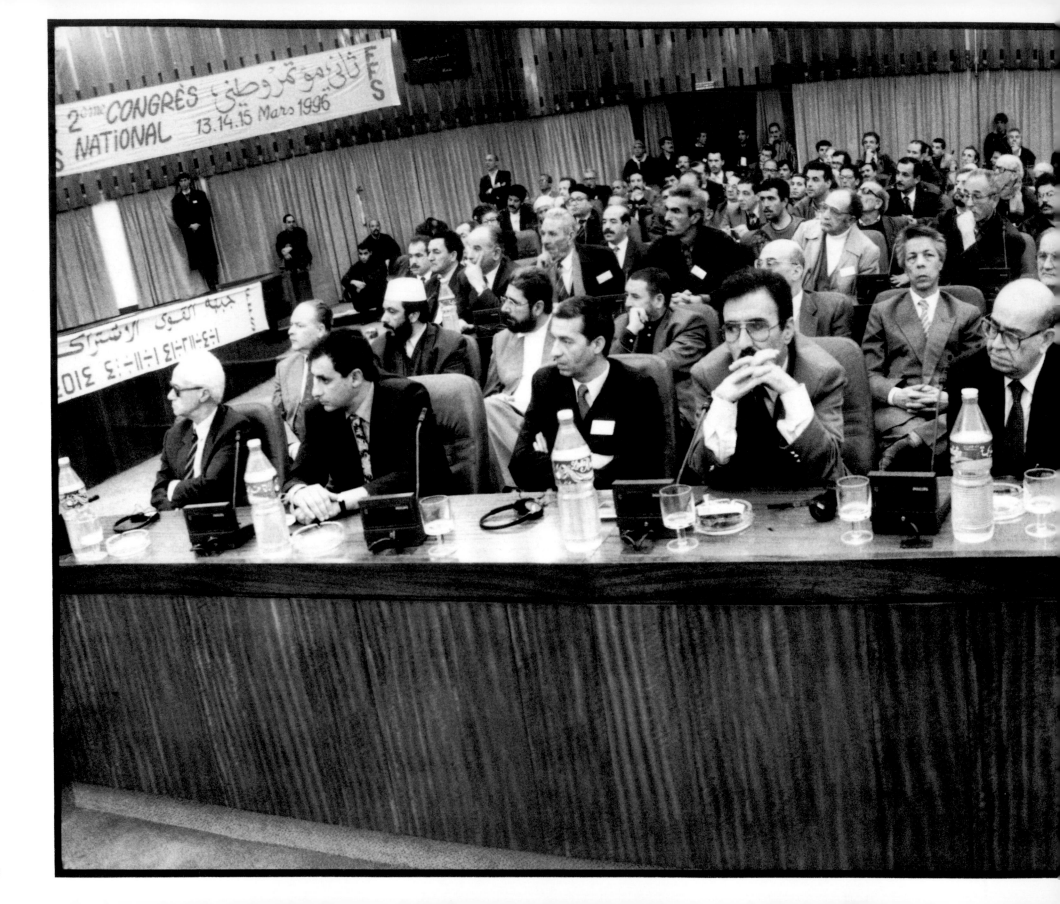

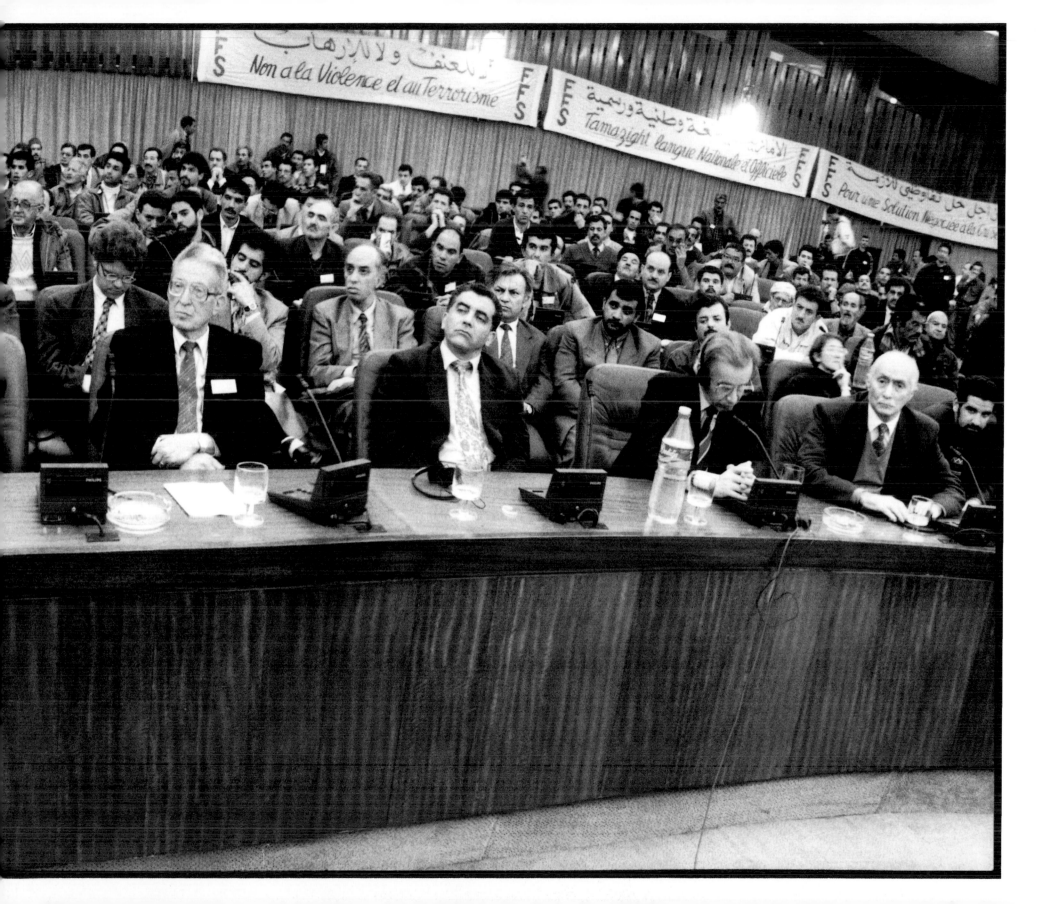

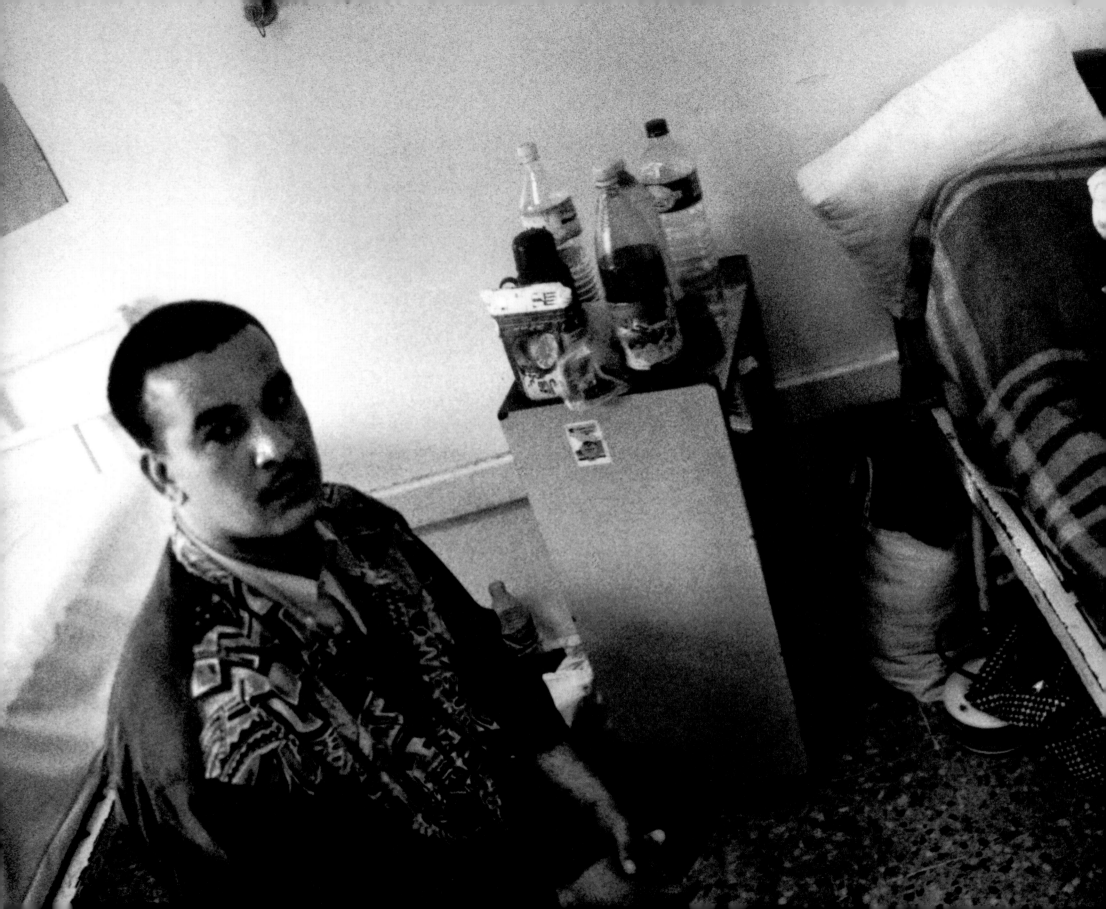

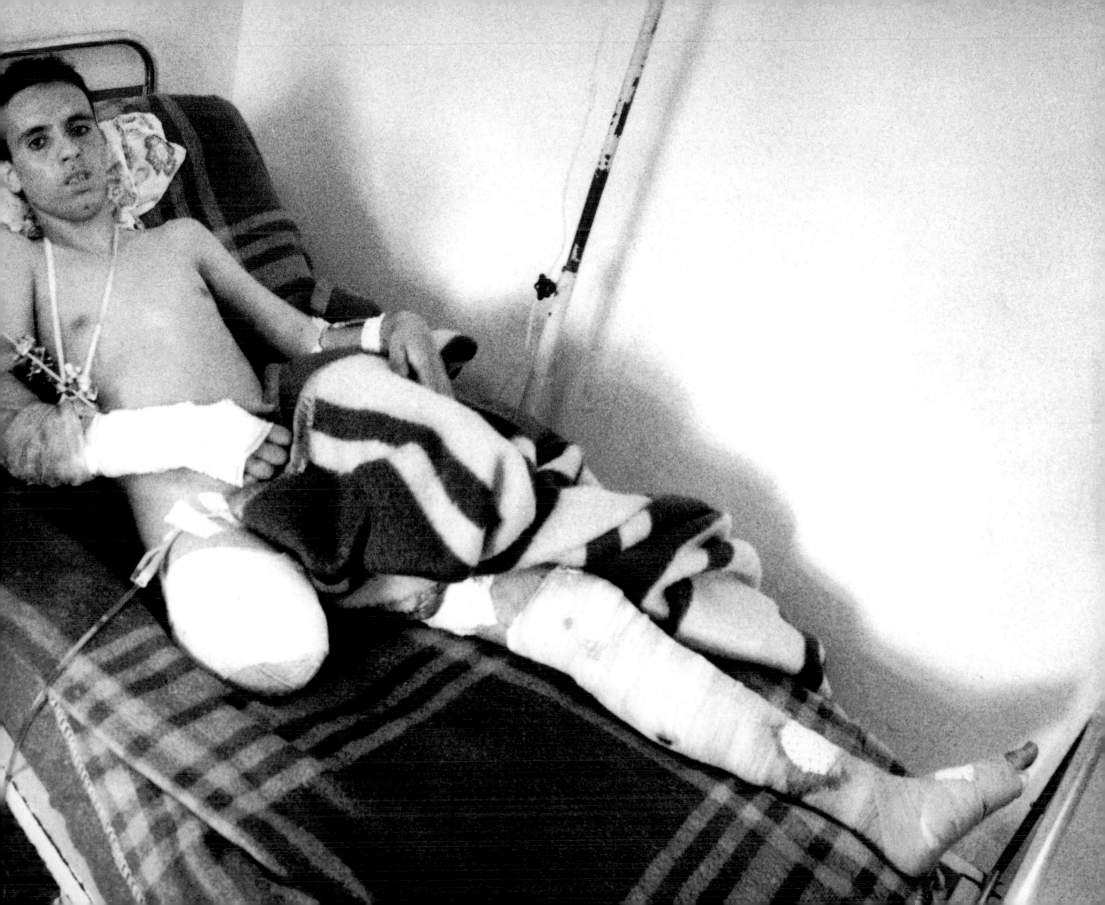

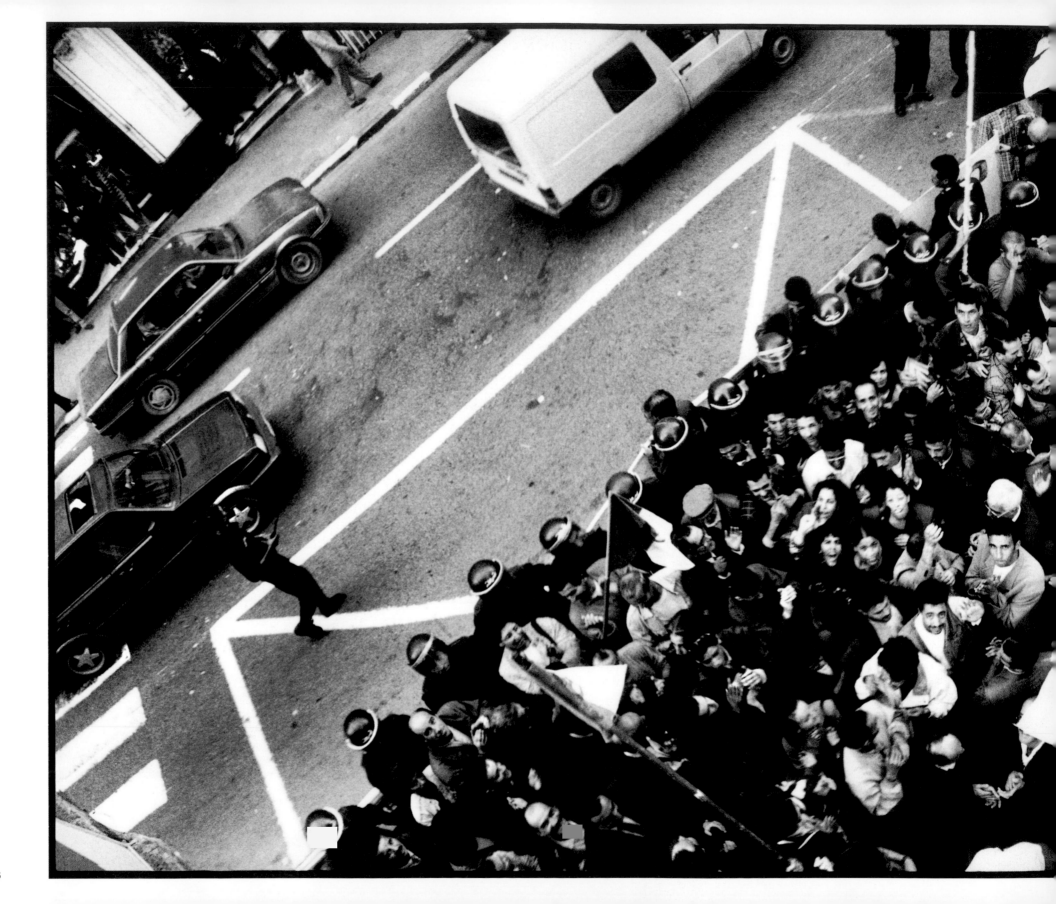

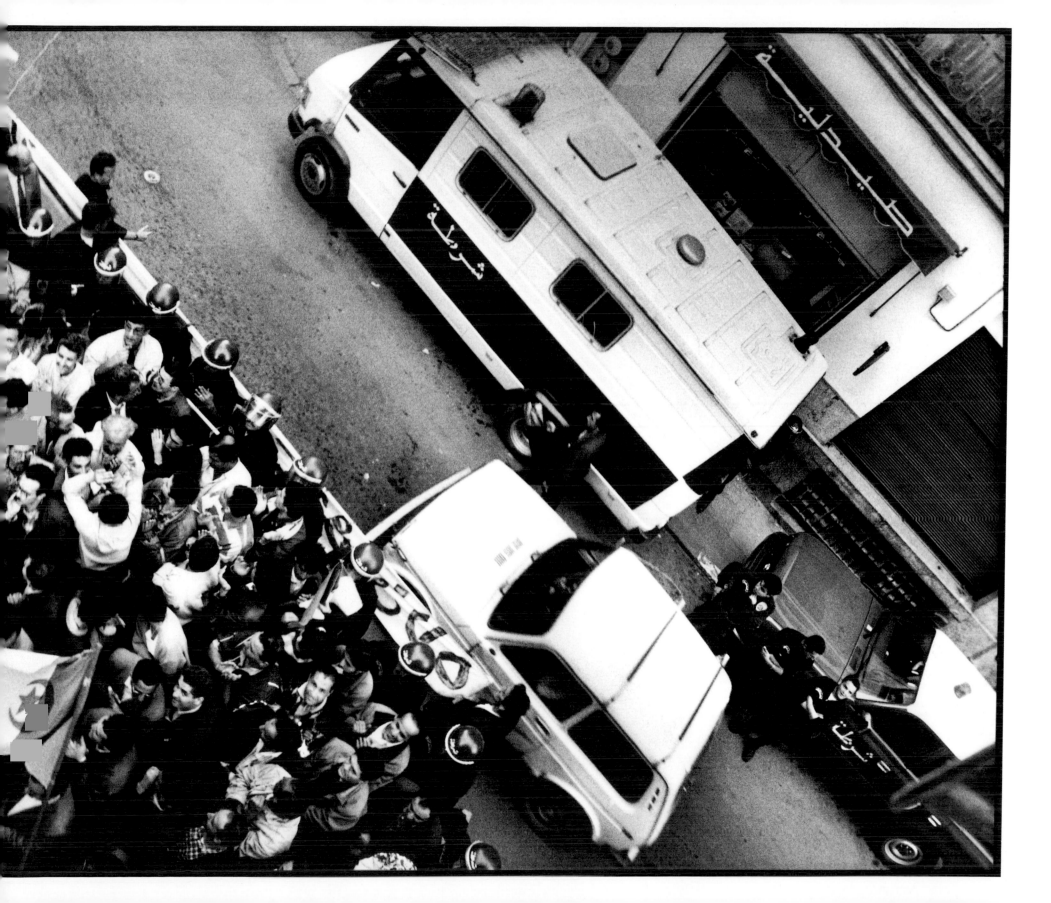

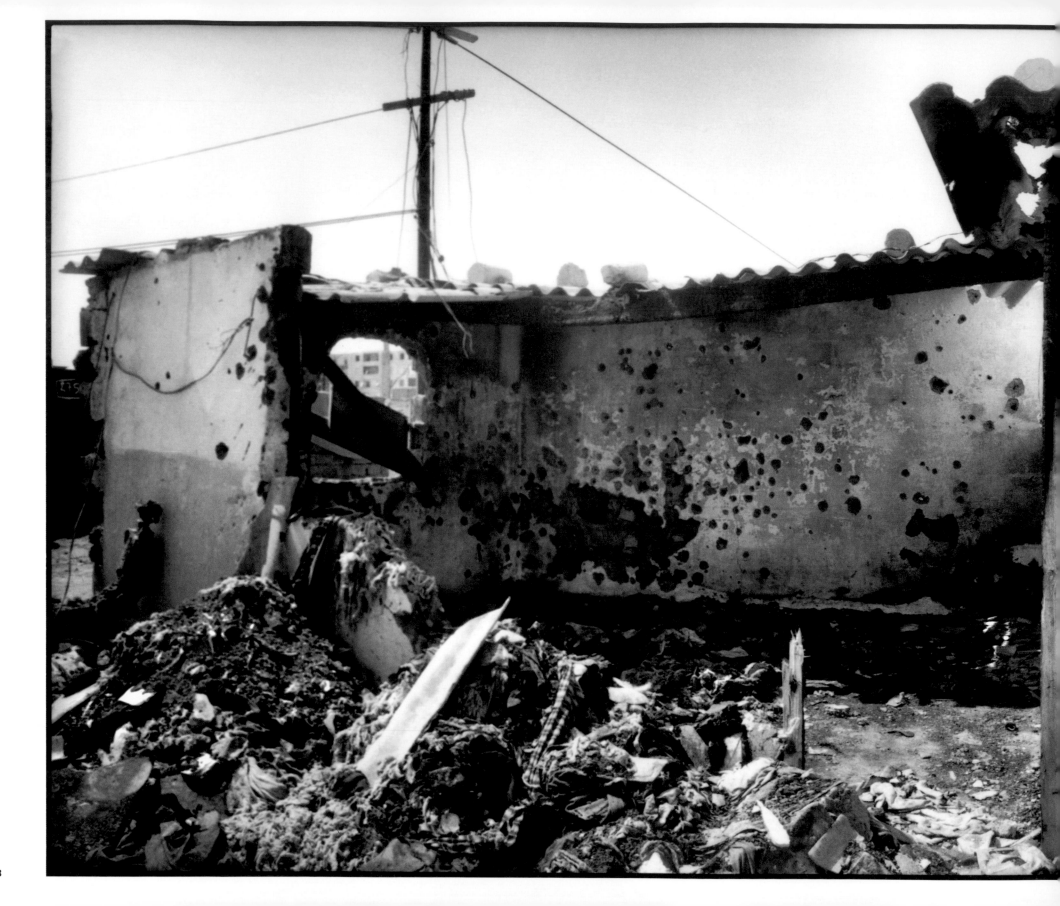

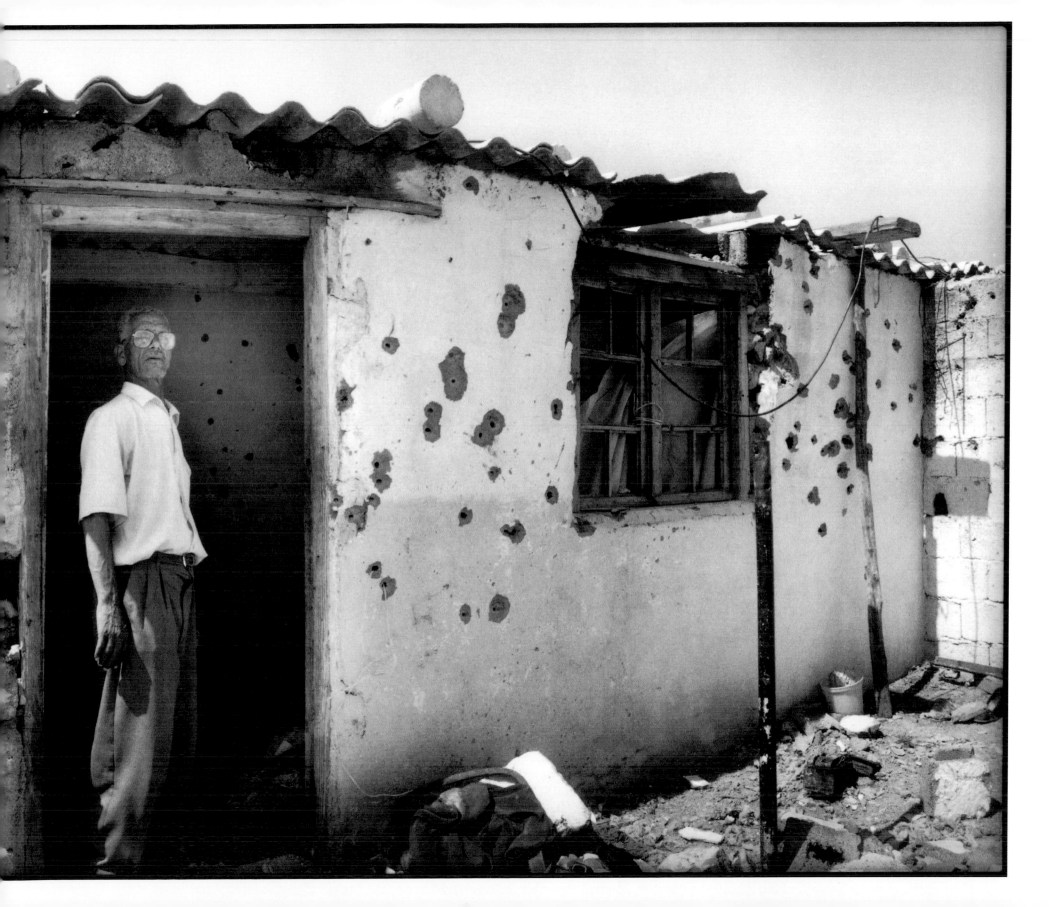

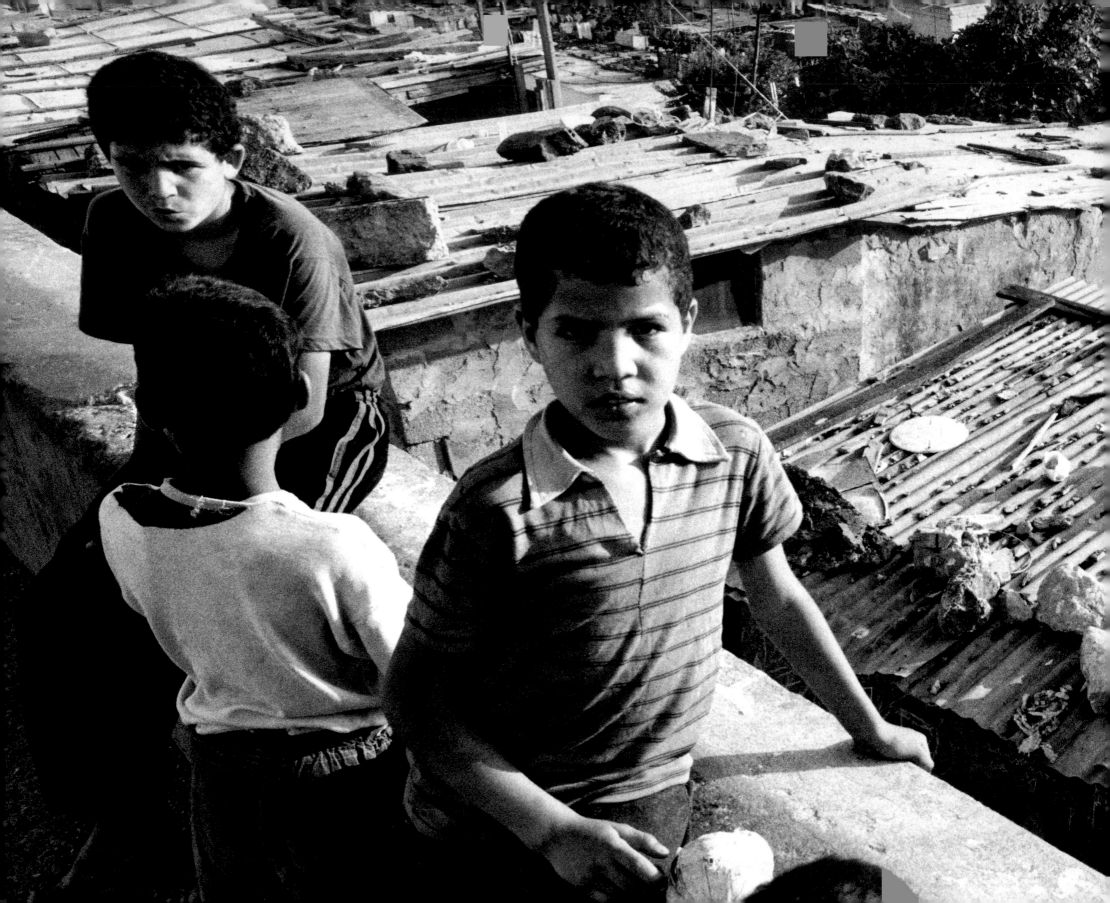

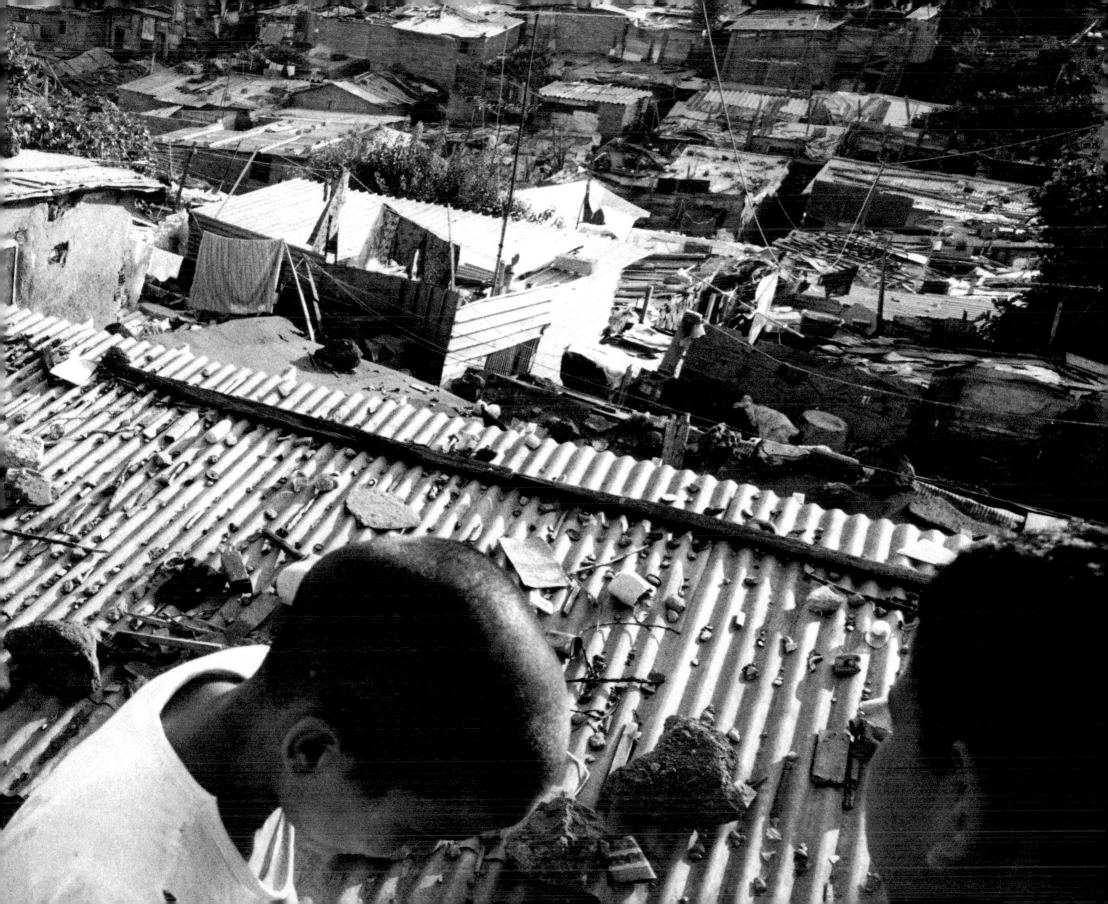

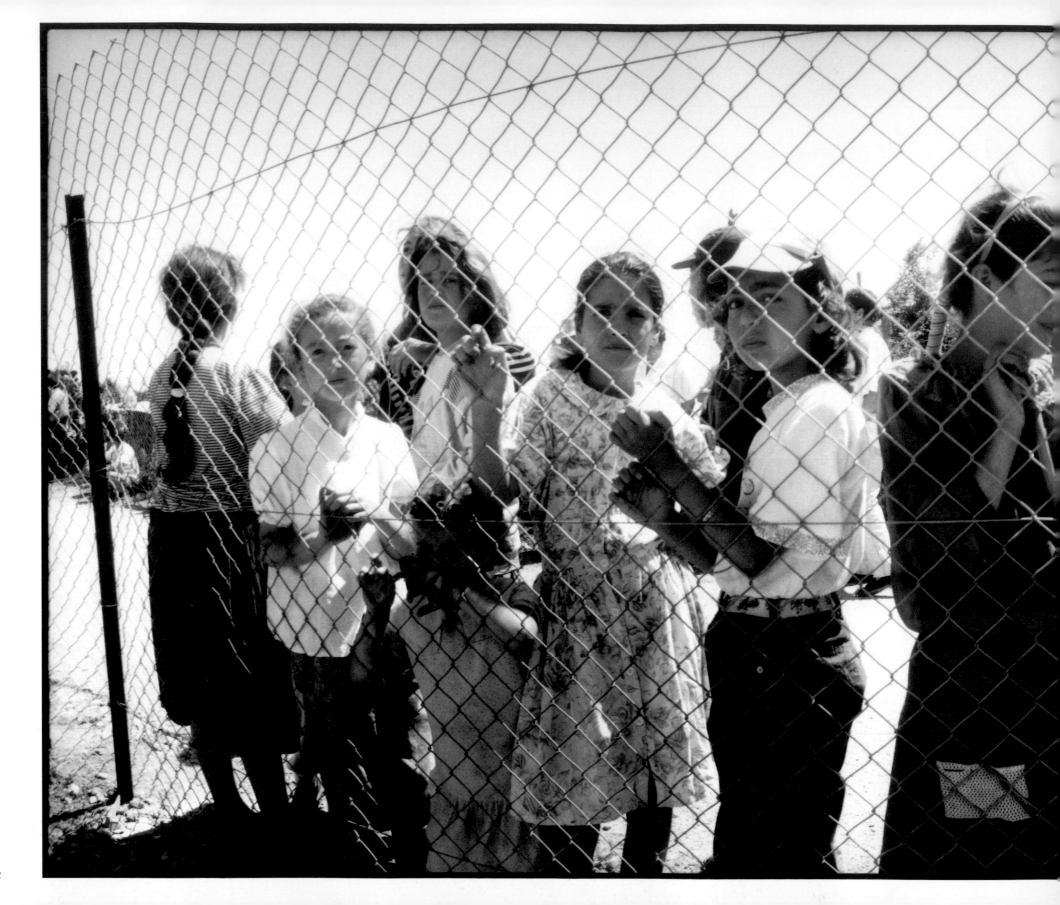

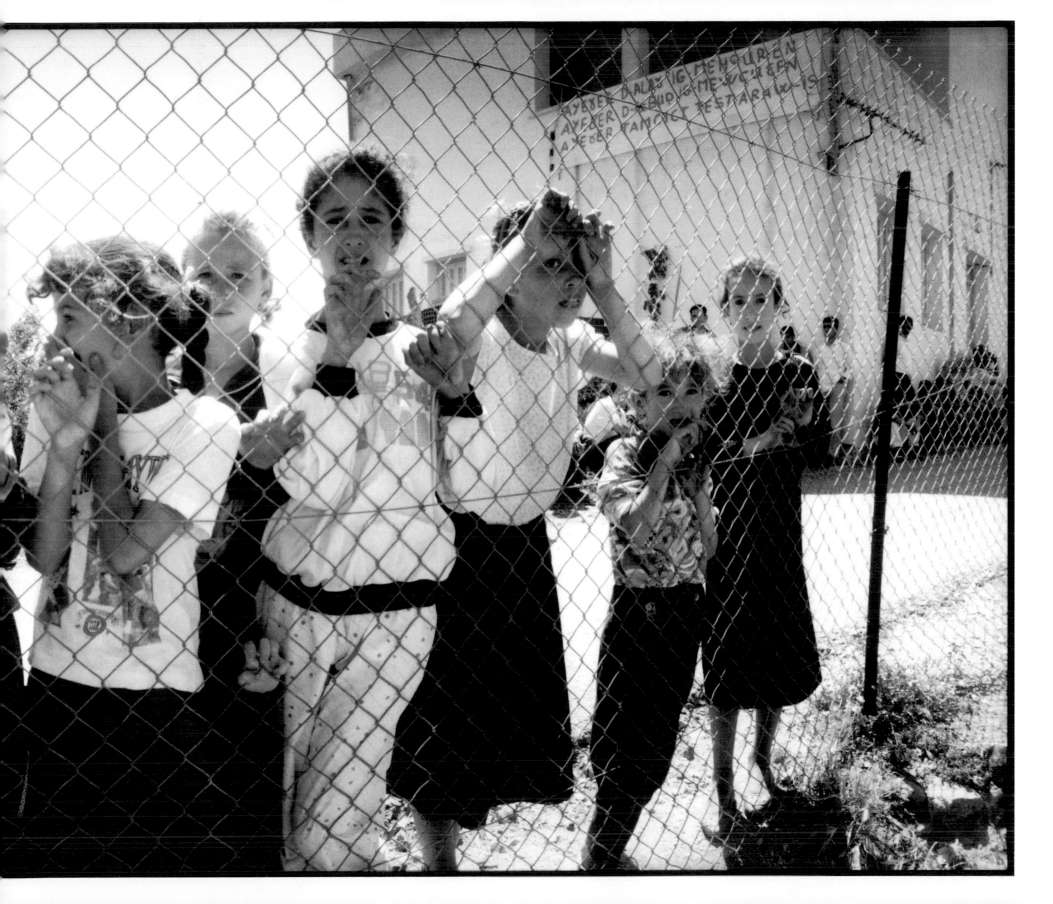

1 A woman from Bouira behind the Algerian flag and a fence that separates her from the presidential candidate, General Limiane Zeroual, who was addressing the people during the election campaign. November 1995.

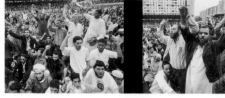

2–3 Stadium in Algiers. An Islamic Salvation Front (FIS) meeting, during the election campaign of December 1991, attended by Islamic militants from all over Algeria. They are shouting "Allah u Akbar" (God is great), and praying for an Islamic state.

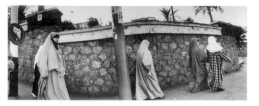

4–5 After Friday prayers at the mosque Ibn Badis of Kouba, women dressed in jellabas return home to care for their families.

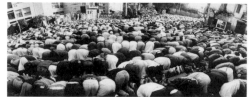

6–7 The mosque Ibn Badis of Kouba. Friday prayers are held the day after the FIS victory in the first round of the parliamentary elections is announced. Joy will last only a few days, however, before the election is overturned. December 28, 1991.

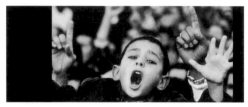

8–9 Martyrs' Square, Algiers. FIS electoral rally. The child is crying and shouting "Allah u Akbar," (God is great). Shortly after the photograph was taken, this six-year-old boy passed out on his father's shoulders. December 1991.

18–19 Algiers after the elections were overturned in 1992. Soldiers abound in the streets of the capital. This area, guarded by police, is know as the Climate of France.

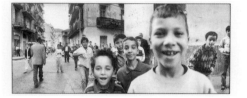

20–21 Children in the streets of Bab el Oued are intrigued by the camera. Seventy-five percent of the population of Algeria is under thirty years old.

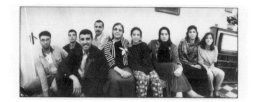

22–23 Portrait of an Algerian family in their living room. November 1995.

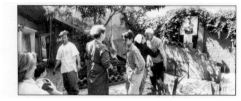

24–25 The festival of 'Id al-Kabir, one of the most important Islamic holidays. Families visit each other to exchange the saha aiddak, the ritual wishes for 'Id.

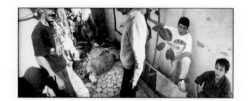

26–27 The sacrificial ritual during the 'Id al-Kabir festival. The sheep's throat is slit in memory of Abraham and his son Ishmael.

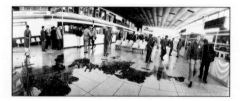

28–29 The international airport of Algiers. Cleaners at work in the departure hall, one year after it was devastated by a bomb explosion.

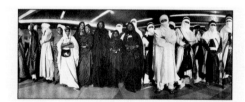

30–31 Charity program organized by Algerian television to gather funds for convalescent homes. The Tuaregs, the men from the desert, perform in front of an audience in the capital in the neon-lit decor of the shopping mall of Riadh el Feth in Algiers.

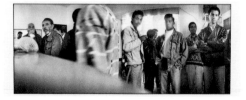

32–33 In a bar with the panoramic camera on the counter. The customers watch the lens slowly moving. Even so, they do not imagine that the camera is taking a photograph.

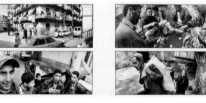

34–35 Young men lean against walls in an area of Bab el Oued. Young men of Belcourt dream of leaving Algeria for a foreign country. In Hussein Dey a group of friends play dominoes, forbidden by the Islamists. In the Casbah an old couple returns from the vegetable market.

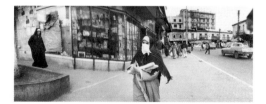

36–37 Kennedy Square in El Biar. French baguettes are a vestige of French colonial times. Bread is an important basic food in Algeria, but its price has increased tenfold since 1991.

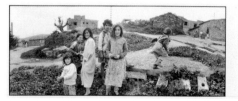

38–39 Berber girls in a village in the Kabyle mountains. In order to preserve their language and Berber culture, the Kabyles flout the July 5, 1998 law discouraging all languages except Arab.

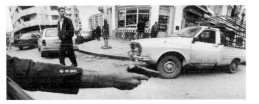

40–41 A plainclothes policeman panics in the dense traffic of Bab el Oued, a working-class area of Algiers. With his gun in hand, the policeman tries to force his way out of the traffic jam in his unmarked car, to the indifference of a passerby.

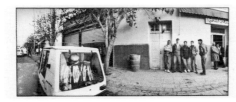

42–43 These young, unemployed men are called hittists, those who prop up the walls. In a cafe at the beach the unemployed talk politics or sell imported Marlboros.

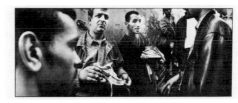

44–45 In an alley of the Casbah in Algiers, trabendists sell and buy brand-name goods on the black market.

46–47 In the heavily guarded House of the Press in Algiers, the editors of El Khabar, an Arab-language independent newspaper, close the next morning's paper. The building was bombed on February 11, 1996. The independent press is constantly under threat from both the Islamists and the state.

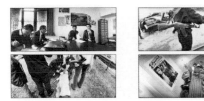
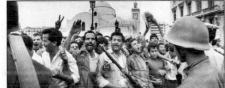

48–49 Editorial conference at Hebdo Libere, a French-language weekly. A body found in the street. Stopped by a police barrage. A journalist in his hotel in the tourist center of Sidi Fredj, which is guarded by the military.

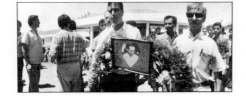
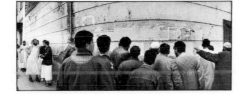

50–51 Commemoration at Azfoune, in the Kabyle region, of the death of Tahar Djaout, the first writer and journalist killed by the Islamists, in May 1993. Since then, more than sixty photographers and journalists have been murdered by the bullets of fundamentalist terrorists. June 1994.

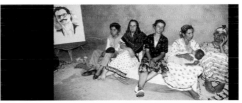
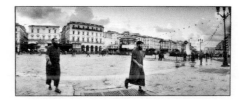

52–53 In memory of their prodigal son, the family of Tahar Djaout gather together a year after his death to mourn him in the house where he was born at Azfoune in the Kabyle mountains.

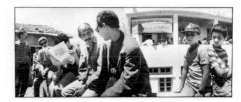
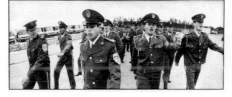

54–55 Azfoune, Kabyle. In distress and anger, Algerian intellectuals and journalists who are threatened with death cry, "A state that accepts that its elite lives in hiding is not a state."

56–57 The day of the funeral of President Boudiaf, who was assassinated at Annaba by a member of his security guard. The people, in despair, go into the streets to pay him tribute. They shout "Give us back our Algeria!" July 1992.

58–59 The mosque of El Sunna in Bab el Oued. After the Friday sermon, under close police guard, FIS militants rush to the walls of the mosque to read the latest bulletins issued by leaders who have been in hiding since January 1992.

60–61 Martyrs' Square in Algiers. Rare supporters of the FIS continue to defy the authorities with beards and Afghan clothes. (Algerians who volunteered to fight on the Islamist side of the Afghan war against the Soviet army are called "Afghans.")

62–63 The central police barracks of Leveilly in Algiers. Former traffic policemen have been trained to fight, temporarily, against the terrorists. Once peace returns, the notorious Ninjas will go back to their normal jobs handing out traffic fines.

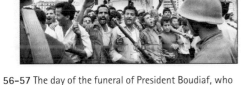
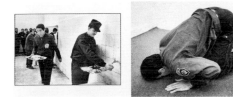

64–65 Members of the Algerian security force eat their lunch and pray inside the barracks. They are a favorite target of the armed terrorist groups, and the policemen no longer dare to be seen in their homes or neighborhoods. Graffiti all over the city accuses them of being infidels and enemies of God. March 1995.

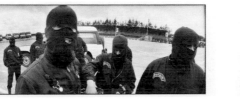

66–67 In the courtyard of the police barracks. A patrol of anti-terrorist Ninjas wearing balaclavas prepares for duty. The government has invested a great deal of money in anti-guerilla equipment and training for these intervention brigades.

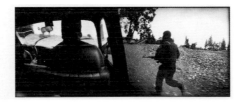

68–69 Baraki. In what is known as the Triangle of Death, the Ninjas in their four-wheel-drive armored cars comb the strongholds of the armed Islamist groups. The Ninjas are carrying out the government's policy of eradicating Islamists. March 1995.

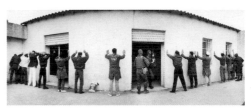

70–71 Chateau Rouge. Two seconds after the anti-terrorist force arrived at the cafe, all the customers were driven outside and forced to place their hands on the wall. Often the Ninjas carry lists with names and photographs of the Islamists they are seeking.

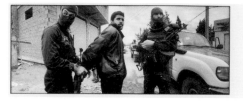

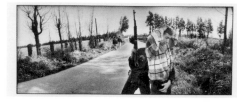

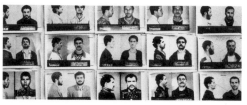

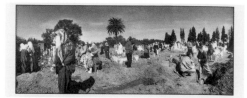

72–73 The arrest of a young suspect. The man will be interrogated at the police station, and his details will be filed there. Later he will be released.

74–75 In the Metidja plain the trees alongside the roads have been cut down by the army in an attempt to stop armed Islamist groups from ambushing military convoys and police patrols.

76–77 In a police station, portraits of wanted Islamists are displayed. When the Ninjas return from one of their eradication raids, they cross out the faces of their victims. One Ninja, in a fit of personal rage, has written the word "abattu" (finished), on the portrait of a bearded Islamist he has just killed.

78–79 The cemetery of El Allia. The family members of armed Islamic terrorists who were killed by the Ninjas visit the cemetery. The freshly dug tombstones bear the victims' names and the words "Martyr for Algeria." Another corner of the cemetery inters the policeman killed by Islamists. The families do not meet.

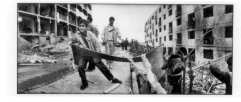

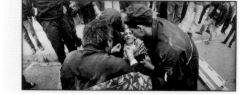

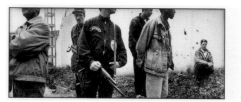

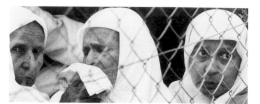

80–81 Just after the muezzin's call to prayer at dawn, a huge explosion shakes the sleeping city of Algiers. Islamist groups were targeting a residence for families of policemen from the central barracks of Leveilly (see photographs 62–63 and 64–65).

82–83 Cité Garidi, Kouba. A car bomb injures sixty-nine people when it explodes in a residence for the families of policemen. The bomb exploded near the kitchens while the policemen's wives and children slept on the other side of the building, so no one is killed.

84–85 Islamist leaders order armed groups to kill not just policemen, but their families and relatives too. It is difficult to say exactly how many policemen and soldiers have fallen victim to the conflict.

86–87 Blida. The mother of Bouslimani, one of the leaders of the Islamist party, weeps for her son who was killed by the GIA (Armed Islamic Group) because he refused to validate their call for the jihad, the holy war.

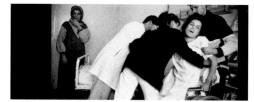

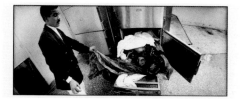

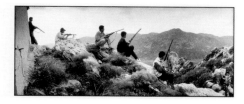

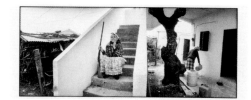

88–89 The Mustafa Hospital in Algiers. The family of Nacera, a student victim of a car bomb attack, traveled a long way to come and see her in the hospital.

90–91 The burnt body of an unidentified woman who was a victim of the 1995 bomb attack on the boulevard Amirouche. The body has never been claimed and lies abandoned in the morgue of the Mustafa Hospital. She is just one of the estimated eighty thousand victims since the start of the conflict in 1992.

92–93 The first self-defense groups were organized in the Kabyle region because people there were the first to counter-attack with their hunting guns. When the government saw that this kind of mobilization was effective, it began to arm many more civilians all over the country. They are now known as the Patriots. March 1995.

94–95 Igoujdal, Kabyle. During the war of liberation, Ouardia, sixty-three, was condemned to death by the French and then imprisoned. She has taken out her hunting gun again to teach the young men of the village how to use arms.

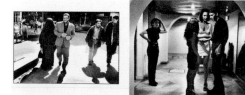

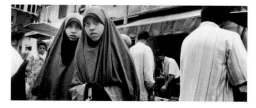

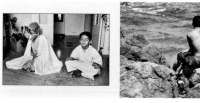

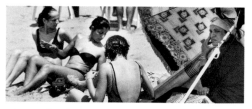

96–97 Friday afternoon. A young couple walks in Ben M'Hidi street in the center of Algiers. At night, in the disco of the El Djaazair hotel, girls and boys come to dance to the wild rhythms of both Western and Middle Eastern music.

98–99 At the Belcourt market two girls in jellabas stare into the photographer's eyes. They want to know if he will raise the camera against his waist to take a photograph. They do not realize that the photograph is being taken at that very moment.

100–101 A mother teaches her children how to carry out their ablutions and the sacred duty of prayer five times a day. A loving couple meets discreetly by the sea at Sidi Fredj.

102–103 On a beach near Algiers, a mother sitting in the shade watches over her daughters. Young men come to admire their bodies as they lie on the sand under the Algerian sun.

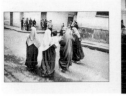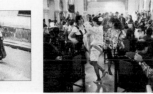

104-105 The lower area of the Casbah in Algiers. The woman spotted the photographer at once. November 1995. Hotel El Djazair, Algiers. In private, during wedding celebrations, girls can show off their beauty. November 1997. The Algerian tragedy makes one forget that life still goes on.

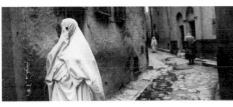

106-107 Ghardaia. In the capital of the Mozabites the veil has been worn for centuries. This Algerian community is very traditional and lives in harmony, untouched by the conflict.

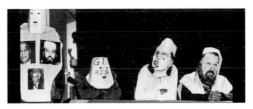

108-109 The Ibn Khaldoun hall in Algiers. For the International Day of Women, feminine organizations held a mock trial, under government protection, and condemned to death those who were "guilty of fundamentalism." March 8, 1995.

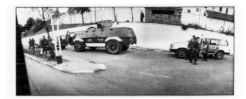

110-111 Police patrol the prison of Serquadji where a mutiny of Islamist prisoners left hundreds dead. The Red Cross is not permitted to visit the prisons, and no one from the outside worlds knows what conditions are like inside.

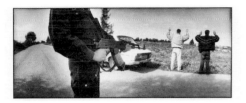

112-113 On the shoulder of a main road in the Metidja region. After several civilian massacres there, people wonder who is killing whom, why the army failed to intervene, and who is profiting from the slaughter.

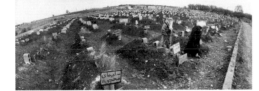

114-115 Cemetery near Raïs. In one night, more than three hundred villagers were massacred by armed groups. Most of the victims were women and children, including newborn babies. October 1997.

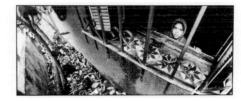

116-117 Raïs. Wahiba, a sixteen-year-old girl, survived the massacre thanks to her grandfather. His throat was slit and he fell on top of her. She passed out, and the killers left her for dead. She also escaped the fate of many young girls who are kidnapped and raped by the armed groups. November 1997.

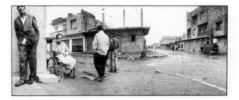

118-119 The town center of Bentalha after the massacre on September 23, 1997. Shocked, despairing, and fearful, the peasants of the Metidja region still cannot understand what has happened to them.

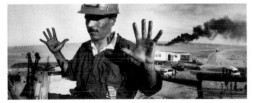

120-121 Hassi Messoud. Gas and petrol flow in the pipelines as never before since independence. Many foreign companies have signed contracts for billions of dollars with the Algerian government. Oil fields are guarded day and night. November 1997.

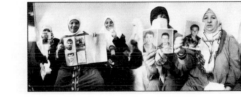

122-123 Kouba, Algiers. In the office of attorney Mohamed Tahiri, mothers show portraits of their sons who have disappeared. They will be sought for in the prisons, the morgues, and the underground movements. Since the beginning of the conflict, an estimated twelve thousand people have vanished. June 1998.

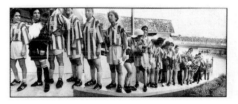

124-125 Outside the 5th of July Stadium, football fans say their prayers. At a rock concert at the Coupole, young people are searched for weapons. In the stadium, two women's football teams play for an all-male audience.

126-127 Algeria is the only Muslim country that allows women to play football, in an effort to encourage women's liberation. They wear shorts and play in front of sixty thousand men, which incites Islamists.

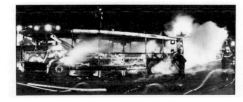

128-129 A bus burns on a roadside outside Algiers. The Islamists often sabotage trains, factories, and telephone lines as well.

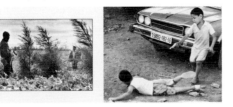

130-131 El Harrach. A young man in the fields is checked out by a Ninja. Armed Islamist groups indoctrinate adolescents and incite them to kill. Two boys in the suburbs of Algiers play cops and terrorists.

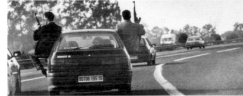

132-133 Plainclothes policemen on the highway to Blida guard Mahfoud Nahnah, the Hamas leader, during the presidential election campaign in November 1995. He is the only candidate who dared to hold a meeting in Blida, reported to be a very dangerous town.

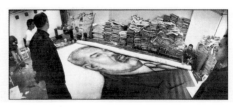

134-135 El Mouradia, Algiers. In the garage of the Hamas headquarters, militants of this so-called moderate Islamist party prepare a huge, hand-painted portrait of their leader, Mahfoud Nahnah, who received 25 percent of the votes during the presidential elections. His party has several ministers participating in the government. November 1995.

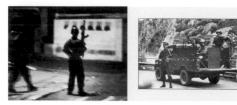 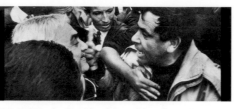 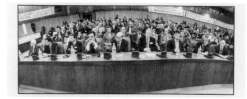

136–137 The army is accused of massacres. With its obsolete equipment and heavy-handed, Soviet-style operating tactics, it is handicapped against the flexible techniques of the armed Islamist groups.

138–139 Bouira. Presidential candidate General Liamine Zeroual on a rare visit to address the people at a meeting in the Kabyle region. His bodyguards are on the alert to stop any possible aggression. November 1995.

140–141 At 10 A.M. a body is found beside the road to the airport. Every day corpses are found in the dustbins of the Casbah or in the forest. For fear of being implicated, people rarely contact the police. One of the characteristics of the civil conflict is the opacity of the crimes and the impunity of those who commit them.

142–143 Aït Ahmed, the leader of the Front of Socialist Forces (FFS), returns to Algeria after a long absence. He remains loyal to the Rome agreement, signed with the FIS, and to the idea of dialogue. All opposition parties, including the Islamists, have been invited to the congress. November 1996.

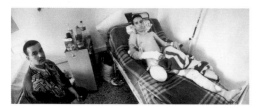 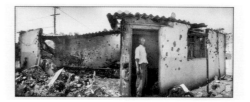 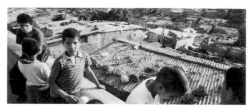

144–145 The El Ketar hospital in Bab el Oued. Djamil, a twenty-year-old vegetable seller, has been injured by a homemade bomb, which was hidden under his market stall on the Square of the Three Clocks. His right leg had to be amputated. November 1997.

146–147 The result of the local elections was challenged by all the opposition parties. The demonstrators are surrounded by riot police outside the headquarters of the Assembly for Culture and Democracy (RCD). They accuse President Zeroual of electoral fraud. November 1997.

148–149 Bab el Zouar. Youcef Cherifi, fifty-two, returns to his ruined house after the anti-terrorist brigades exterminated an armed group that had occupied his home. The victim wonders who will help him to reconstruct his house. June 1998.

150–151 El Harrach. The survivors of massacres, who fled their villages in the Metidja plains, find refuge in the slums of the capital.

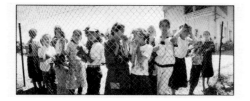

152–153 Igoujdal. The young people are the strength and the future of the country. Algerians want an end to the violence. All thirty million of them want to go on living. June 1994.

160 Ibn Khaldoun Hall, Algiers. The International Day of Women. March 8, 1995.

Library of Congress Catalog Card Number: 98-85810

Book conception by Michael von Graffenried
Book design by Jim Waters, Paris
Jacket design by Michelle M. Dunn

Printed and bound by Entreprise d'arts graphiques
Jean Genoud SA, Switzerland

The staff at Aperture for Inside Algeria is:

Michael E. Hoffman, Executive Director
Vince O'Brien, General Manager
Maureen Clarke, Editor
Stevan Baron, Production Director
Helen Marra, Production Manager
Lesley A. Martin, Managing Editor
Nell Elizabeth Farrell, Phyllis Thompson Reid,
 Assistant Editors
Tim Hale, Production Assistant
KC Lynch, Editorial Work-Scholar
Jacquie Byrnes, Production Work-Scholar

Aperture Foundation publishes a periodical, books, and
portfolios of fine photography to communicate with
serious photographers and creative people everywhere.
A complete catalog is available upon request. Address:
20 East 23rd Street, New York, New York 10010.
Phone: (212) 598-4205. Fax: (212) 598-4015. Toll-free:
(800) 929-2323.

Visit Aperture's website: http://www.aperture.org

Aperture Foundation books are distributed
internationally through:
CANADA: General Publishing, 30 Lesmill Road, Don Mills,
Ontario, M3B 2T6. Fax: (416) 445-5991.
UNITED KINGDOM, SCANDINAVIA,
AND CONTINENTAL EUROPE: Robert Hale, Ltd.,
Clerkenwell House, 45-47 Clerkenwell Green, London
EC1R OHT. Fax: 171-490-4958.
NETHERLANDS: Nilsson & Lamm, BV, Pampuslaan 212-
214, P.O. Box 195, 1382 JS Weesp. Fax: 31-294-415054.

For international magazine subscription orders for the
periodical Aperture, contact Aperture International
Subscription Service, P.O. Box 14, Harold Hill, Romford,
RM3 8EQ, United Kingdom. One year: $50.00. Price
subject to change.

To subscribe to the periodical Aperture in the U.S.A. write
Aperture, P.O. Box 3000, Denville, NJ 07834. Tel: 1-800-
783-4903. One year: $40.00. Two years: $66.00.

First edition
10 9 8 7 6 5 4 3 2 1

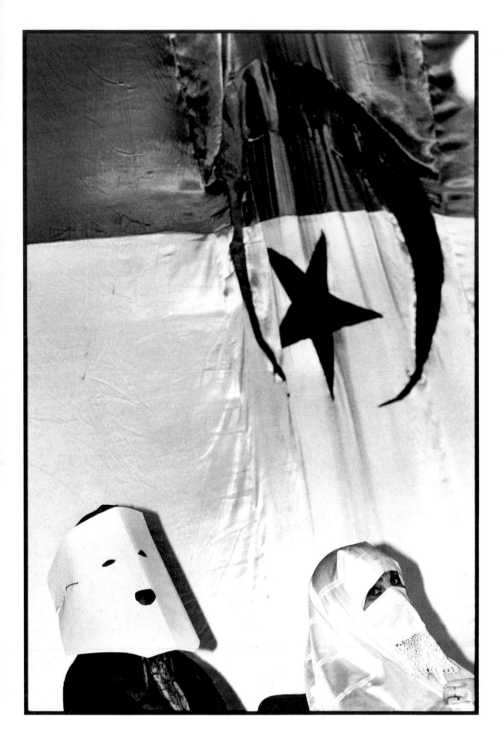

Date Due

DE 17 '00			